Claire Bingham

MODERN LIVING

Scandinavian Style

teNeues

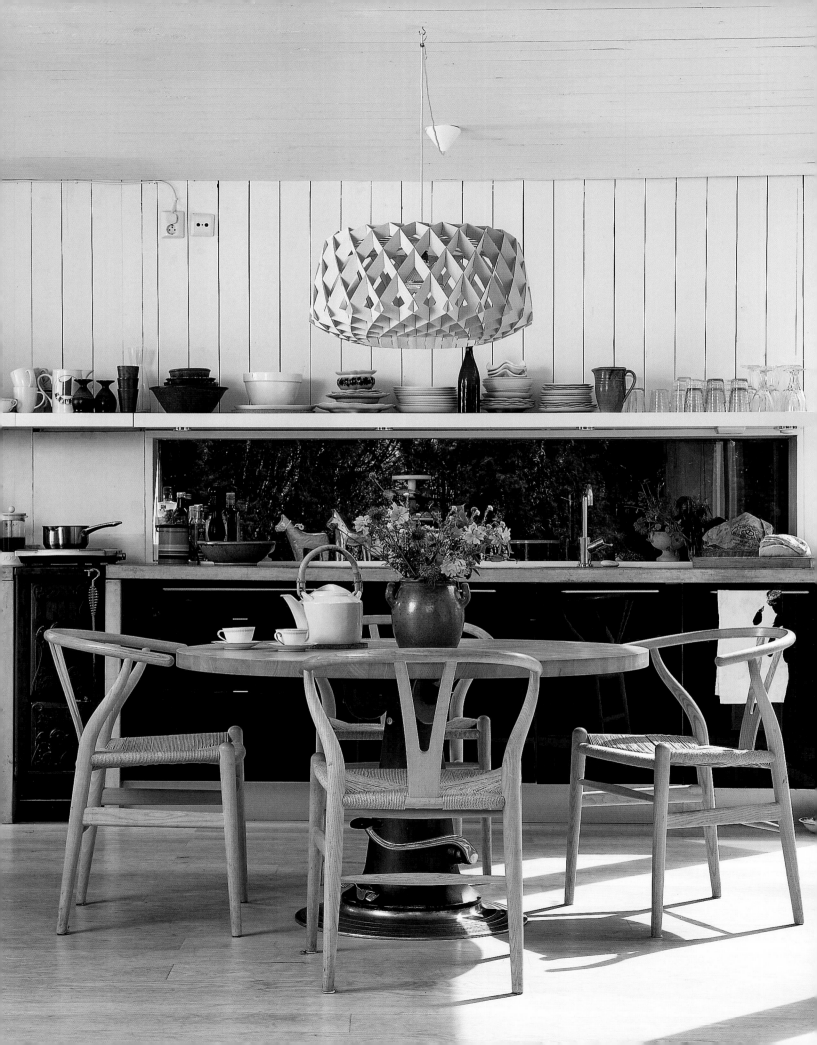

INTRODUCTION

There's no denying it: Scandinavian design is a looker. Not an in-your-face, stiletto-heeled, and showy kind of outfit, but a fresh-faced, pared-back, and quality style that is as useful as it is a thing of grace. Each piece of furniture, lighting, or interior layout is intended to enhance the experience of using it/being in it, as well as being easy on the eye. Which is what makes Scandinavian style so endlessly gratifying. It's a keeper.

The Nordic countries—Norway, Sweden, Denmark, Finland, and Iceland—have an unpretentious approach to design. Simplicity, integrity, comfort, and craft are the trademarks, not forgetting cozy. From flickering candlelight to toe-sinking sheepskin throws, no one does cozy like a Scandinavian. Tactile fabrics, mood lighting, and lovingly crafted pieces are combined with a feel-good factor—just what you need for a restorative home.

In this book, we look at the various cues that make up the uncluttered Scandi style and room-by-room, provide useful tips on how to get the look at home. Featuring a selection of gorgeous things, mingled with advice from cool Scandinavian creatives, we crack the secrets to creating this signature style.

For me, the beauty of this simplified look is that it is flexible and can adapt to any décor. It's predominantly practical—not in a mundane, basic way but in a polished, timeless fashion that goes beyond trends and seasons. I love the craftsmanship and thought that goes behind the classic pieces, whatever the design era. On my wish list are a set of Wishbone chairs designed by Hans J. Wegner in 1949 and a beautiful hand-knotted rug by contemporary Danish designer Hella Jongerius.

But what is Scandinavian style? The furniture itself is mostly very straightforward. There's an obsession with making designs that are clean-lined and useful in natural materials, namely bare wood. A decorating scheme can go in a slightly industrial, coastal or country direction— mid-century retro designs in warm teak meet timeworn, upcycled finds. Materials such as natural wood and leather sit against zinc, concrete, and galvanized steel. Any piece can be mixed with different styles and suit a variety of different tastes.

Ultimately, Scandi chic is a pairing of old and new, rough and smooth, natural and man-made. The colors feature a mainly neutral palette, channeling watercolor skies in gray, fresh blue, and dusky pastel tones. But then there's the shock of playful patterns in cheery orange and eye-catching scarlet. Anything that adds texture is good— think scrubbed floorboards and glossy glazed-enamel pots. All these influences merge together to create this exciting look.

In simply-does-it Scandinavian style, this book takes a tour around pared-back yet characterful homes, ranging from an urban loft to a converted farmhouse in the countryside. Each interior is a personal space, yet fits hand in glove with the Nordic appreciation of "ordinary beauty." Tap into easy living with this guide to modern, up-to-date, and everlasting style.

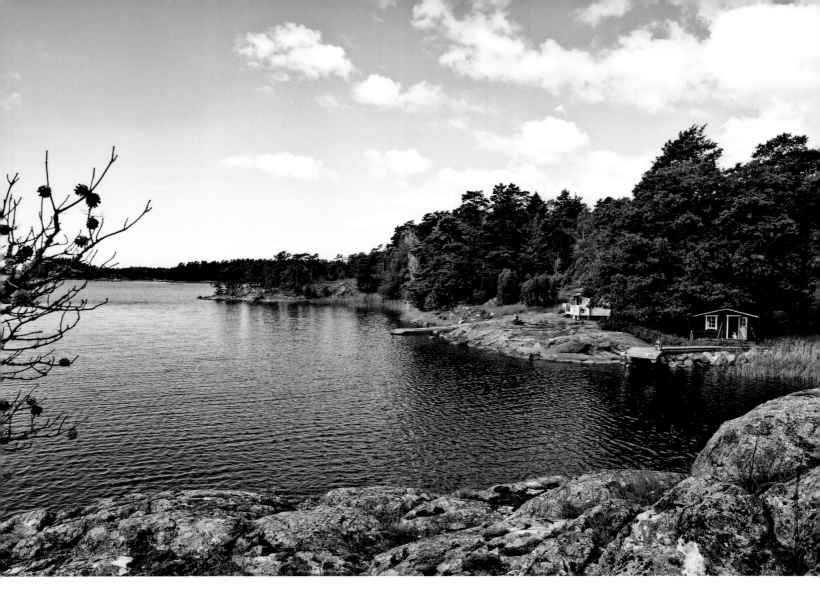

CONTENTS

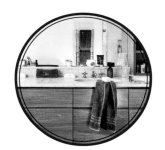
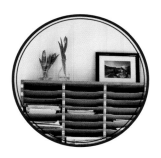
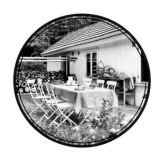

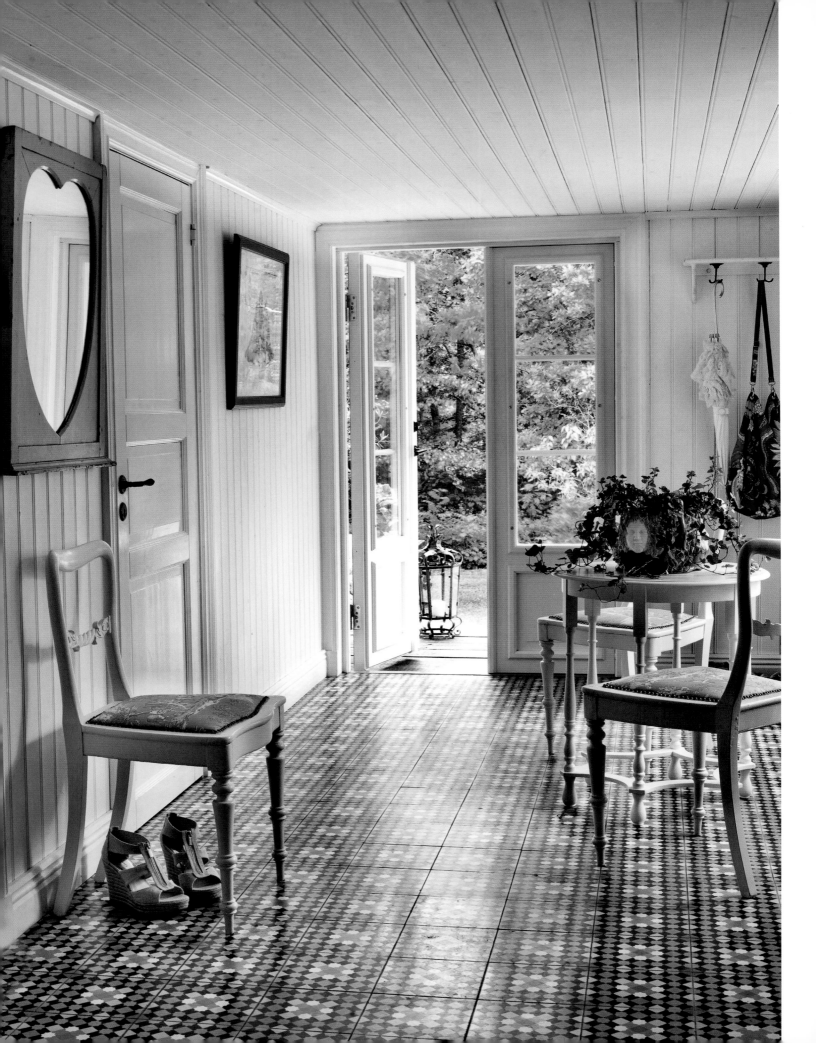

1
HALLWAY

Nordic simplicity is wholesomeness. It is white
with a touch of color. It is things made of wood.
Scandinavian style is also hot. Not a va-va-voom
glamorous sex appeal, but a confident, "yes, you
can do bling, but you choose not to" kind. To
live the Scandinavian dream in your home, it all
begins in the hallway. The idea is to create a space
that will connect and brighten up your journey
through the house. For a start, it means you
should paint it white.

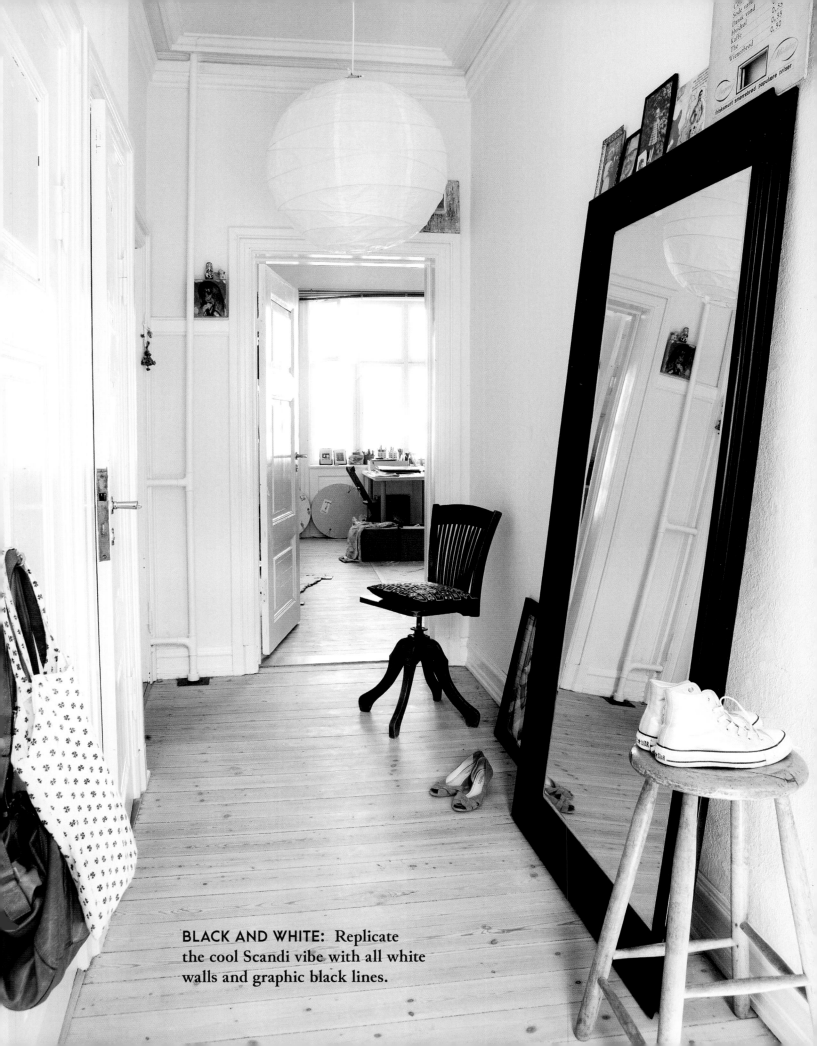

BLACK AND WHITE: Replicate
the cool Scandi vibe with all white
walls and graphic black lines.

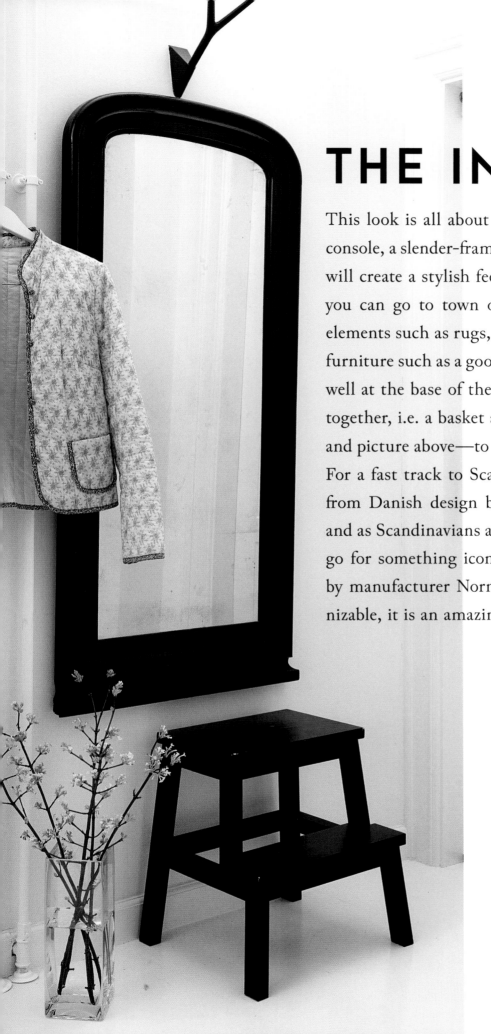

THE INTERIOR

This look is all about quality not quantity: a leggy wood console, a slender-framed mirror and a few glass accessories will create a stylish feel. Because the palette is restrained, you can go to town on walls and floors with decorative elements such as rugs, mirrors, and pictures. Freestanding furniture such as a good bench or three-tier whatnot works well at the base of the stairs. It allows you to group items together, i.e. a basket at the base, a chair alongside, a vase and picture above—to keep the rest of the area clutter free. For a fast track to Scandi style, the Strap circular mirror from Danish design brand HAY is very of-the-moment, and as Scandinavians are renowned for their good lighting, go for something iconic such as the Norm 69 lampshade by manufacturer Normann Copenhagen. Instantly recognizable, it is an amazing sculptural design.

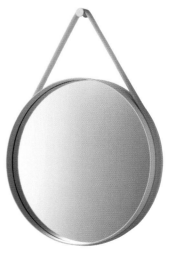

ABOVE: HAY Strap circular mirror

THE PALETTE

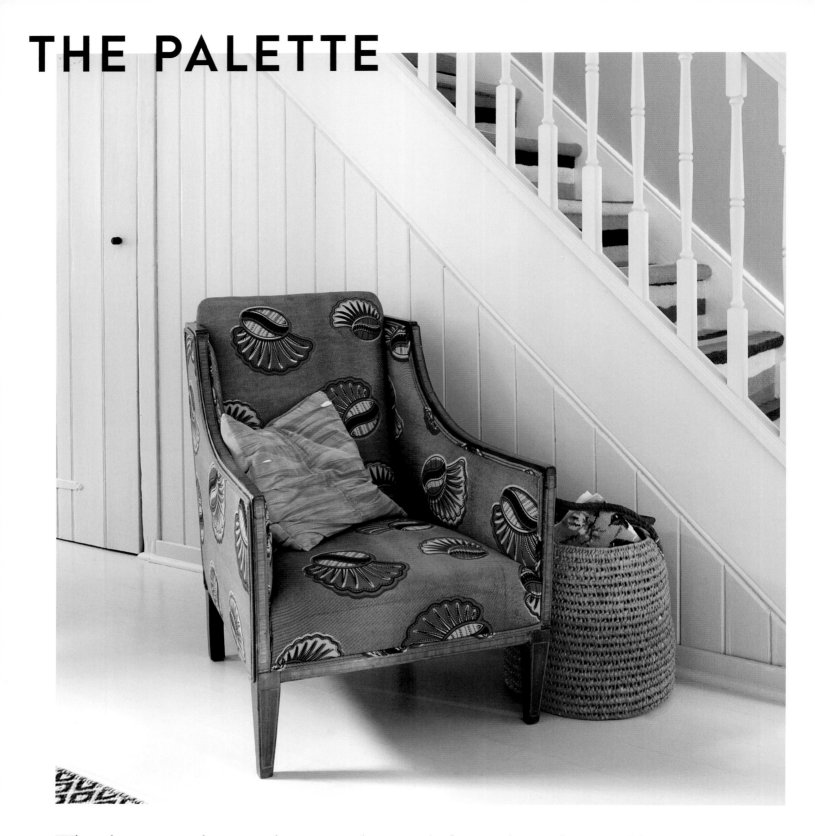

White brings out the warmth in natural materials from rich woods to marble. It is particularly good in the hallway as it bleaches out any architectural imperfections and is easy to maintain. The trick, however, is to choose the right shade. A warm red- or yellow-tinted white is flattering and bright. A white that has more blue in it looks crisp and is best in a sunny, south-facing spot. My favorite shade is Strong White by Farrow & Ball. It has all the brightness of a Brilliant White, but with a touch more warmth.

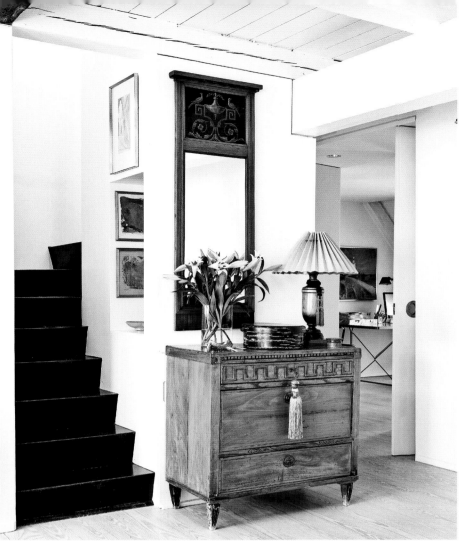

LEFT PAGE: Against white, brightly colored pieces make a striking first impression.

THIS PAGE, TOP: Add a sense of glam to a staircase by painting it glossy black.

White-painted walls, pale flooring, and a front door painted in a soft shade of gray are the keystones to a hallway that feels light and airy and if you take away the internal doors, it will make the space feel even more open-plan. For a more dramatic pairing to white and gray, paint that timber floor black. And sticking with a monochrome scheme, geometric black-and-white patterned wallpaper will add pace to the space. My rule of thumb for decorating is to go darker at the base and lighter as you work upwards. Reserve those stronger, more fun shades for small spaces, such as a downstairs restroom or a porch. I love a gloss wall in a powder room, in cherry red or shimmering in a sexy black.

BOTTOM: Black and white gives a space an edgy, cosmopolitan vibe.

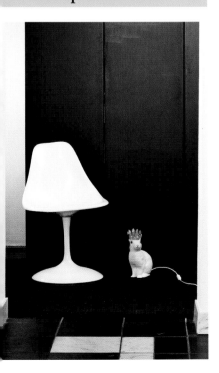

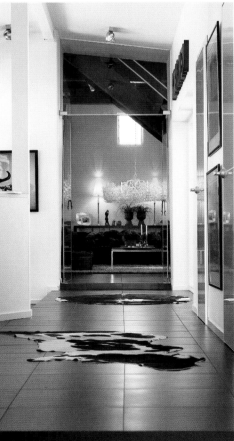

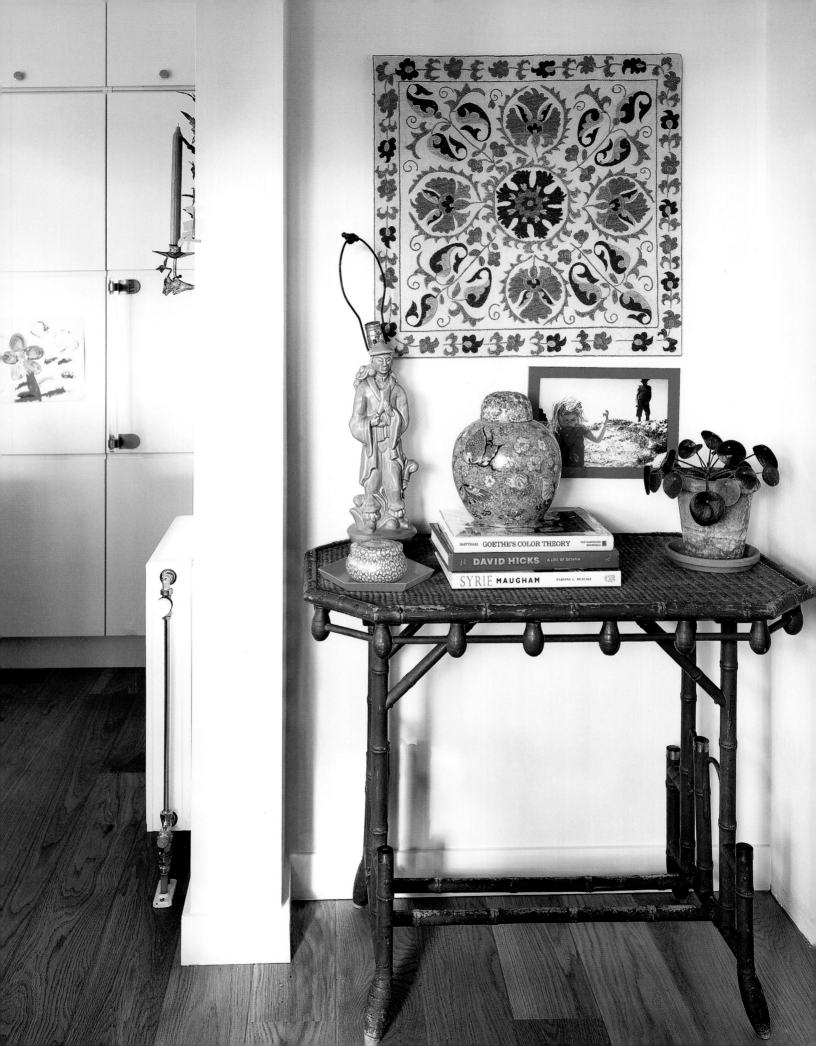

LEFT: Vibrant artwork and oriental pieces punctuate the space and add character.

SMALL WONDERS: Vintage coat hooks, cute key holders, and welcoming bells all have a natural habitat at the front door. Old-fashioned hardware stores and flea markets are a brilliant haunt for sourcing all sorts of accessories with charm.

THE
STORAGE

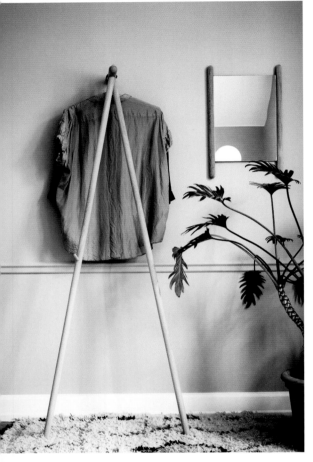

A hallway might be the smallest space, but in terms of duties, it needs to work hard. A simple hanging rail, a coat stand, and contemporary baskets are your Nordic storage options. Straightforward, no screws, and beautiful, Skagerak's Georg coat stand is two long legs attached to a center section that leans against the wall—ideal for a narrow hallway. A long peg rail painted the same shade as the walls is great for hanging up coats, hats, and scarves. I'm a big fan of Mika Tolvanen's felt baskets for shoes, umbrella's, and everything else.

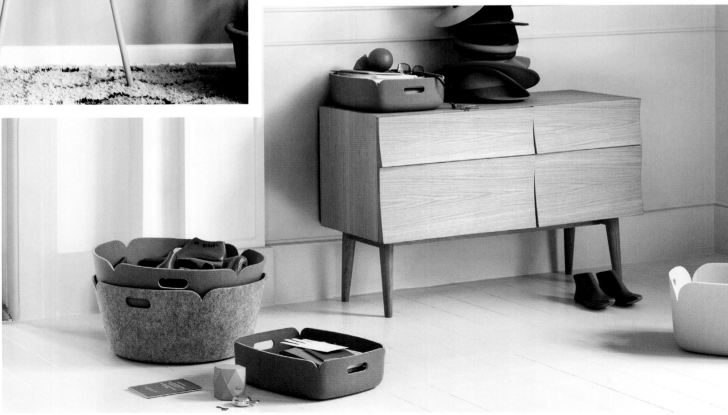

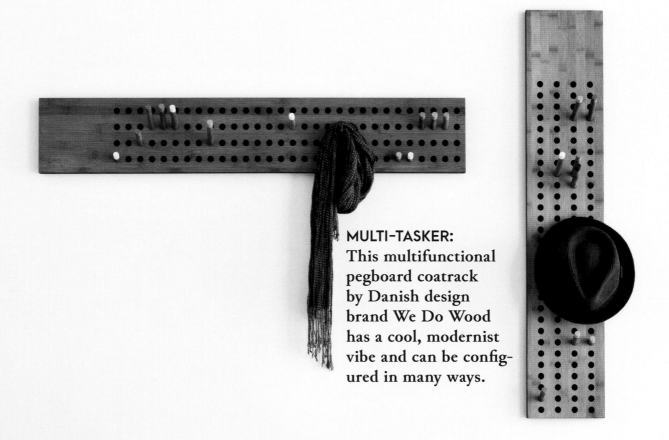

MULTI-TASKER:
This multifunctional
pegboard coatrack
by Danish design
brand We Do Wood
has a cool, modernist
vibe and can be config-
ured in many ways.

HOW TO GO GREEN

——

Practicality, traditional craftsmanship, and finding beauty in nature are central to the Scandinavian way. They don't do fast-fashion items with a dubious place of origin. Instead, they prefer to adopt a more sustainable way of living—using quality materials (leather, cork, bamboo, recycled glass) and buying things that are going to last a long time. My favorites of the eco-genre include the harvested mango wood modular storage system from Mater Design, the Grain bamboo-mix pendant lights by Jens Fager from MUUTO, the Fragment organic cotton cushions from ferm LIVING, and the Viktigt bamboo chair by Ingegerd Råman from IKEA.

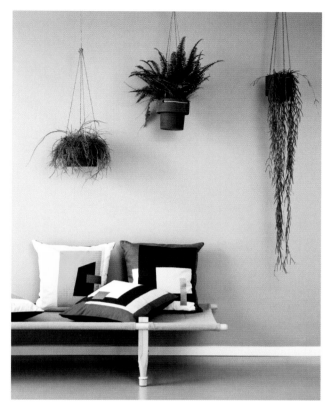

ECO CHIC: Beauty meets simplicity in these eco-smart, sustainable designs.

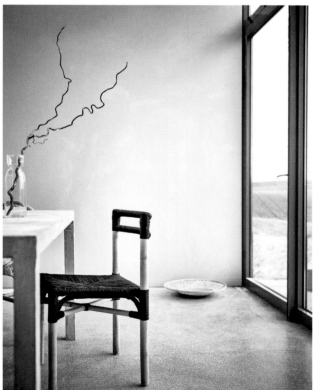

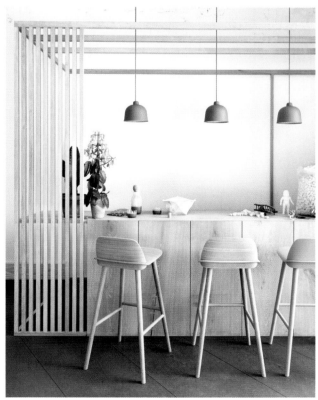

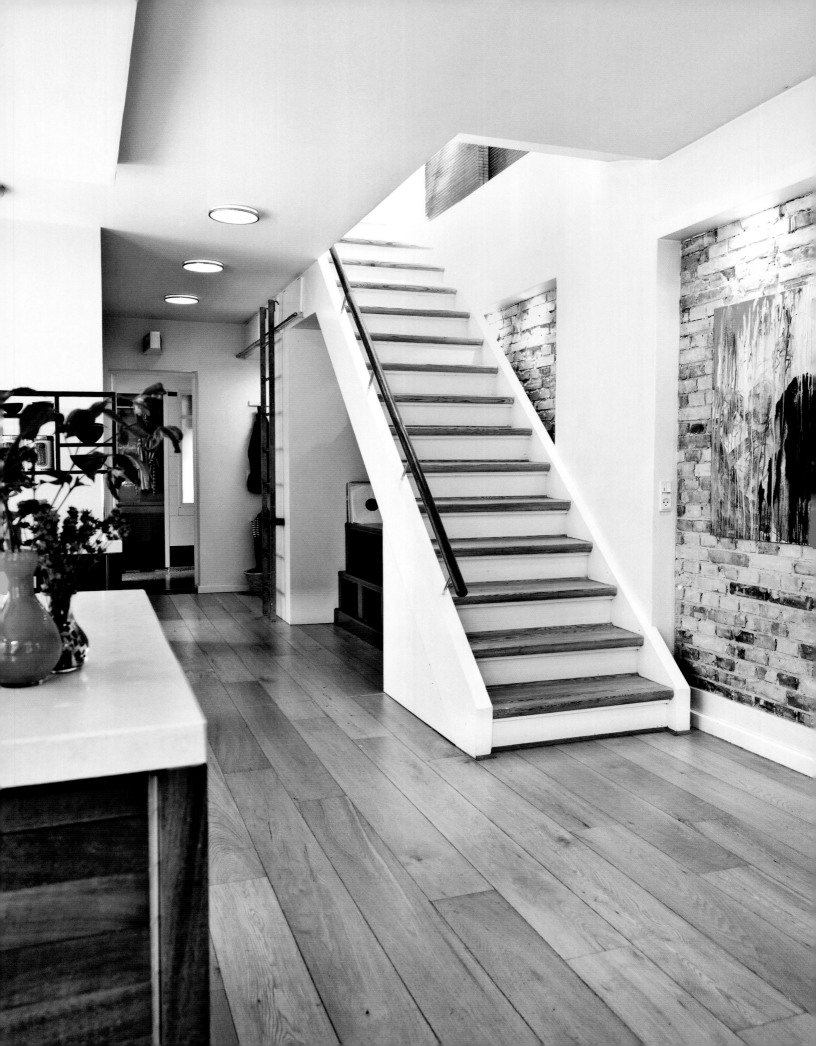

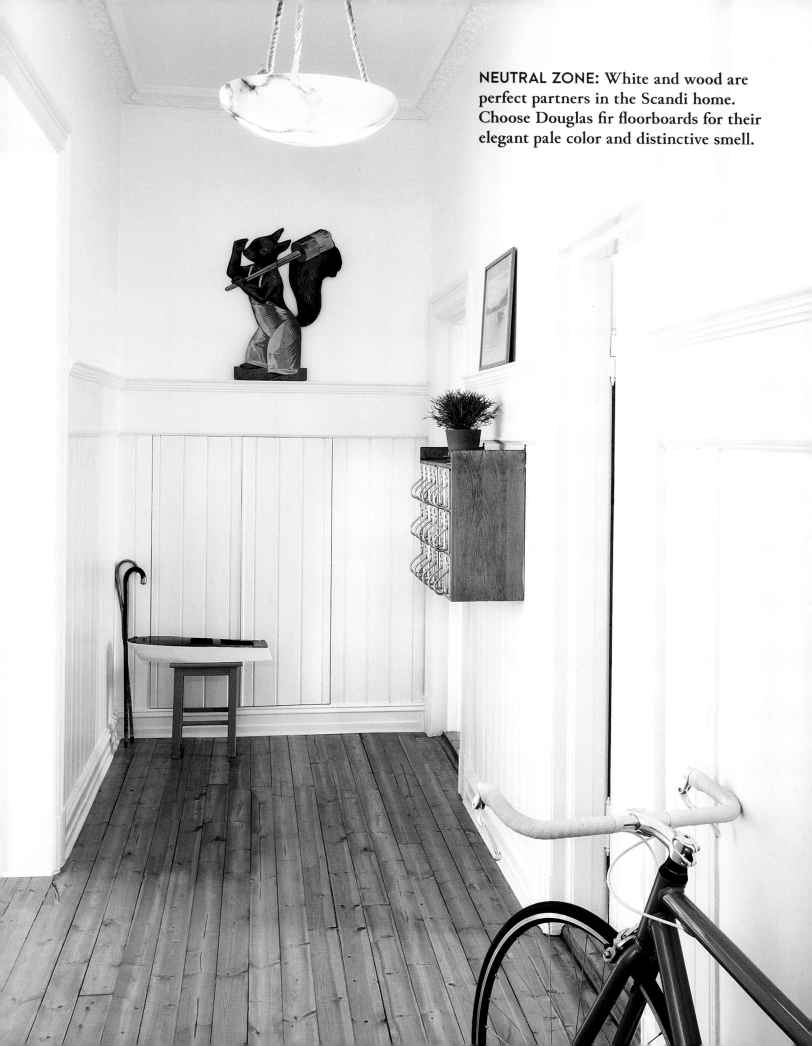

NEUTRAL ZONE: White and wood are perfect partners in the Scandi home. Choose Douglas fir floorboards for their elegant pale color and distinctive smell.

THOMMY BINDEFELD

Creative Director

As creative director of Svenskt Tenn (*svenskttenn.se*), Thommy knows all about how to make a space feel homely. Here, he shares his tips on his favorite aspects of Scandinavian design.

1 | The most common cliché about Scandinavian design is that it is only simple and minimalistic.

2 | We are not interested in decorative design without a function or use. An interest in sustainability, local production, craftsmanship, and high quality is always important, too.

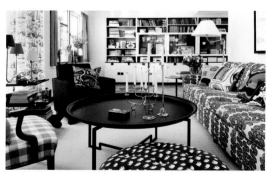

ABOVE: Interiors by Svenskt Tenn

Top Tips from Scandi Creatives

3 | I don't think that Scandinavian Style is just one look. For me, it's most important that you furnish your home with products you are passionate about. That is the best way to guarantee a sustainable and long life of an interior.

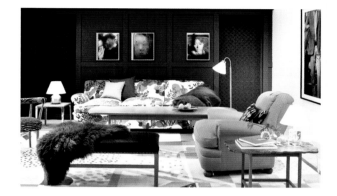

4 | My style is highly selective. I try to mix inherited and new things with decorative items arranged into still lifes and kept in a glass cabinet.

5 | I look for high quality design and production. I'm not interested in buying new things and throwing old things away.

6 | I like a neutral background with interesting accent prints that are bright and sparkling in contrast.

7 | There are no rules to blending different objects and styles. There are no "short dresses versus long dresses" nowadays.

8 | My biggest must-have in a home is an extremely comfortable sofa and a cabinet to put your favorite objects in.

9 | My hallway is extremely small and narrow. Just a doormat and a Zig-Zag chair (the classic by Gerrit Rietveld) to put keys and the dog leash on.

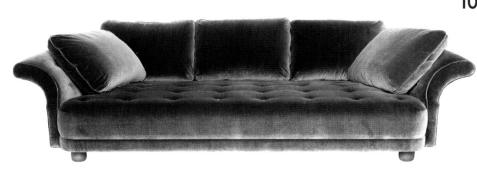

10 | I would spend my last decorating dollar on a Liljevalch sofa from Svenskt Tenn. A cross between a daybed and sofa, it is the greatest seater on the market according to me.

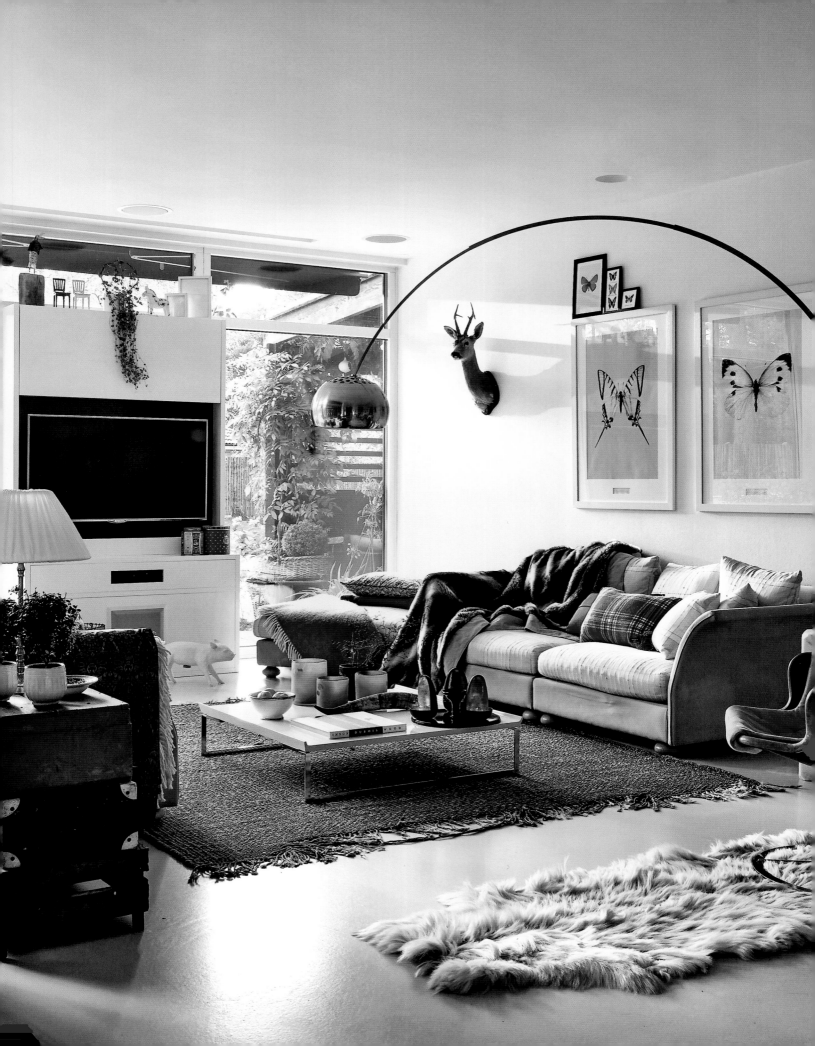

2
LIVING ROOM

Fuss-free and calming, a Scandinavian-inspired living room should be comfortable, casual, inviting, and elegant. A place for entertaining as much as relaxing, it knows how to make the best use of space. Your starting point: good flooring, versatile furniture, and smart wall lights. Choose furniture that is there for good reason and, even better, can be moved around. To Scandify your lounge, here is a breakdown to recreate this easy-going look.

THE PALETTE

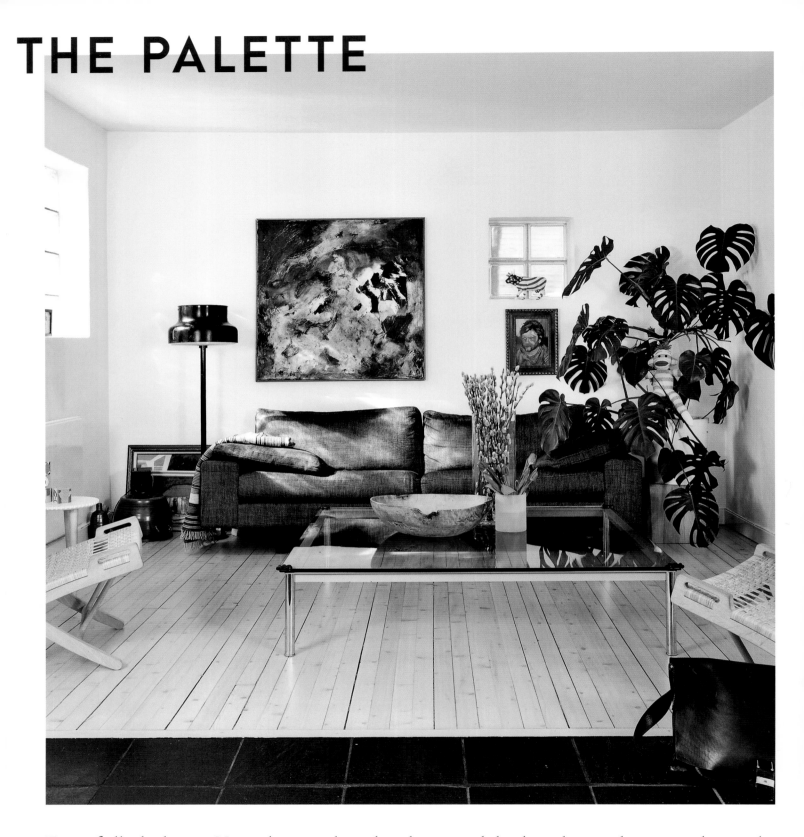

First of all, the basics. Natural materials such as bare wood, leather, slate, and stone are key to the Scandi aesthetic. A contrast of textures from rough timber floors to glazed ceramic pots suits this style. In terms of paint palettes, anything that suggests a connection with the outdoors works well. Cool, gray neutrals look particularly nice in the living room. A variety of soothing putty shades, from light to dark, will add tonal depth. Paired with a limewood floor, this is the perfect canvas to showcase mid-century design and secondhand keepsakes.

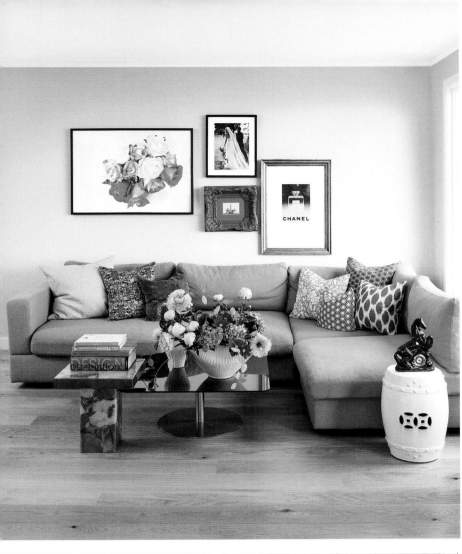

LEFT PAGE: Scandinavians love a good houseplant, and this sculptural Monstera looks great with the squishy sofa and cool artwork on the wall.

THIS PAGE, TOP: A pretty lilac-and-blue palette teams up brilliantly with touches of gold and hot pink.

BOTTOM: Contemporary or traditional, either style suits the casual Scandi vibe.

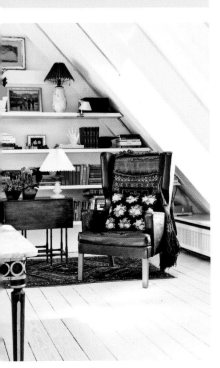

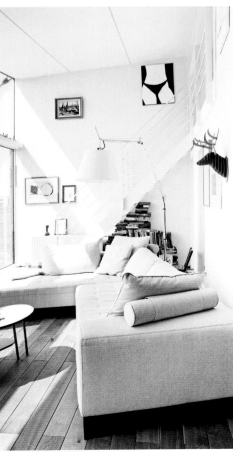

The simple, curvaceous shapes of furniture stand out against the pale wooden flooring and white paint-work. However, whilst Scandinavian interiors may be pure, they are also far from shy. An occasional splash of color is important. A glossy painted chair, original artworks, graphic Marimekko, or folksy prints will add personality and bring touches of color to a scheme of off-whites and pale neutrals. Finish the space with textiles that pick on accent colors in the space.

THE INTERIOR

What you choose to put in your living room matters. First and foremost, furniture and fabrics are selected for their use, whether it's a versatile ottoman that can double up as extra seating or a wing chair positioned by the window to read. It should always be thoughtful and relevant to our lives. Yes, there is strong mid-century influence since Alvar Aalto brought his Nordic cool to shoppers in the fifties but try not to get hung up on retro as such. Scandi style is about good design, no matter what era it is from. To carry off the look, go for an eclectic mix of art, craft, and design from different periods. For instance, a modern streamlined armchair looks great on a threadbare rug and second hand etchings suit a cool, monochrome scheme. Loose linen covers on chairs and cushions complement sleek slate floor tiles. The vintage influence breaks up the neat, contemporary look. And when it comes to sofas, nothing beats a large, leather Danish three-seater. Strew it with velvet cushions and offset with a rustic table and industrial light. For extra Nordic style points, all you need is a pair of antlers on the wall.

BIG PRINTS: Celebrated for its bright and beautiful patterns, Finnish textile and design company Marimekko is a household name in Scandinavia. Big, playful, and dramatic, the designs look as cool and modern as they did when the company was founded in the 1950s.

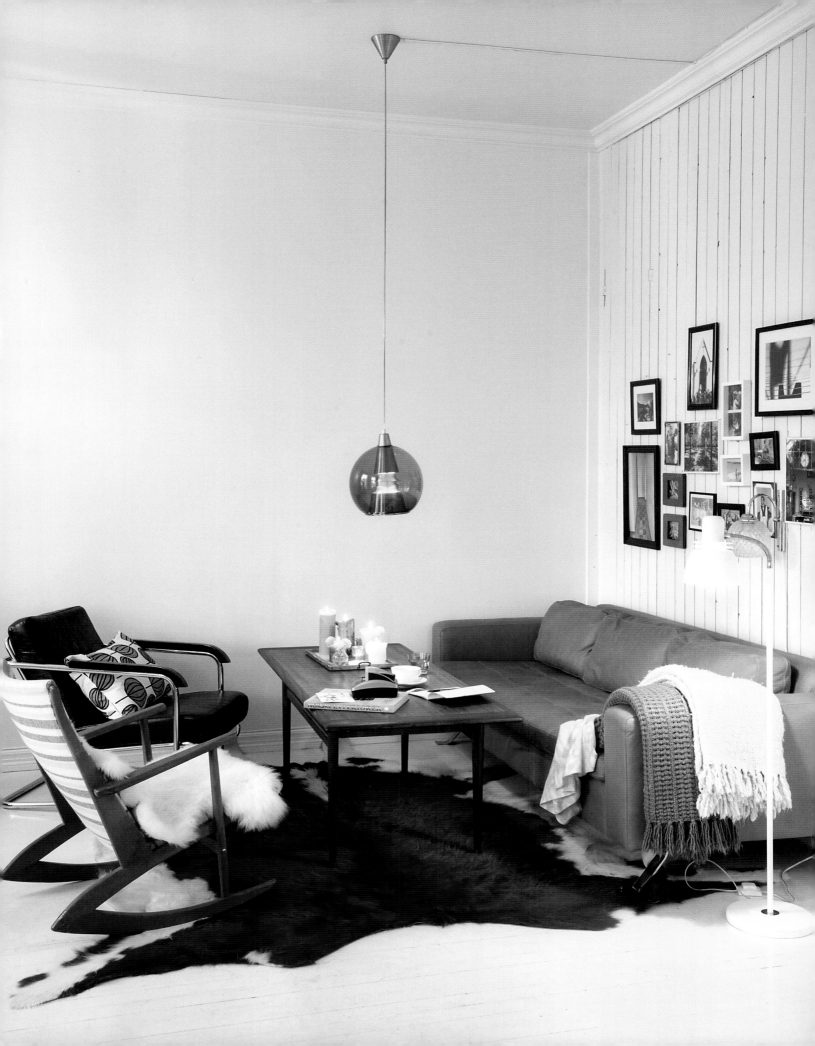

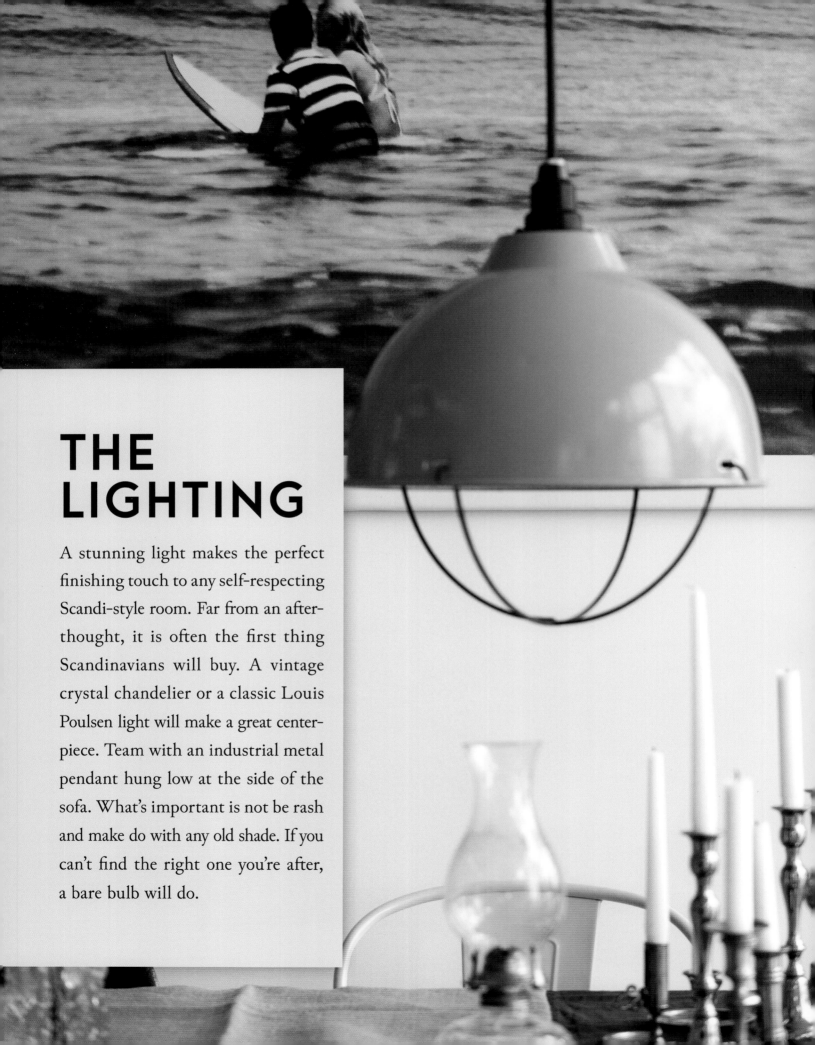

THE LIGHTING

A stunning light makes the perfect finishing touch to any self-respecting Scandi-style room. Far from an after-thought, it is often the first thing Scandinavians will buy. A vintage crystal chandelier or a classic Louis Poulsen light will make a great center-piece. Team with an industrial metal pendant hung low at the side of the sofa. What's important is not be rash and make do with any old shade. If you can't find the right one you're after, a bare bulb will do.

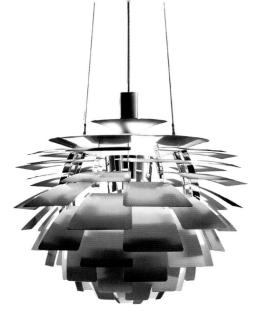

LOUIE LOUIE: The classic Artichoke and PH5 pendant lights by Danish designer Louis Poulsen.

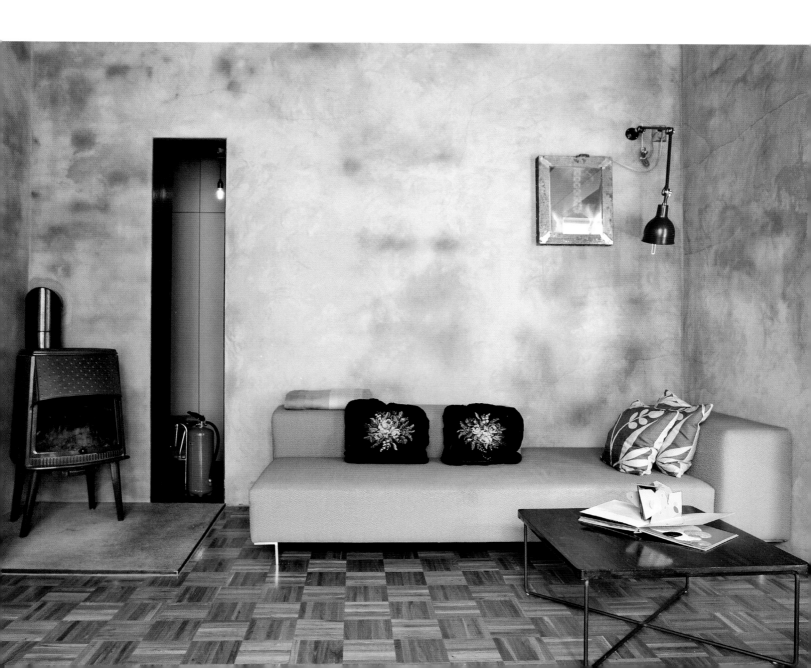

HOW TO DO LIME-WOOD FLOORS

The dream Scandi floor—subtler than white paint, lime washed floorboards will show the natural grain of the wood, giving a fresh, elegant, and cleanly scrubbed look. To recreate the effect at home, start by sanding back your floor to allow the lime coating to adhere. Lime wash is best applied with a cloth or brush, slowly working in the paste following the direction of the grain. Allow the paste to dry overnight and finish with a wax.

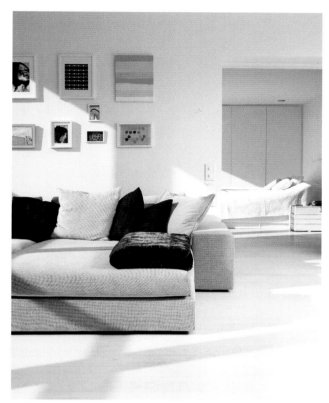

WHITE OUT: For the purist within, a lime wash floor will make other interior features stand out.

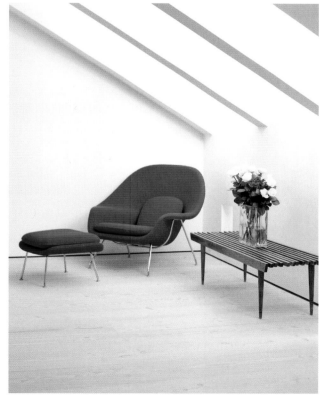

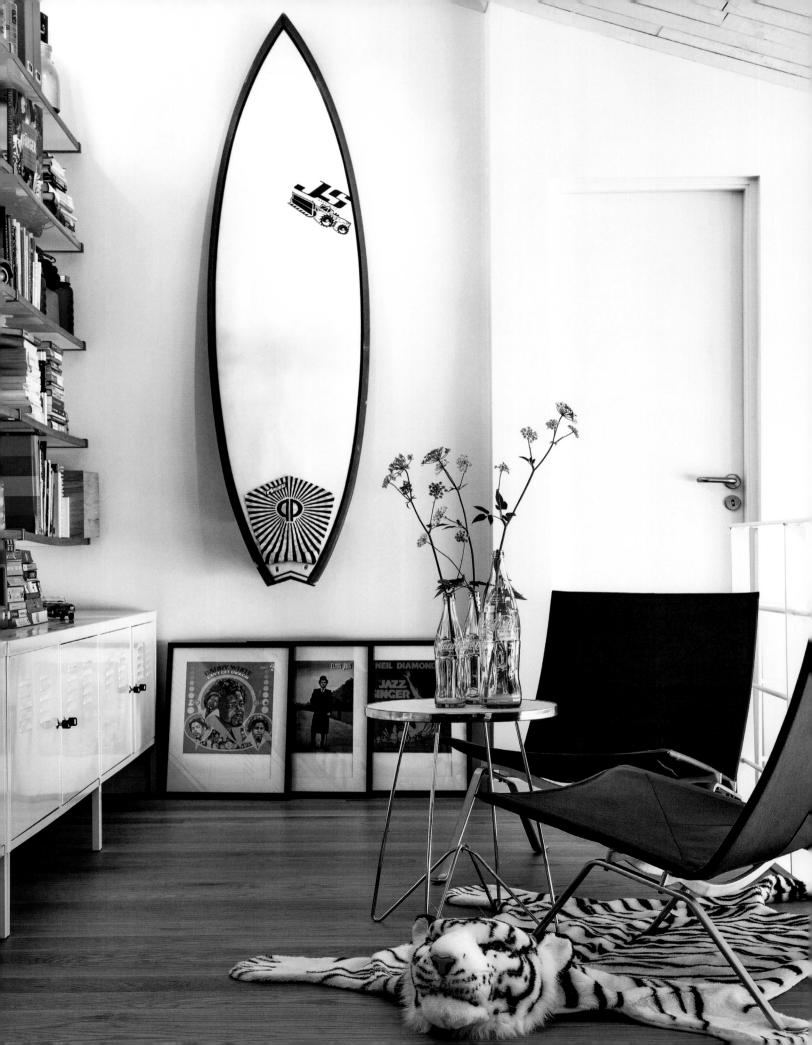

LEFT: Style a hip, creative space with a fresh, clean white scheme, chic black furniture, and a surfboard on display.

FORM AND FUNCTION: Trunks and streamlined drawers keep clutter out of sight.

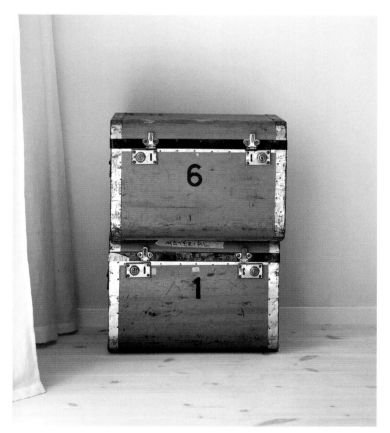

There are a million combinations that get you to the perfect design solution. It's that exploration that's so nice. *Kelly Wearstler*

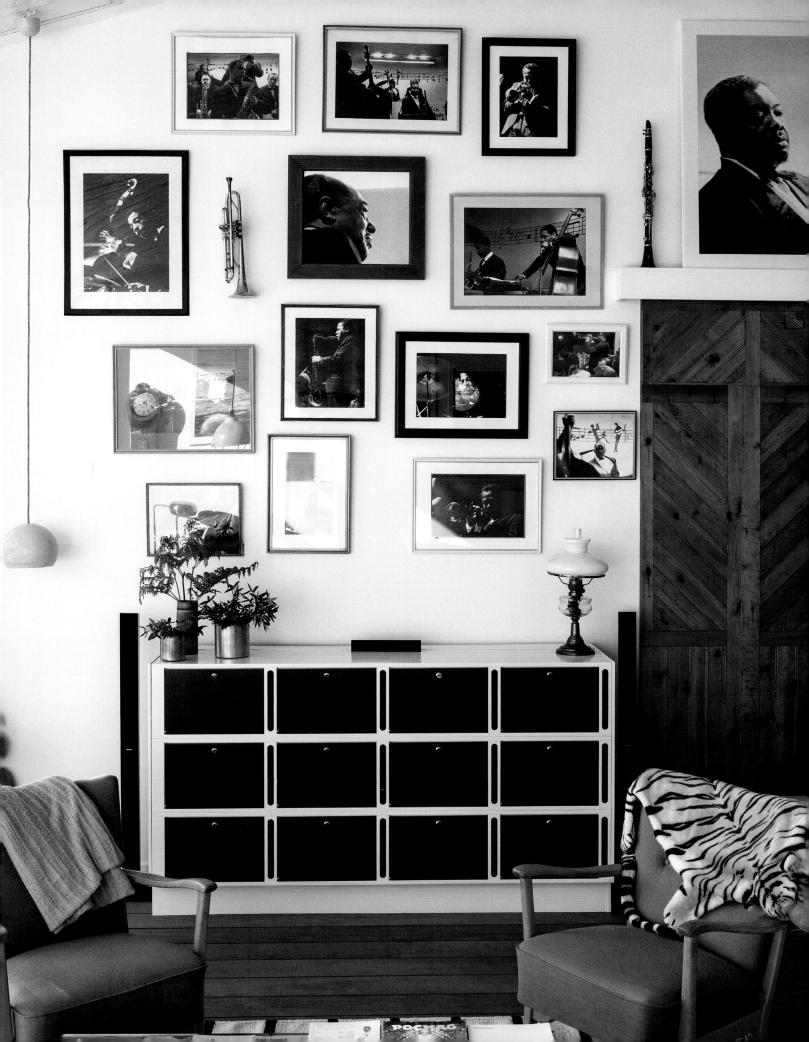

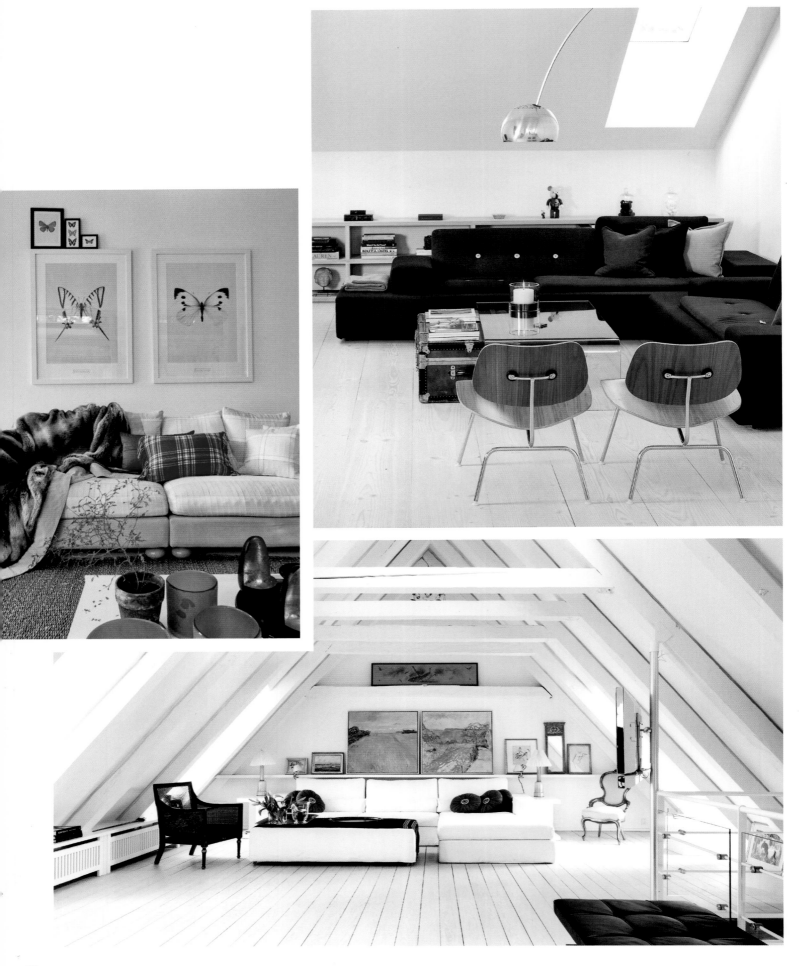

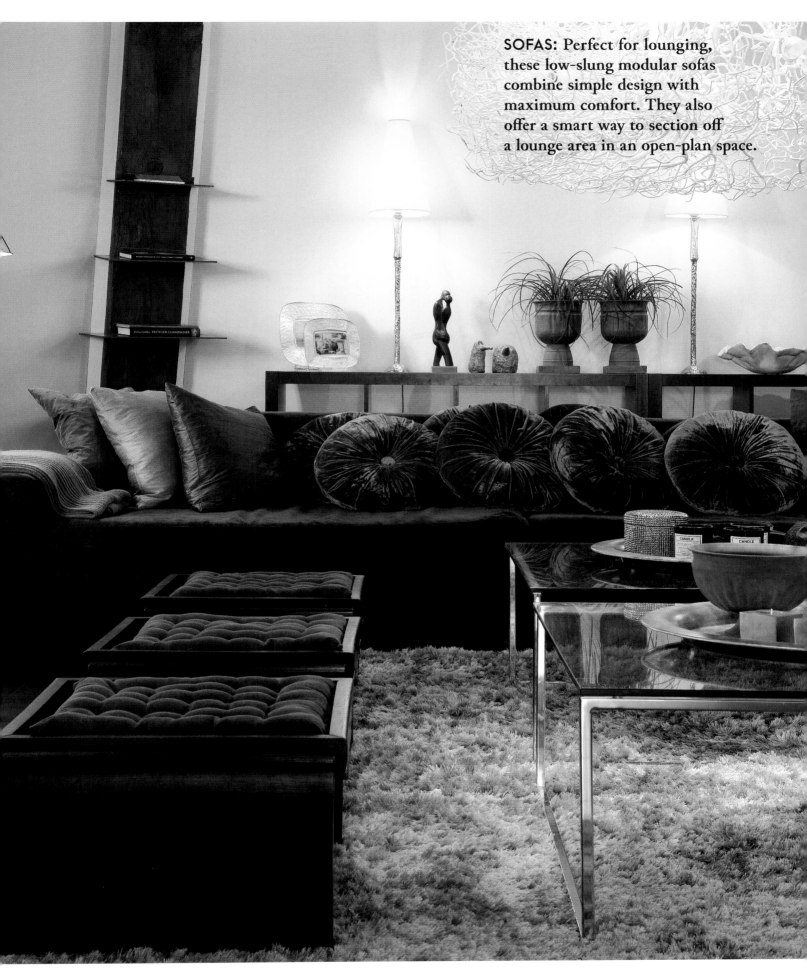

SOFAS: Perfect for lounging, these low-slung modular sofas combine simple design with maximum comfort. They also offer a smart way to section off a lounge area in an open-plan space.

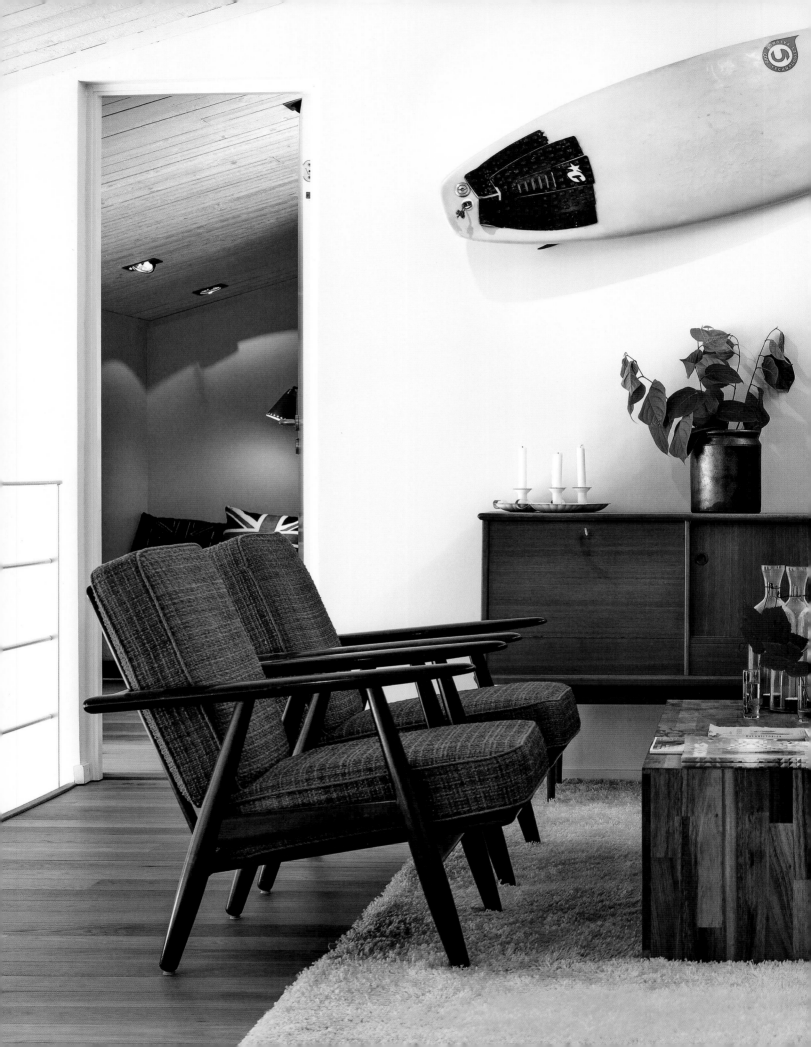

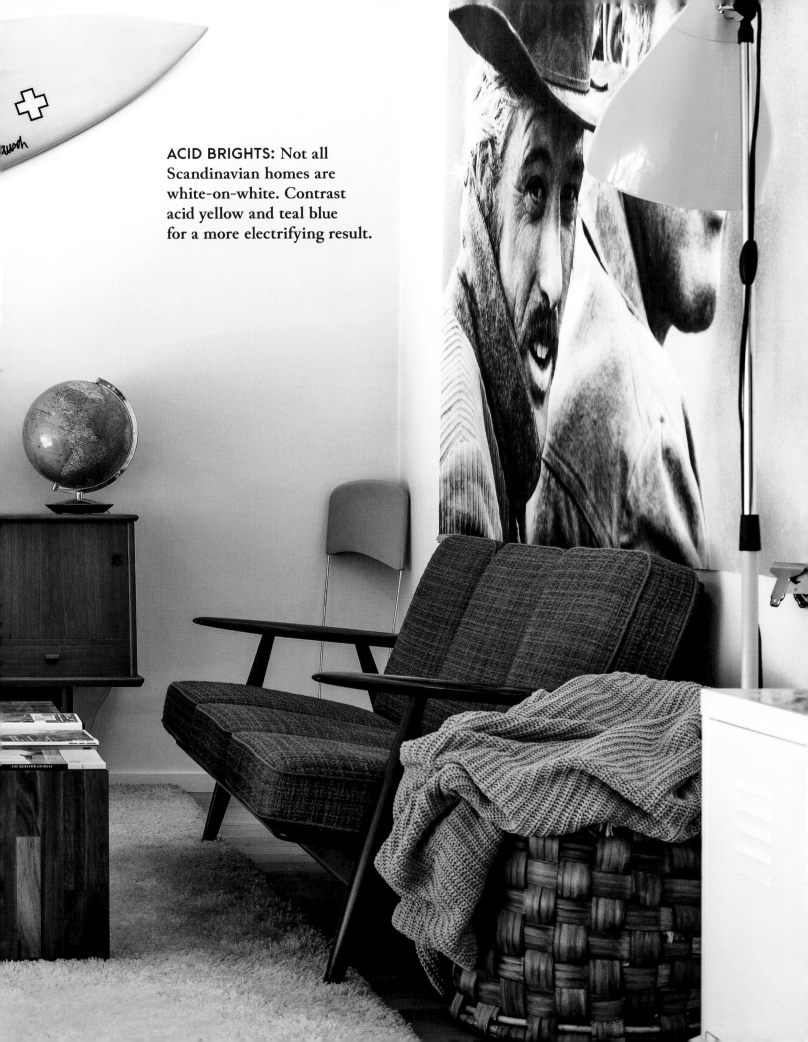

ACID BRIGHTS: Not all Scandinavian homes are white-on-white. Contrast acid yellow and teal blue for a more electrifying result.

CHRISTINA SCHMIDT

Designer & Retailer

Co-founder of design store Skandium (*skandium.com*) and "It" lady of Scandinavian design in London, Christina shares her style advice for budding Scandi-lites.

1 | The first mistake about Scandinavian design is that Scandinavia is one thing. There are five countries, each with a different history and variation in taste.

2 | My approach to decorating depends on the type of space. Every room dictates what it wants. If one "listens" to that, one gets a happy space, meaning a space offering strength and support.

3 | I prefer a monochrome base color in a variety of textures with a few accent colors in artwork and accessories.

4 | I always look for simple harmonies. There's nothing worse than overdesigned housewares. Try not to reinvent the wheel, just stick to pleasing lines.

ABOVE: Interior inspiration by Christina

5 | Gray with gray-on-gray is my favorite color combination.

6 | My technique for blending different objects is to choose shades of the same color in different textures.

7 | My best décor or design advice is check your proportions and use curtains.

8 | A great armchair and inspiring artwork are my biggest must-haves in a home.

9 | My living room is monochrome and easy on the eye. It offers a peaceful sanctuary where each item has a purpose.

10 | I would spend my last dollar on good light. Floor light, table lights, ceiling lights—you name it. Light creates atmosphere and shapes the space.

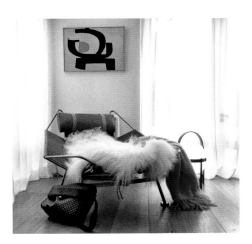

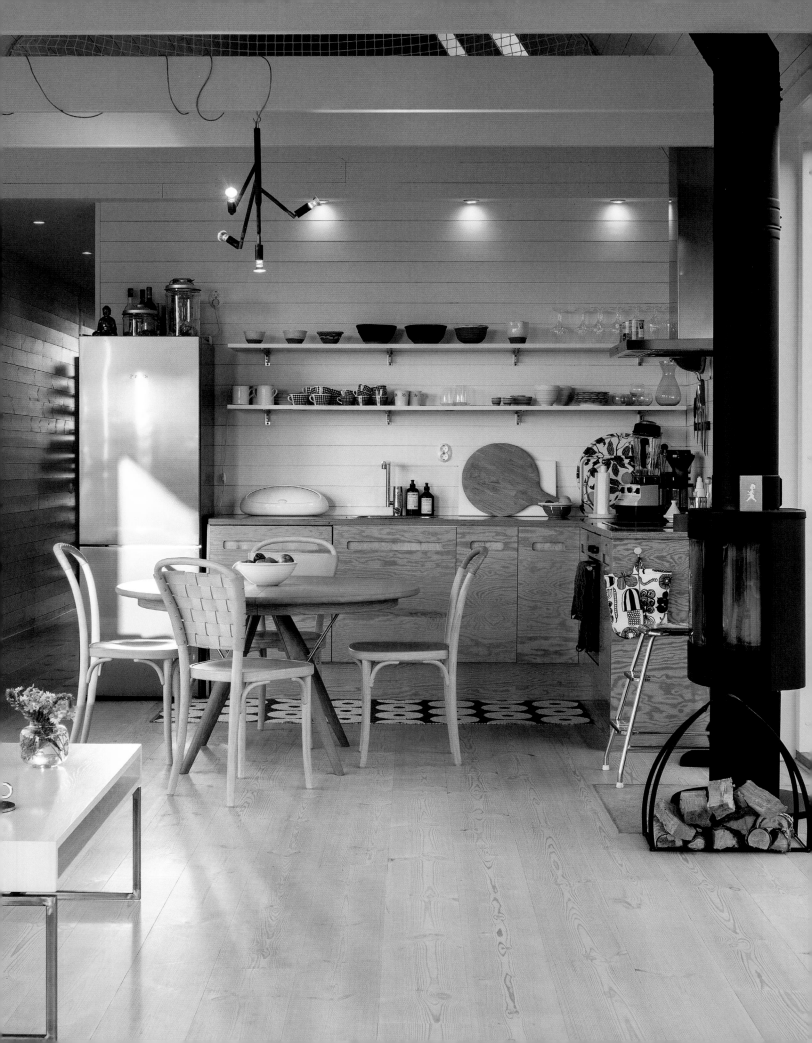

3

KITCHEN

Stylish, simple, and well thought through, Scandinavian kitchens are all about utilitarian design. They marry function with the beauty of natural materials—namely wood, and lots and lots of white.

THE INSPIRATION

Think simple execution in both shape and material. Designer Nina Tolstrup of Studiomama says, "I think that we have a very pragmatic and hands-on attitude to design. Simplicity is valued and wood has always been a preferred material that is renewable and often locally sourced." Christina Schmidt, from London design store Skandium, agrees, "Scandinavian design stems from the idea of modernism merging with pragmatic country traditions. You get something called Funkis in Sweden, which translates to functionalism. Simple, utilitarian items made in good craftsmanship tradition, supposedly lasting a lifetime and more. Well made items are uplifting, a joy to live with, supportive, and easy for everyday living." With this in mind, here is where to begin.

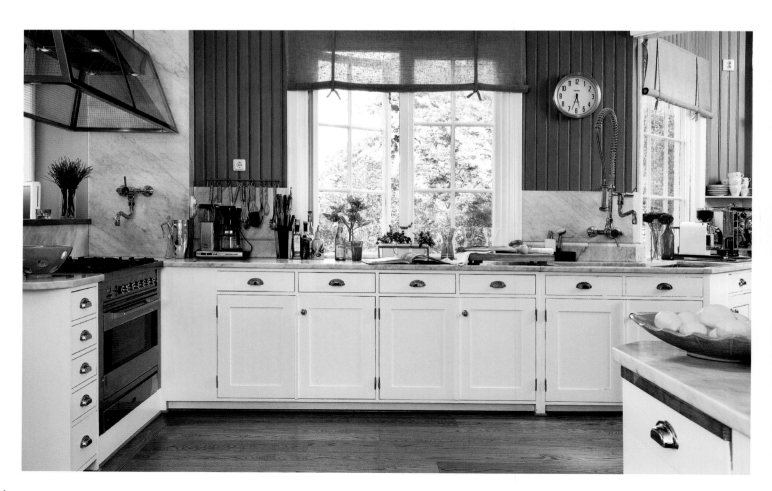

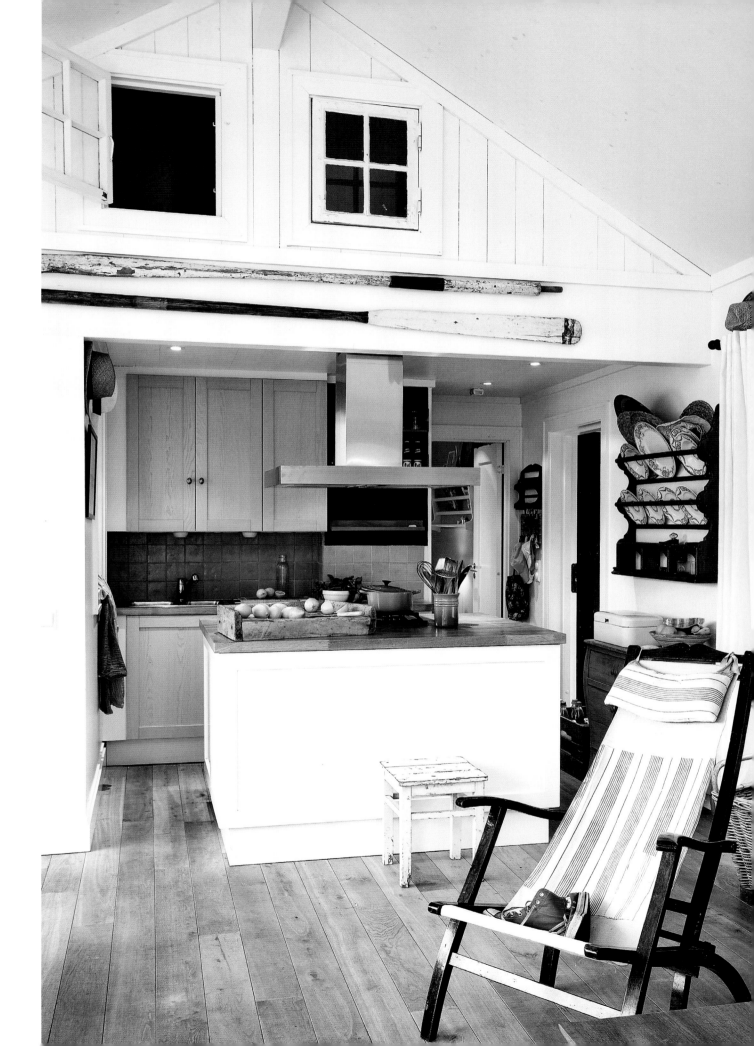

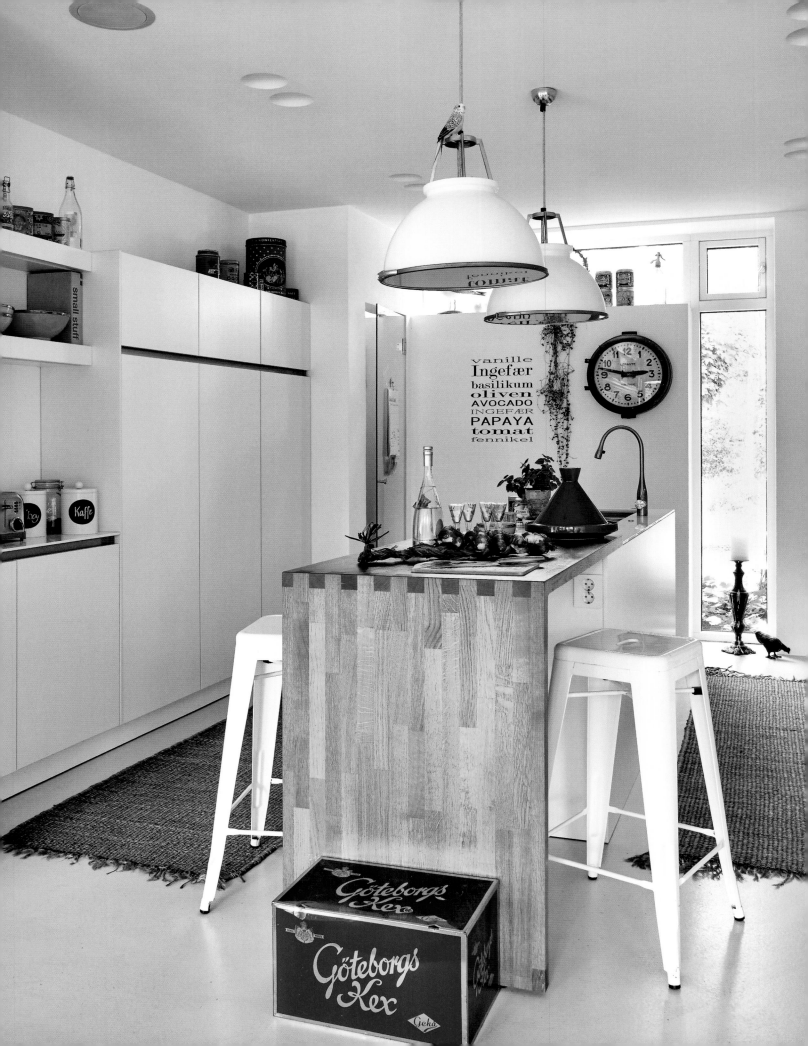

LEFT: A breakfast bar fits in well with the Scandinavian family way of life. Illuminated by a couple of industrial-style drum pendants, the island makes a feature of the wood detailing and grain.

LIGHT AND DARK: Push yourself into new color territories or opt for a pure and simple deco look. Either way, the white or black walls offer a versatile backdrop to display dishes and collectibles on open shelving.

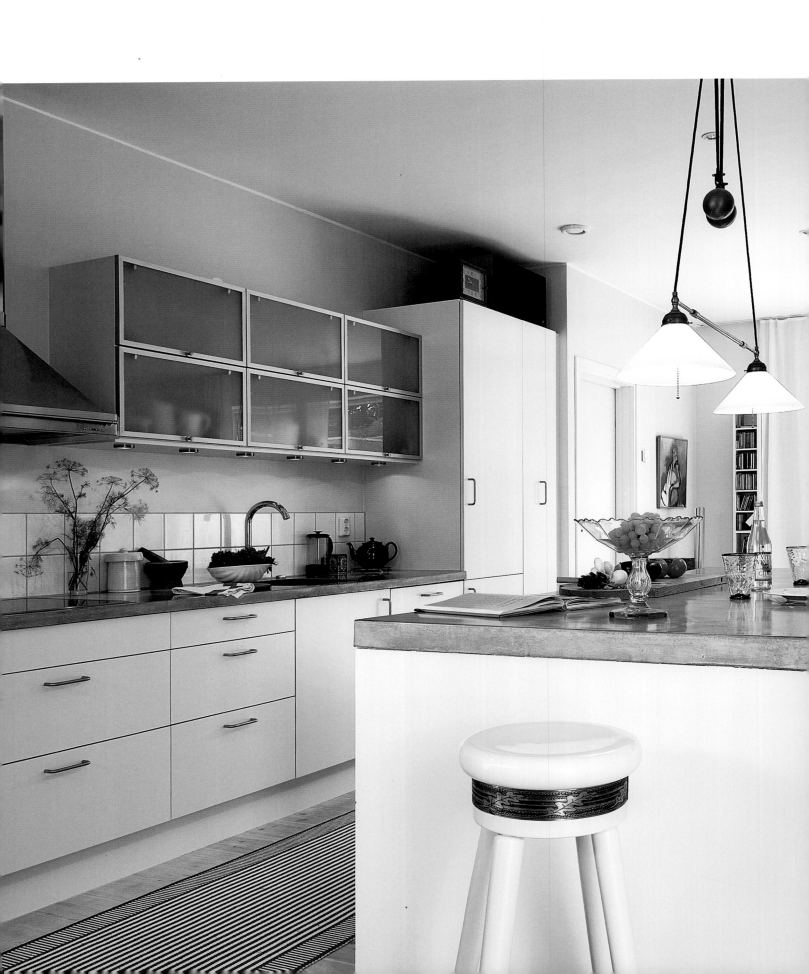

THE MATERIALS

Start from the ground up. In order of priority, I say floor first, countertops second. The rest—the units, walls, lighting, sink, and any furniture—will work themselves around. A dream chevron white oak floor looks amazing with pale gray units and a concrete countertop. Similarly, a poured concrete floor paired with gloss-white units and an off-white Corian countertop is divine. Touches of wood will enliven a classically Nordic monochrome scheme. Sheepskin throws on dining chairs will soften the clean lines of the spartan furniture, too.

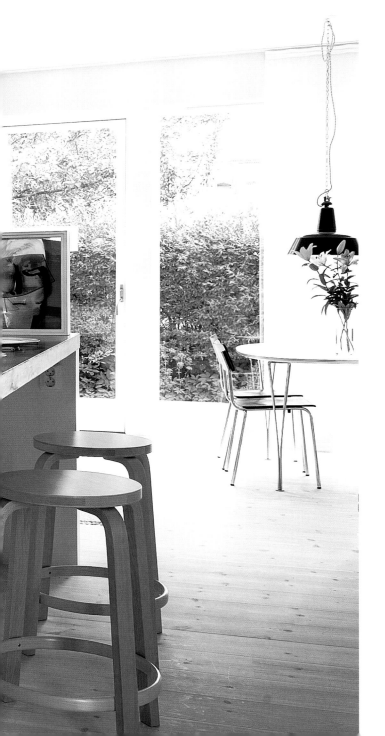

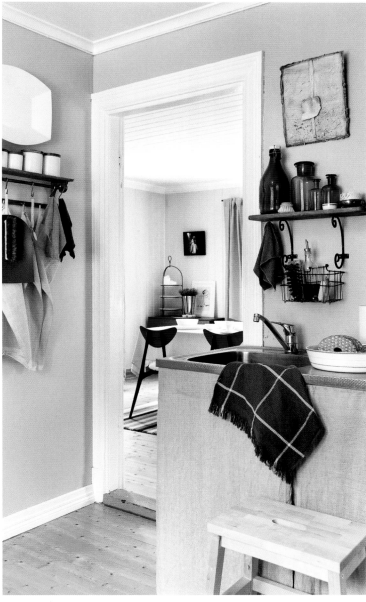

HOW TO
MAKE THE
MOST
OF A SMALL SPACE

———

Designers are getting niftier with pieces that perform various roles. When space is tight, look to multifunctional furniture that creates space for storage as well as doubling up as a table. When breakfast is done, you pack up your dishes and simply fold it away. With sturdy brackets and a bit of cabinet know-how, you can create something similar yourself.

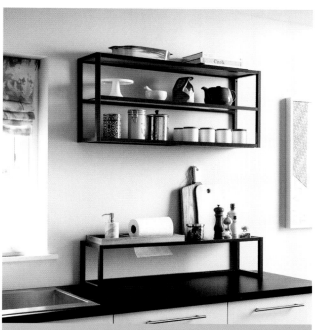

TRANSFORMATION: From Magnet's smart Innovation Plus range, this wall cabinet converts into a handy breakfast bar.

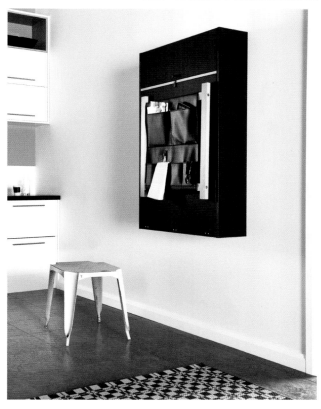

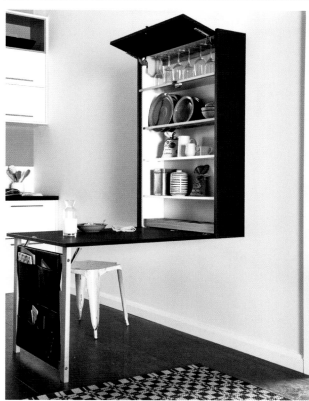

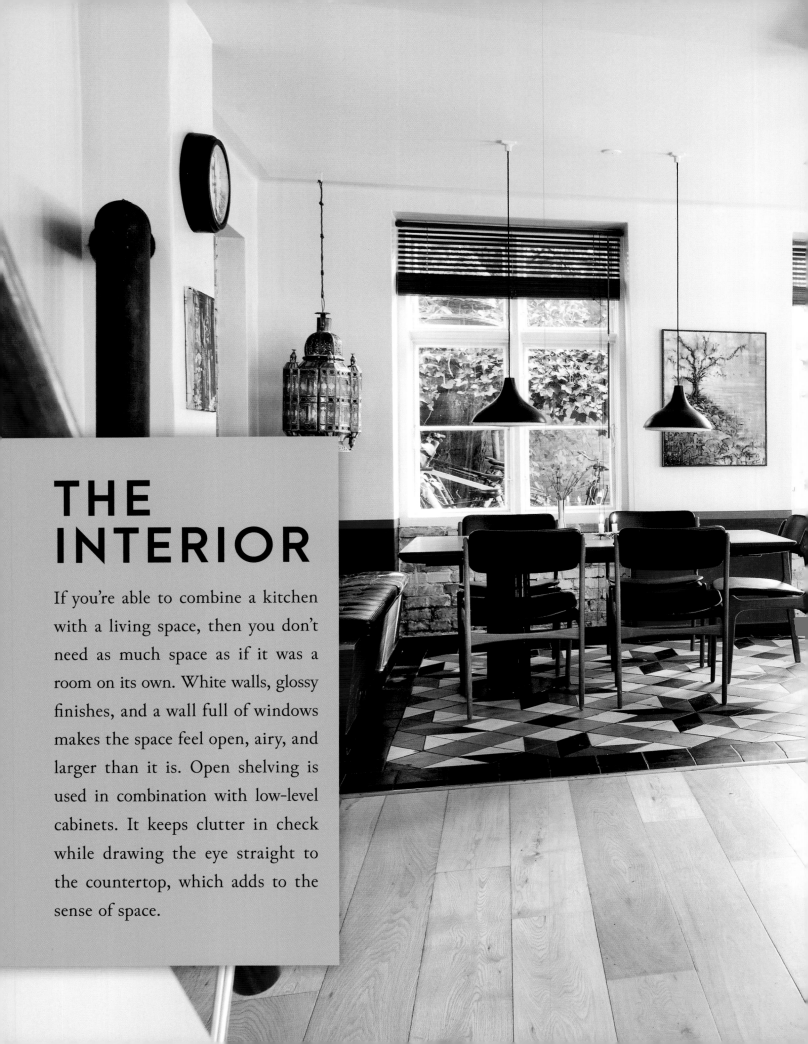

THE INTERIOR

If you're able to combine a kitchen with a living space, then you don't need as much space as if it was a room on its own. White walls, glossy finishes, and a wall full of windows makes the space feel open, airy, and larger than it is. Open shelving is used in combination with low-level cabinets. It keeps clutter in check while drawing the eye straight to the countertop, which adds to the sense of space.

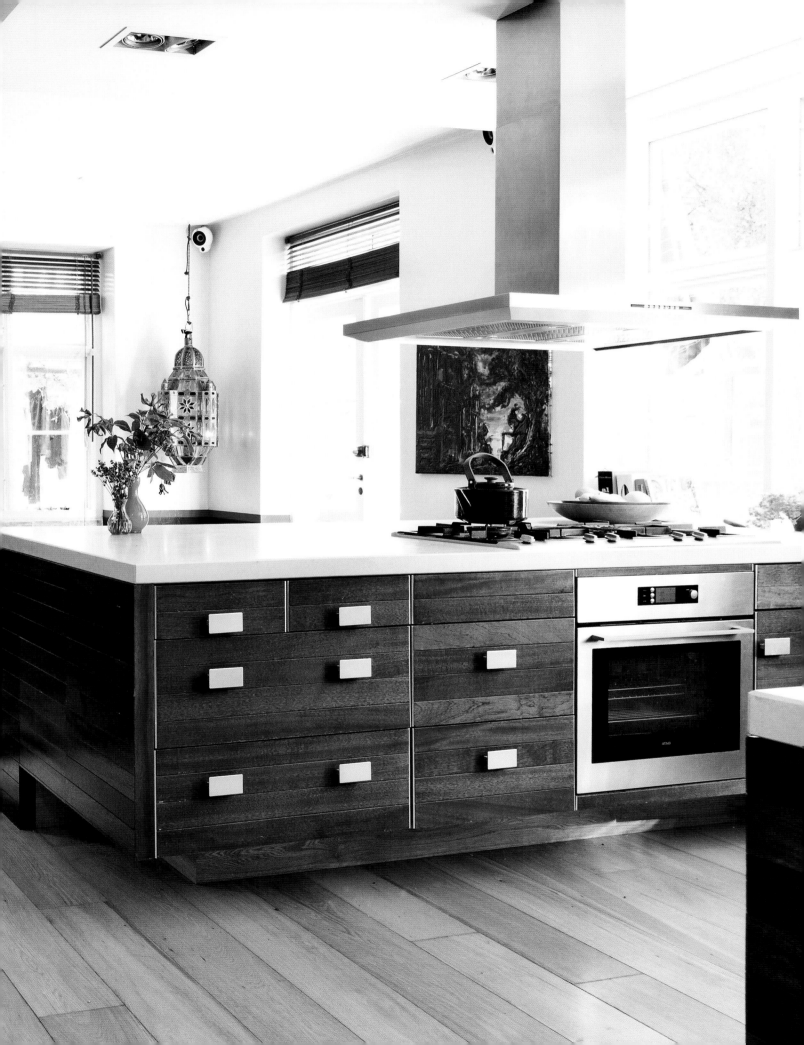

An island doubles up as a countertop-cum-breakfast bar, meaning there's space for freestanding pieces of furniture elsewhere in the room. For instance, a glass-fronted vintage cabinet in soft gray or white is really handy for storing dinnerware, glass, and ceramics, as well as keeping any collection in check. A large dining table makes mealtimes super easy, as well as providing space for the family to hang out during the day. Not to be overlooked, contemporary IKEA units have a place. Set them off with a solid wood or sleek Corian countertop and a beautiful marble backsplash.

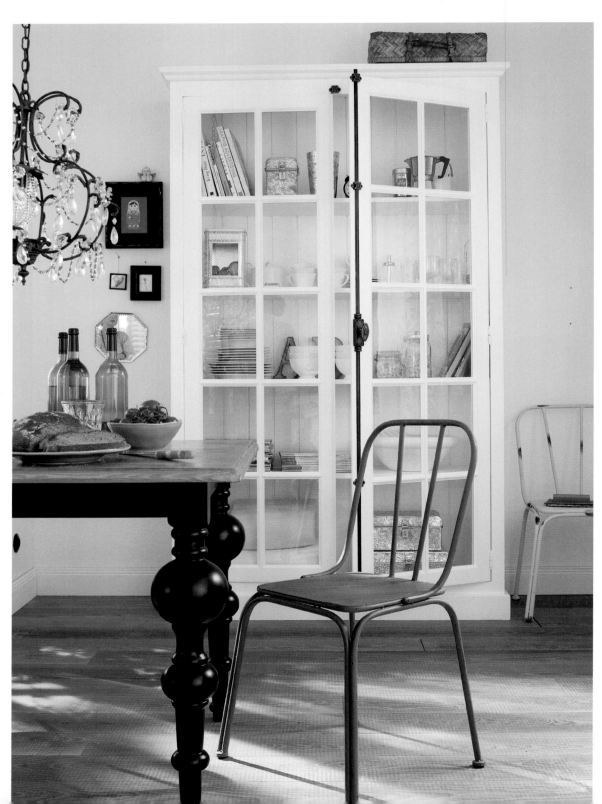

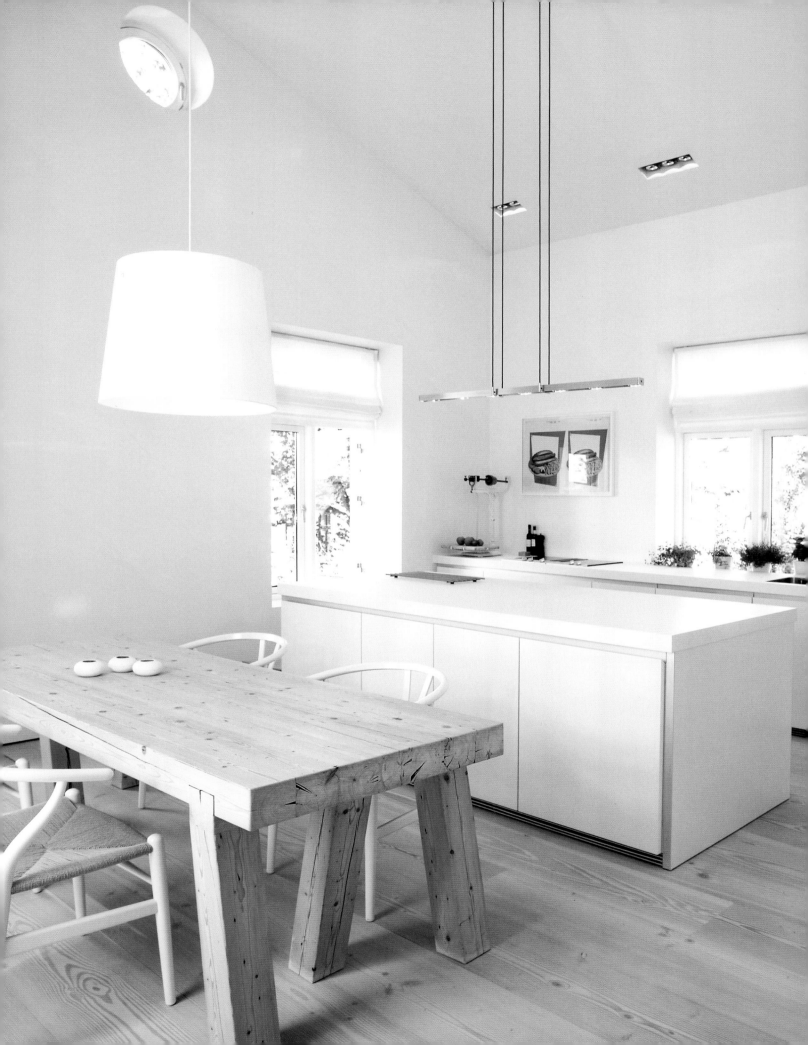

The Scandinavian mind-set is not about name-dropping designers. However, I wouldn't say no to some Arne Jacobsen "Series 7" chairs standing neatly around my kitchen table.

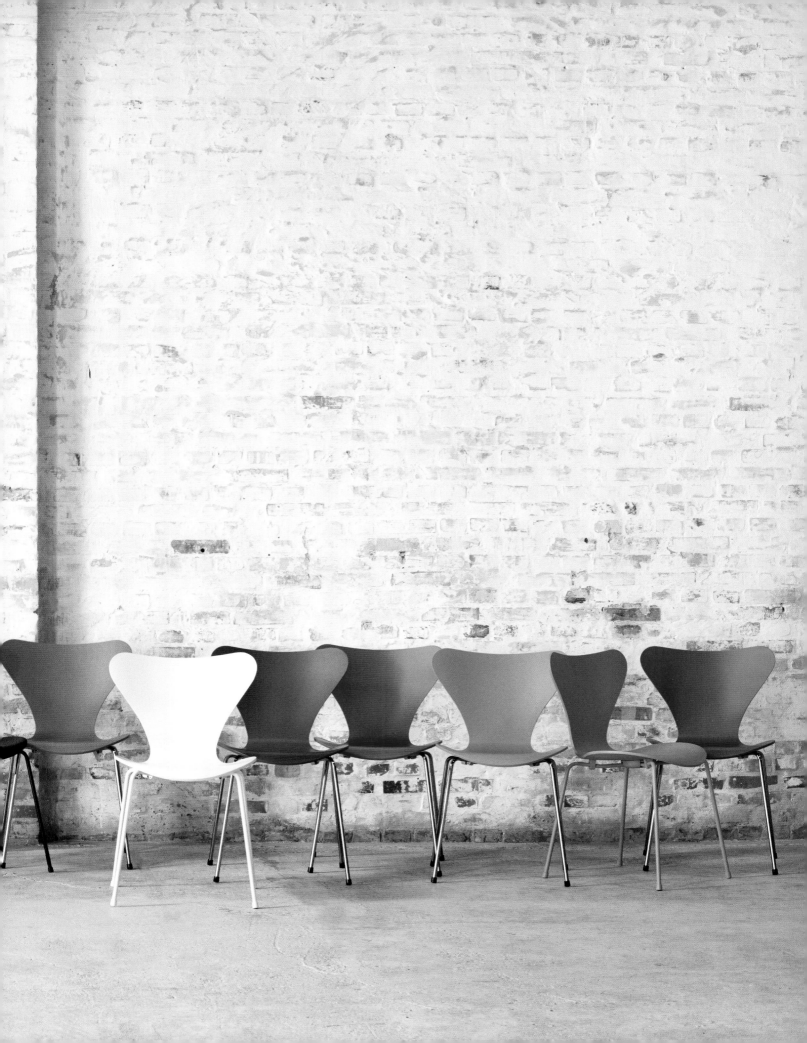

Before you get stuck on halogen spots, think about lighting alternatives alongside what you need and where. Wall lights above the worktop and pendants over an island are key—utilitarian fashion with a simple glass, white bone china, or spun metal shade. A Lean wall lamp by Örsjö Belysning over a countertop is perfect for me.

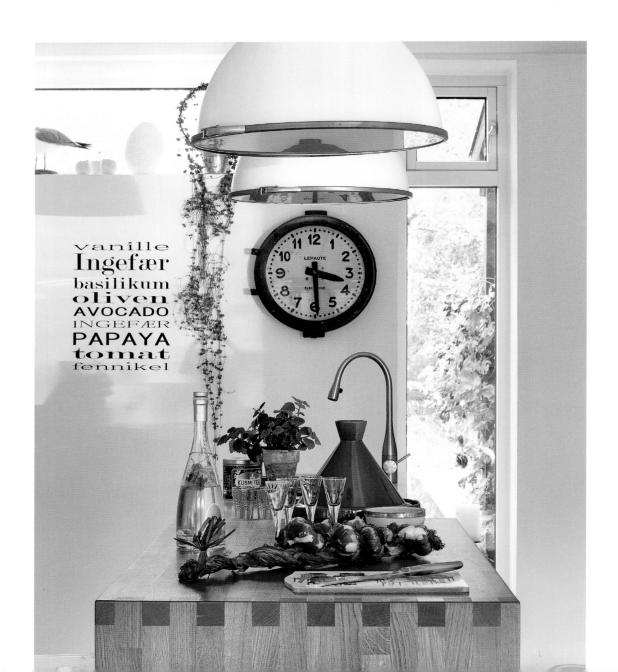

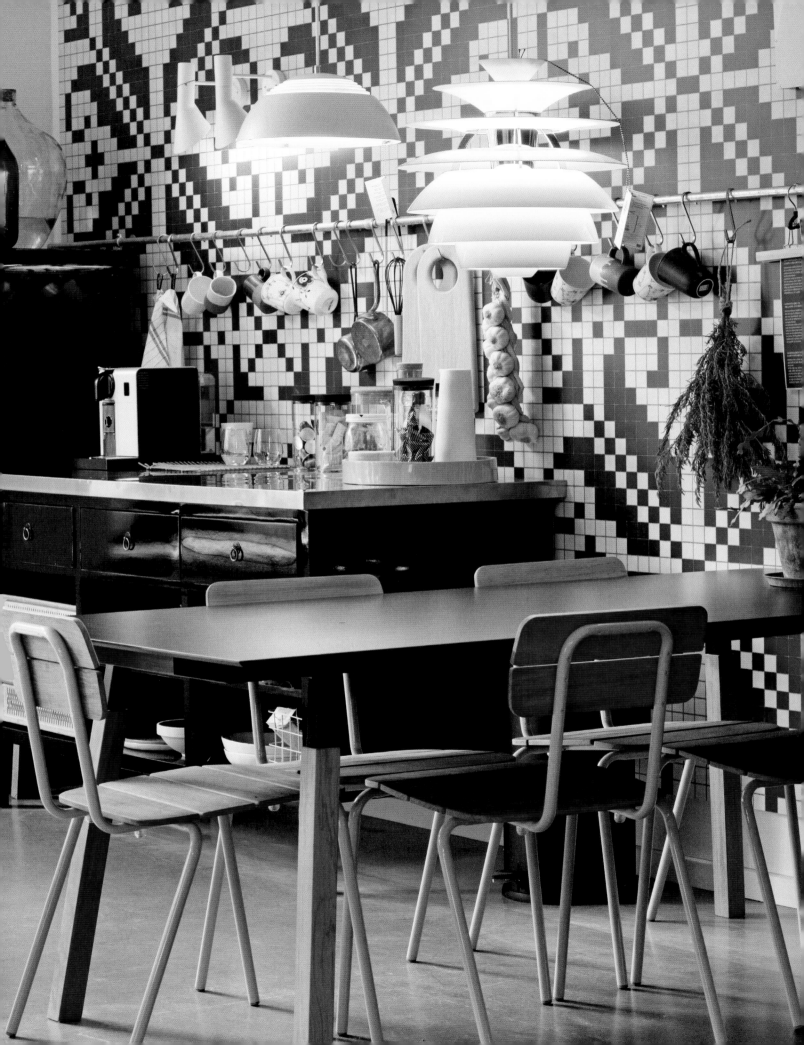

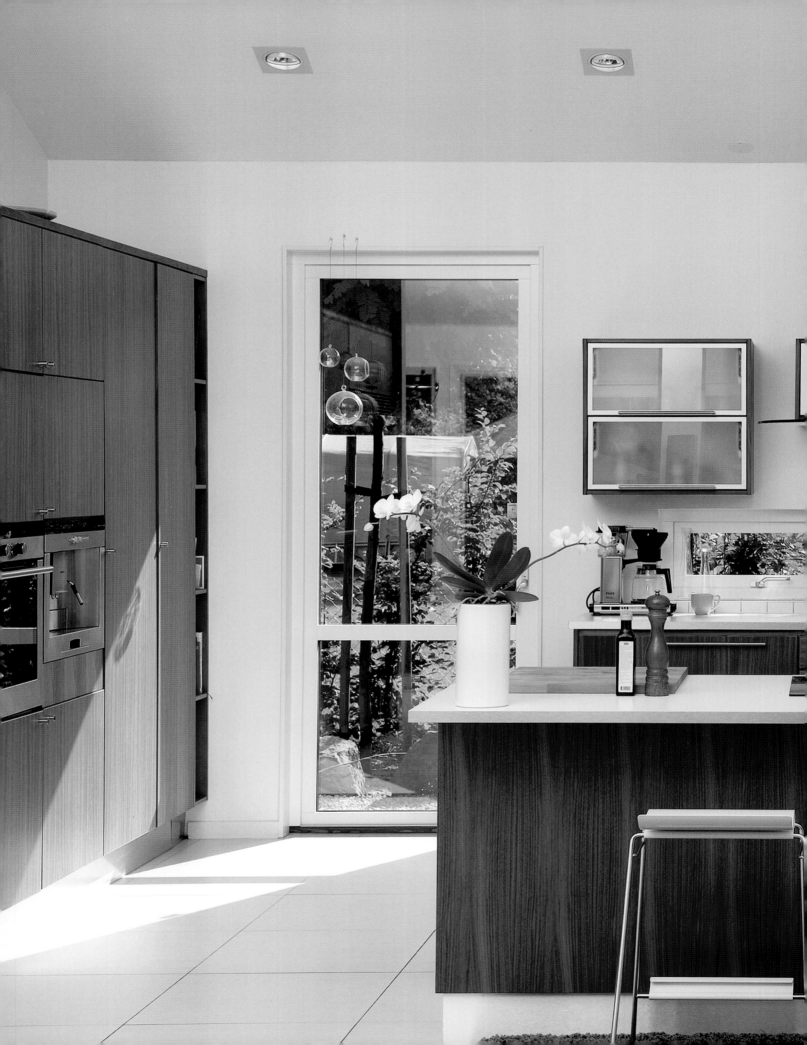

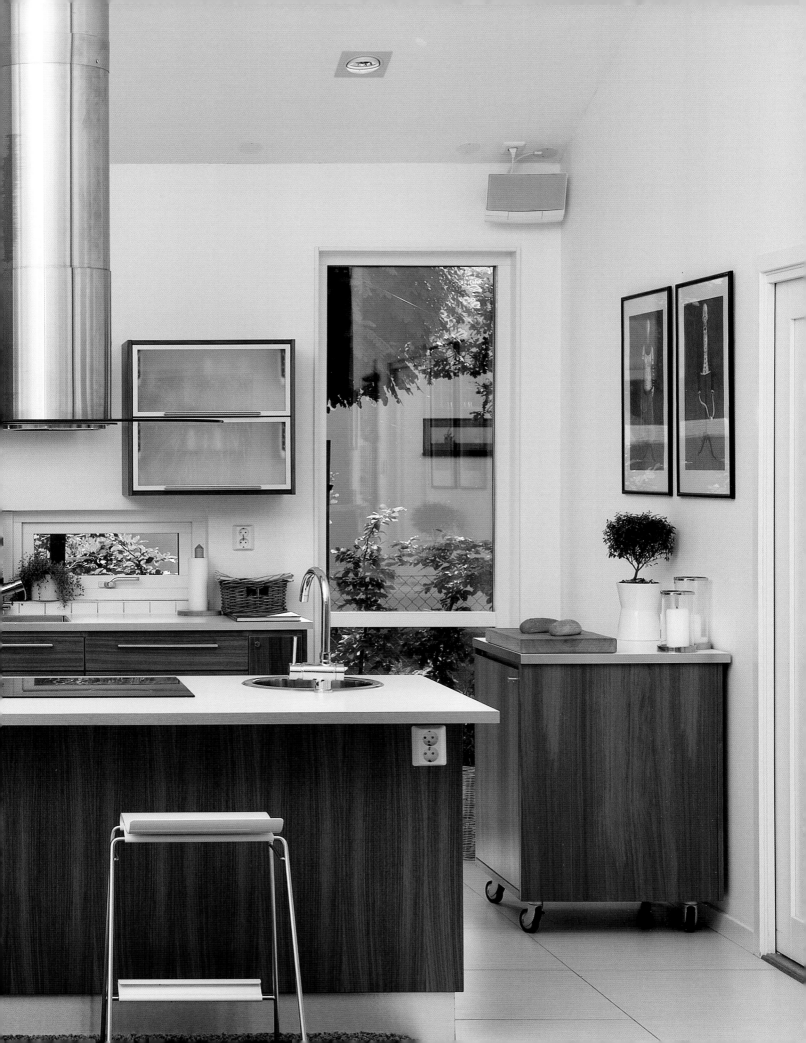

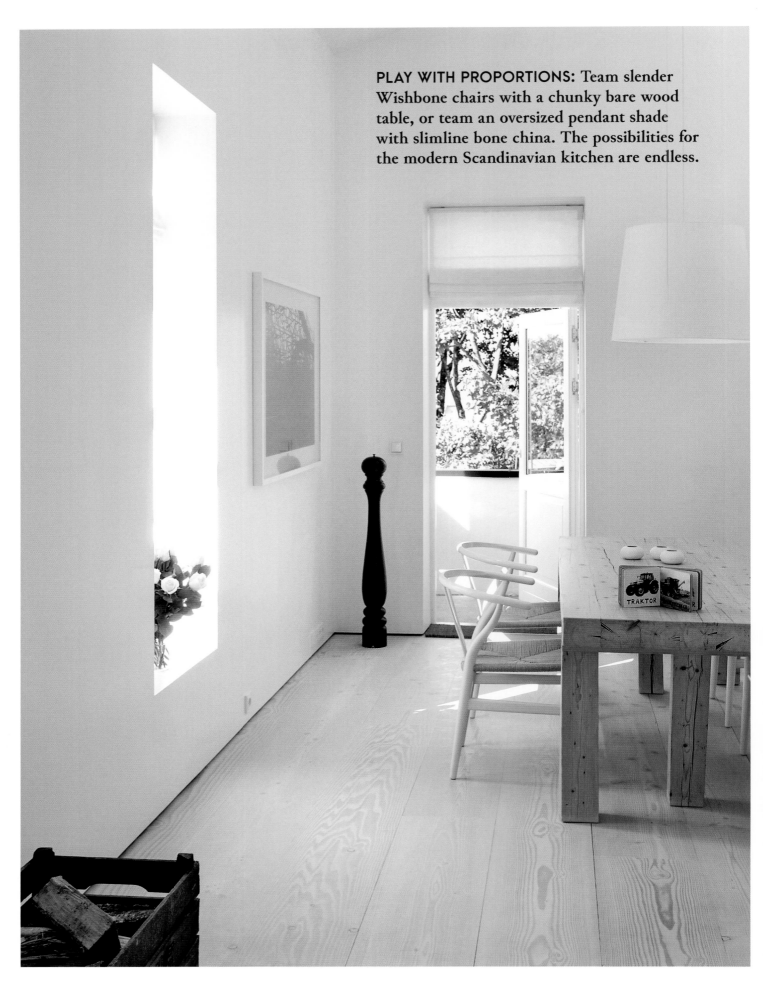

PLAY WITH PROPORTIONS: Team slender Wishbone chairs with a chunky bare wood table, or team an oversized pendant shade with slimline bone china. The possibilities for the modern Scandinavian kitchen are endless.

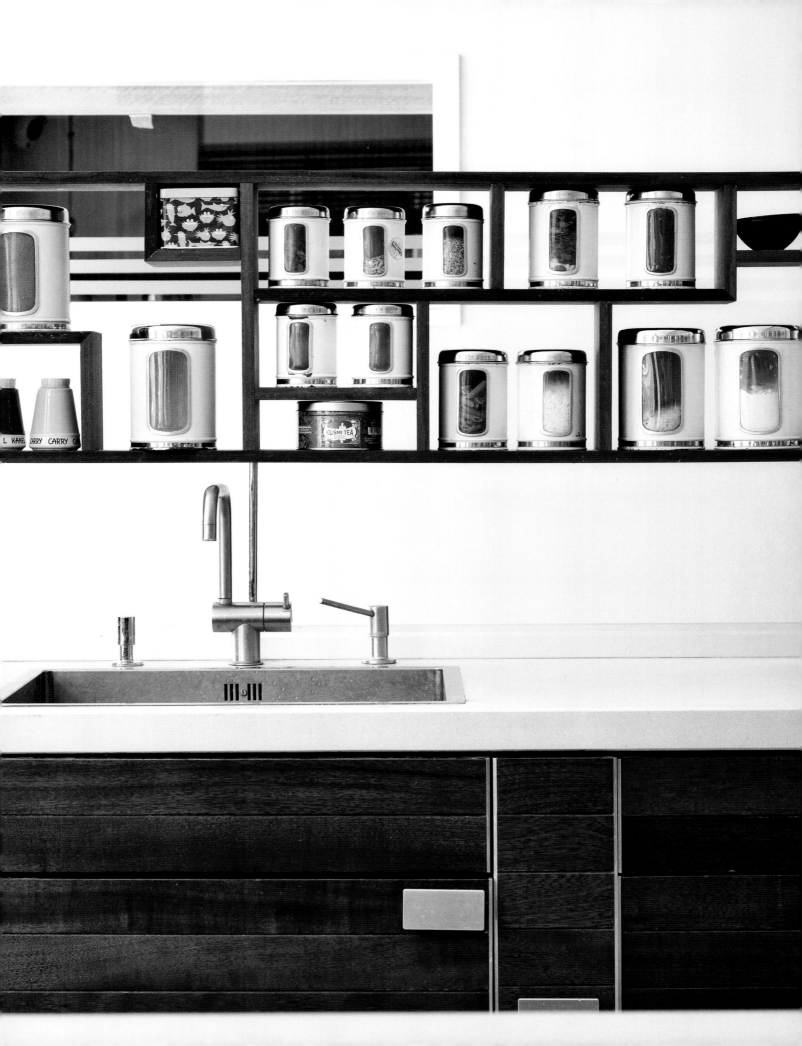

Top Tips from Scandi Creatives

ANDERS FÄRDIG

Design Pioneer

Founder and CEO of Design House Stockholm (*designhousestockholm.com*), Anders shares how to create an interior with timeless appeal.

———

1 | The common cliché about Scandinavian design is that it has to be the vision of a Scandinavian. Scandinavian style has become a global concept and can be designed by a Thai creative as well as a Swede or Dane.

2 | Functionality, quality, and ergonomics make Scandinavian style special. We show that simplicity can be beautiful.

3 | To get the look, follow the necessity of the product. If you need the product, make sure that you can live with it for a long time.

4 | Right now, I love it that Scandinavian design has a much wider audience than ever before.

Top Tips from Scandi Creatives

5 | For me, decorating should emphasize the usefulness of the product. I usually prefer tactile materials above ornaments.

6 | I look for harmony in a piece of design.

7 | Blending different styles is like expressing different sides of your personality; it is the total expression that counts.

8 | My best decorating advice is to not look at design or décor as the importance when you are designing. Look at what the product should be used for first.

9 | The main feature of my kitchen is good material and useful tools.

10 | My biggest must-have in a home is space.

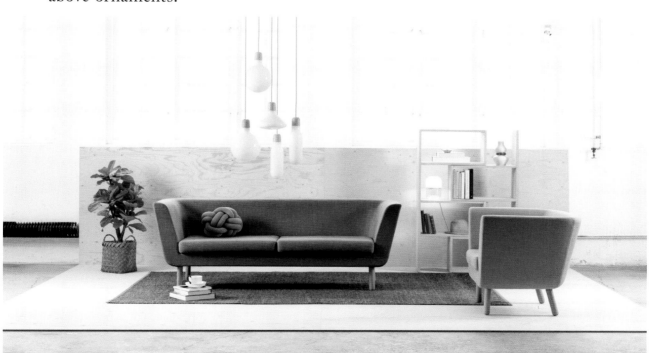

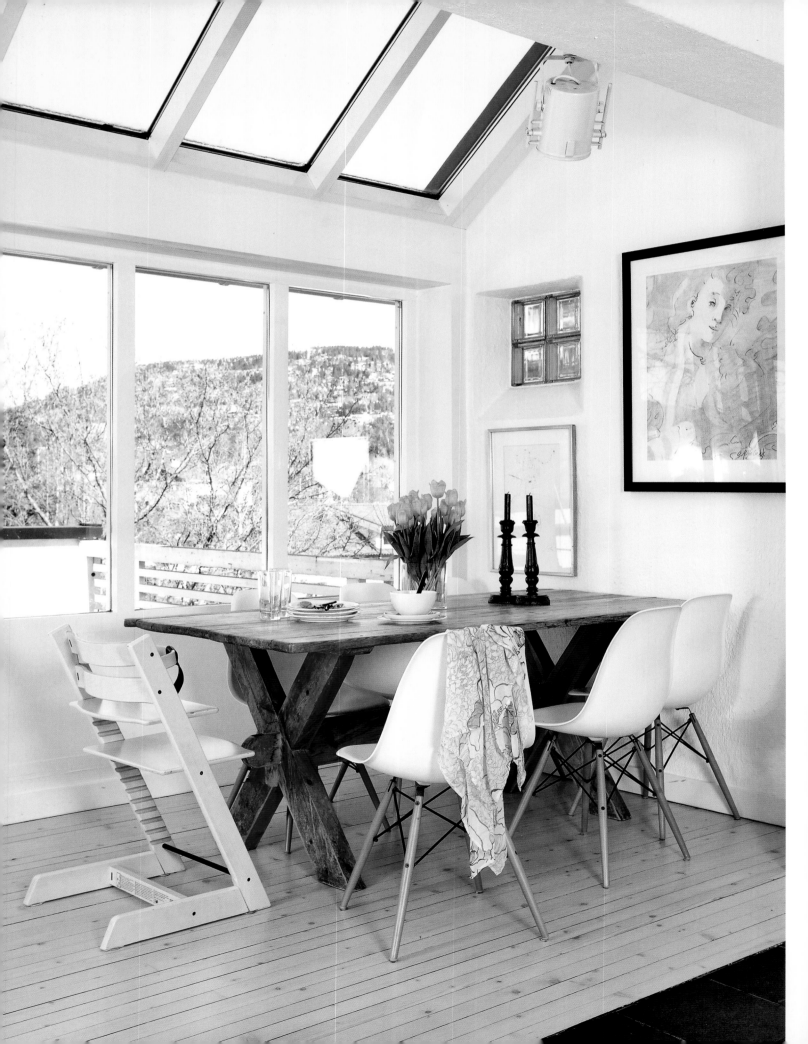

4

DINING ROOM

Round table or square? Combined with the kitchen or separate? The dining room can be a tricky space but simplicity is the key to getting the Scandi style right. A little bit sporty, a little bit luxe, the aesthetic is all about clean lines and neutral colors. Look out for simply designed furniture, mid century-inspired prints, and plenty of natural wood. And if your dining room leads out to the garden, then that's an added plus.

THE PALETTE

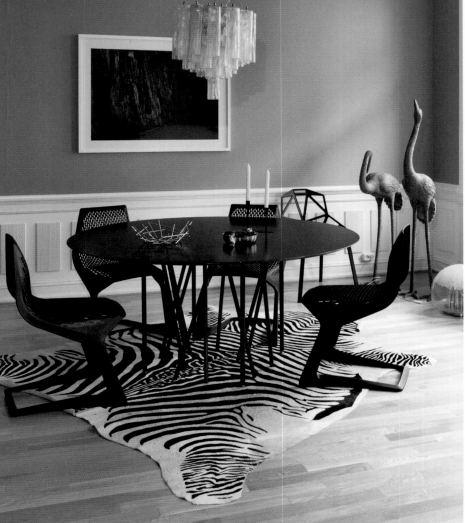

A mix of materials is a simple way to jazz up the clean-lined Scandi aesthetic. Use timber, stone, ceramic, and concrete to create a tactile backdrop with a palette in soft gray or contrasting black-and-white. In a white room, try painting one wall off-black. Pale woods stand out against a slate color and a matte finish will keep the look soft. To heighten the luxury factor, every room benefits from a touch of metallic and this is especially so in the dining room. A small gold light or silver candelabra will stand out against the chalky-colored scheme.

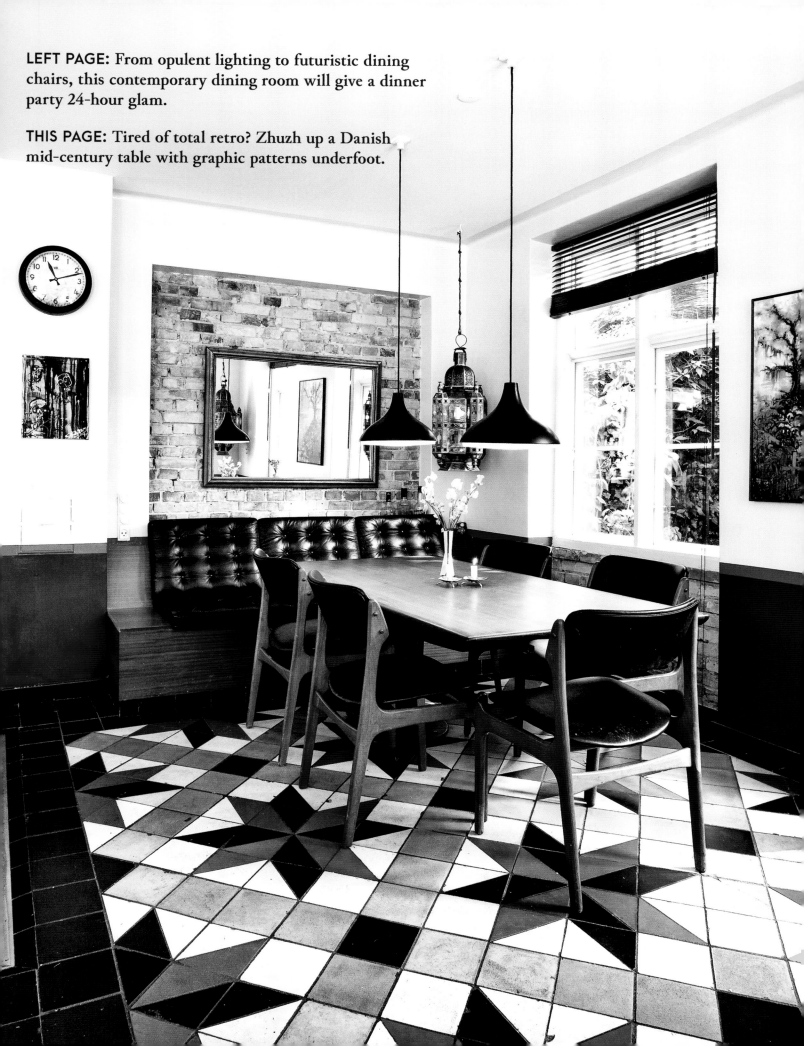

LEFT PAGE: From opulent lighting to futuristic dining chairs, this contemporary dining room will give a dinner party 24-hour glam.

THIS PAGE: Tired of total retro? Zhuzh up a Danish mid-century table with graphic patterns underfoot.

THE INTERIOR

As anyone who appreciates Scandinavian design will know, everything begins with function. A space needs to work according to lifestyle, rather than simply look good. What storage do you need? Do you eat at the table? Is there somewhere to do homework while you get dinner on?

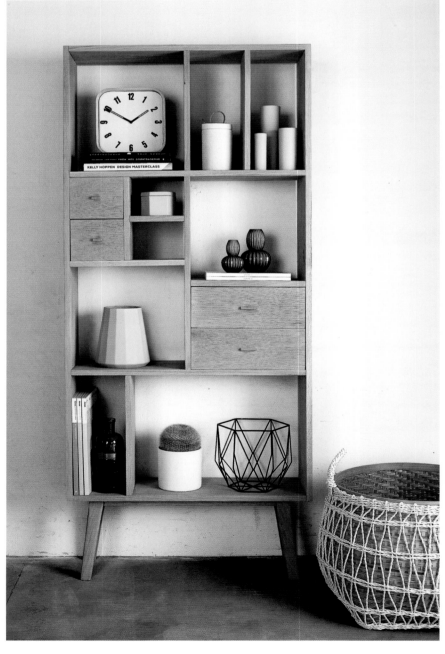

Top of the wish list for an adaptable dining space is a large refectory table. Designed for multiple uses—work, rest, and play—it is a space-conscious choice for families who just love to entertain, as well as being a worthy investment, considering how much it is used. To create more space, use a bench on one side. This pulls the table out of the center and opens up the other side of the room. When picking out furniture Skandium's founder, Christina Schmidt advises, "There are many mid-century second-hand furniture dealers around or simply buy Danish, Swedish, Finnish, even Norwegian classic pieces, luckily still in production with original manufacturers. The idea is simple pieces well made, using good quality materials." For pieces with long-term value, beautifully crafted design classics will never go out of style.

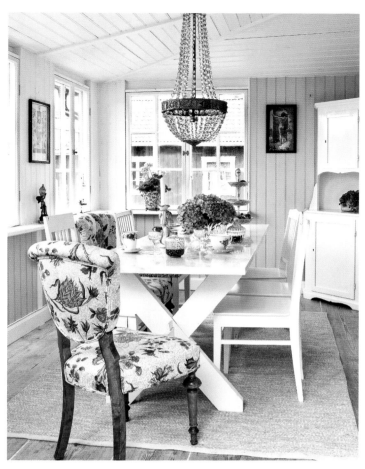

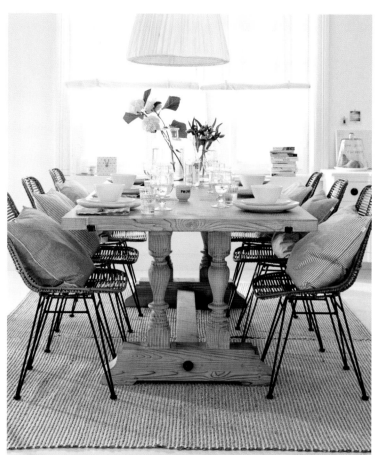

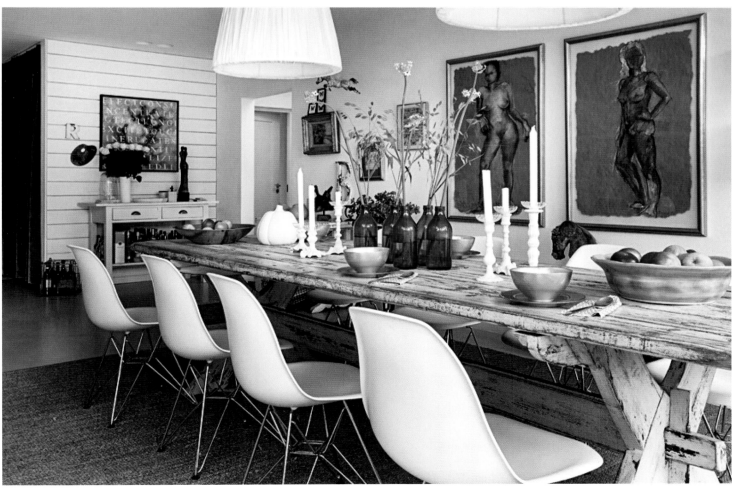

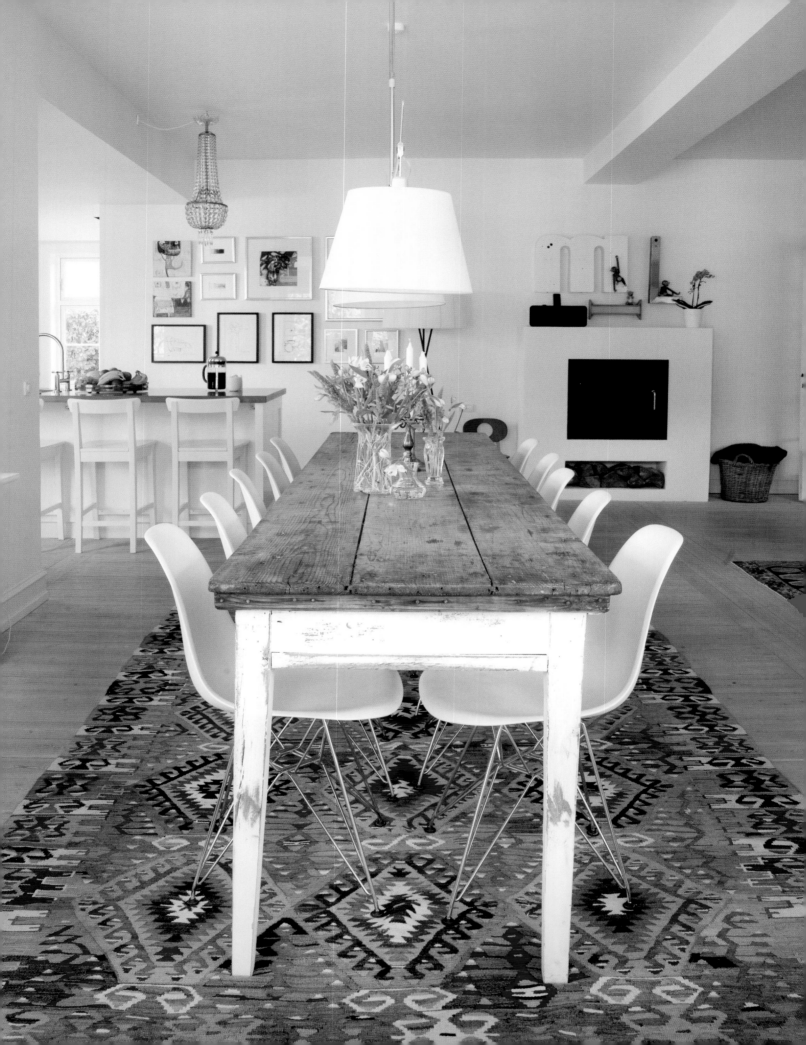

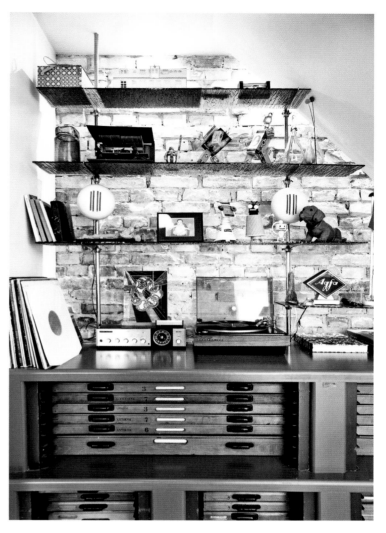

STYLE CRUSH: Have fun and mix up styles in a big space. A smart combo of a rustic table, contemporary fireplace, and mid-century furniture gives this interior a Scandi edge.

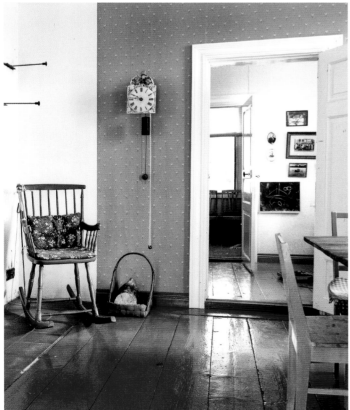

Although generally clean-lined and simple, Scandinavian interiors are often more "vintage" than you might think. Incorporate a mix of old and new to add layers and stop a space from looking too much like a showroom. Natural rather than rustic is the idea. The finishing touch? Rugs and curtains. It's nice to have some softness when everything else around is hard. Sheer voiles add a relaxed, summery feel to a contemporary, uncluttered space.

THE TABLEWARE

Artisanal tableware forms part of the Scandi lifestyle for casual dining. Look for handmade glasses and strong shaped pots—items that add interest but don't shout. Decorative or minimal, the aim is to go for pieces that enhance an experience rather than simply "entertain." I love a mix of materials like inky, glazed craft pottery with timeless, white bone china and beautifully grained wood. Candles too, are very Scandi. Group them together on trays and enjoy the Nordic vibe.

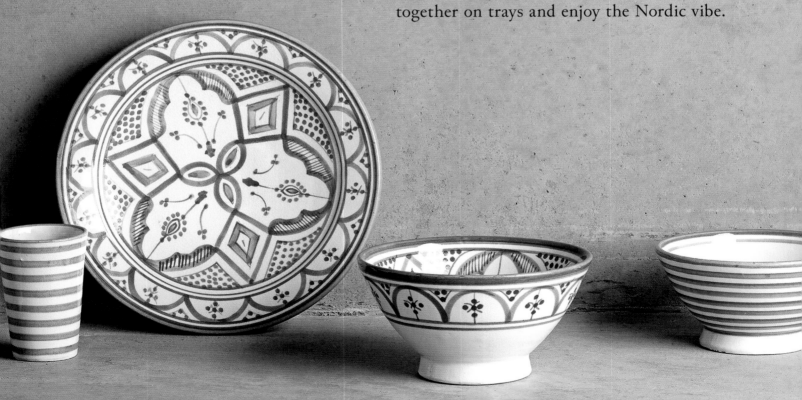

CHARACTER AND CHARM: These simple, functional
designs deliver on style as well as practicality.

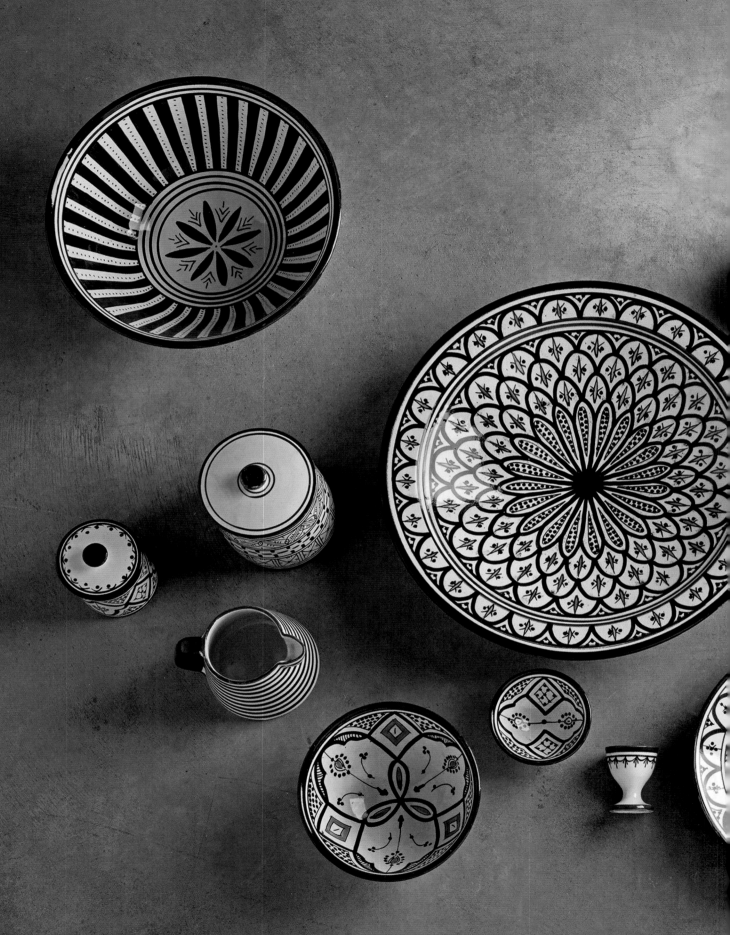

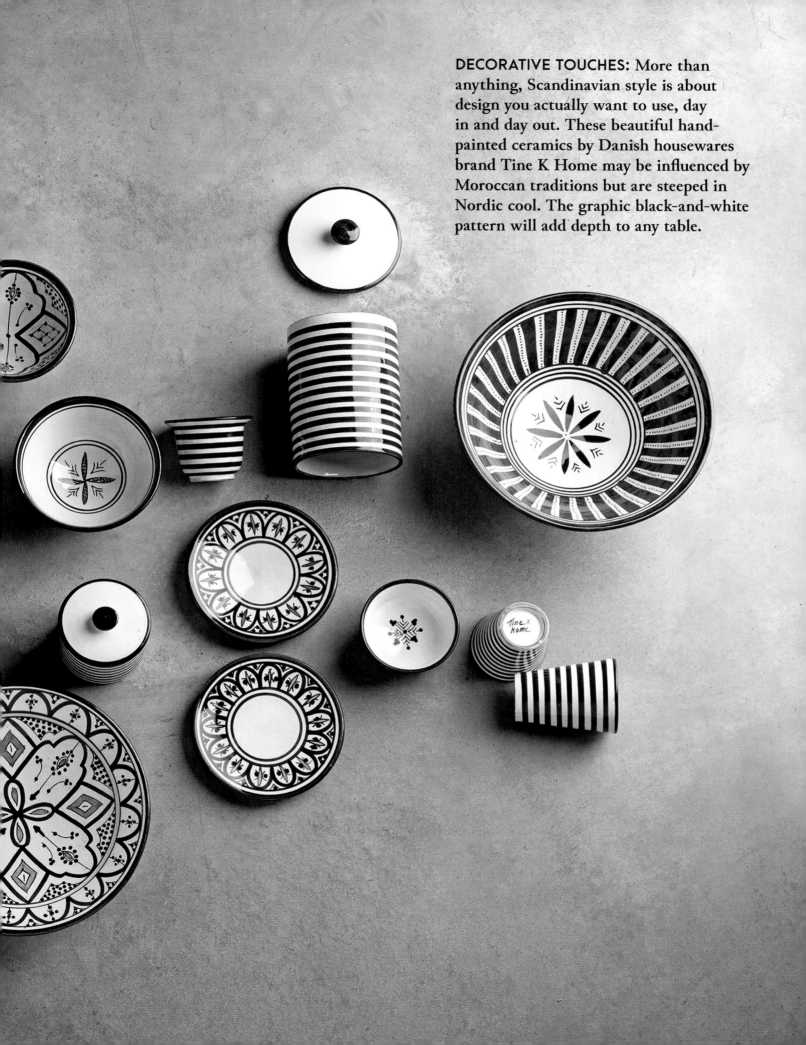

DECORATIVE TOUCHES: More than anything, Scandinavian style is about design you actually want to use, day in and day out. These beautiful hand-painted ceramics by Danish housewares brand Tine K Home may be influenced by Moroccan traditions but are steeped in Nordic cool. The graphic black-and-white pattern will add depth to any table.

HOW TO HANG A COOL
CEILING PENDANT

———

Add drama to your entertaining zone by hanging identical pendant lights over your table. A dimmer switch is great for changing the atmosphere to suit the mood. However, it is scale that is of utmost importance when positioning the lamp's height—too low and you're knocking your forehead; too high and it doesn't relate to the dining table below. Naturally, each pendant height will vary depending on its size, but as a rule of thumb a lamp positioned between 28 to 32 inches above the table is about right.

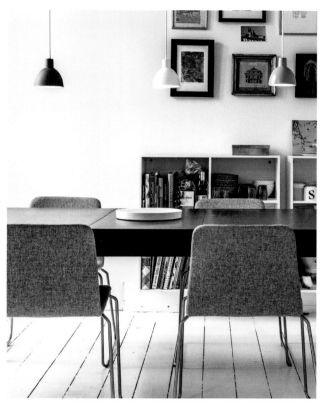

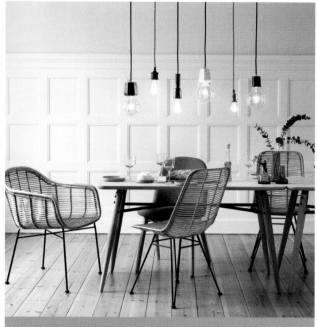

MORE IS MORE: A cluster of pendants makes for a dining table look like no other. Vary the heights for a less uniform feel.

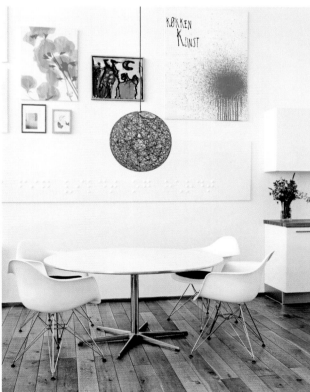

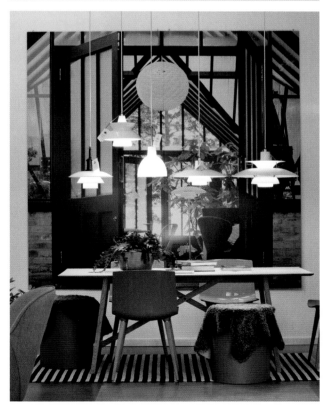

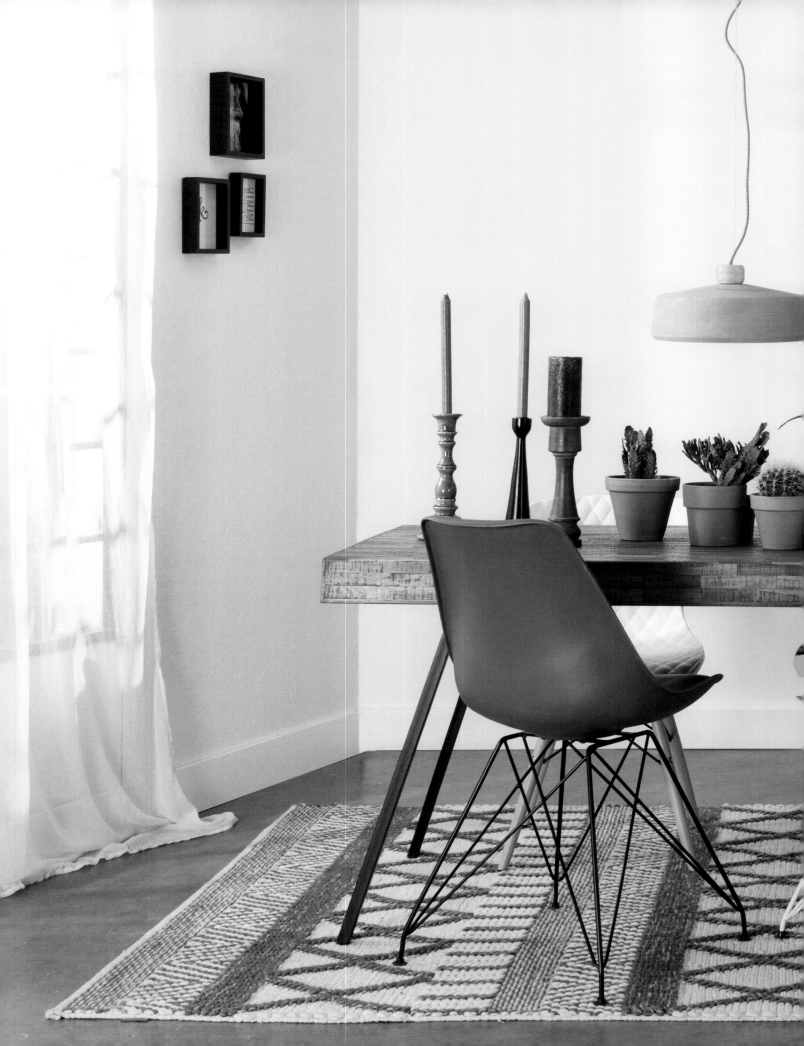

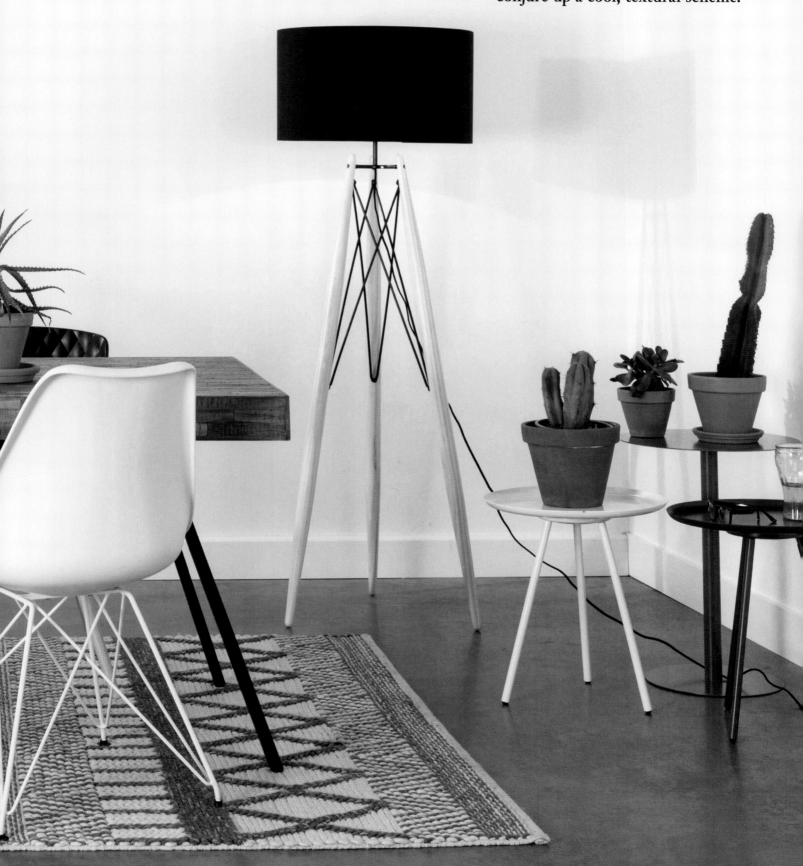

MODERN RUSTIC: Richly grained wood gives this dining table its distinctly Scandinavian vibe. Match its sleek metal legs with retro chairs and unglazed clay accessories to conjure up a cool, textural scheme.

NINA BRUUN

Designer, Colorist & Trendspotter

Design manager of Danish furniture and accessories brand MUUTO (*muuto.com*), Nina discusses the thought process behind her distinctive Scandi style.

1 | The most common cliché about Scandinavian design is that everything is made of light wood.

2 | To get the look, clean up and make sure you have enough storage space. Choose to display only what is necessary and what means a lot to you.

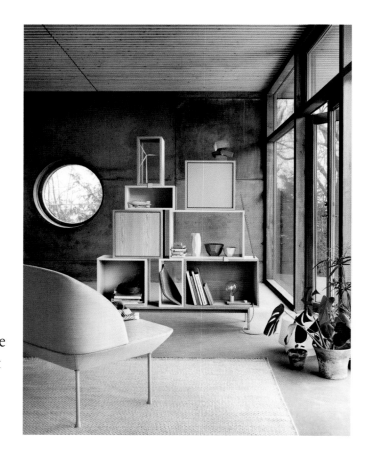

Top Tips from Scandi Creatives

3 | Scandi style is slowly moving away from minimalism and monochrome towards more colors and personality.

4 | Design for me is functionality and quality united in a great shape.

5 | I always follow my gut feeling when putting together a scheme. I do not like it when decorating is dictated by trends.

6 | Right now, my favorite color combination is aubergine and ultramarine alongside pale sea green and rose.

7 | My best décor advice is to be surrounded with objects that have meaning. Be yourself and invest in good design that lasts.

8 | My biggest must-have in a home is a good dining chair, which I can sit in a 1,000 different ways and where guests can enjoy a glass of wine while I cook.

9 | My dining room contains a big dining table, as I love having guests over and it will seat a minimum ten people.

10 | I would spend my last dollar on fresh flowers, definitely.

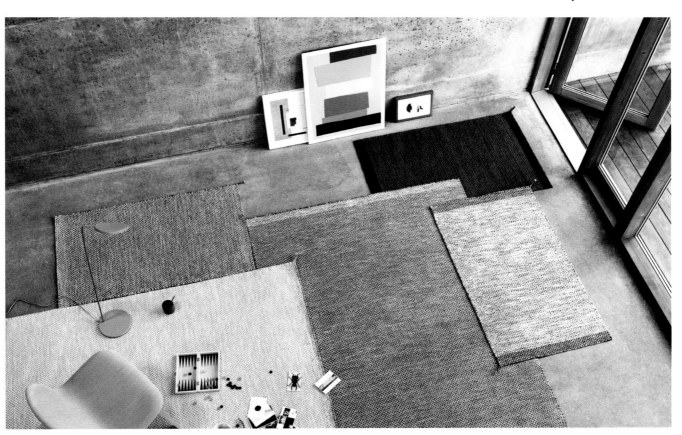

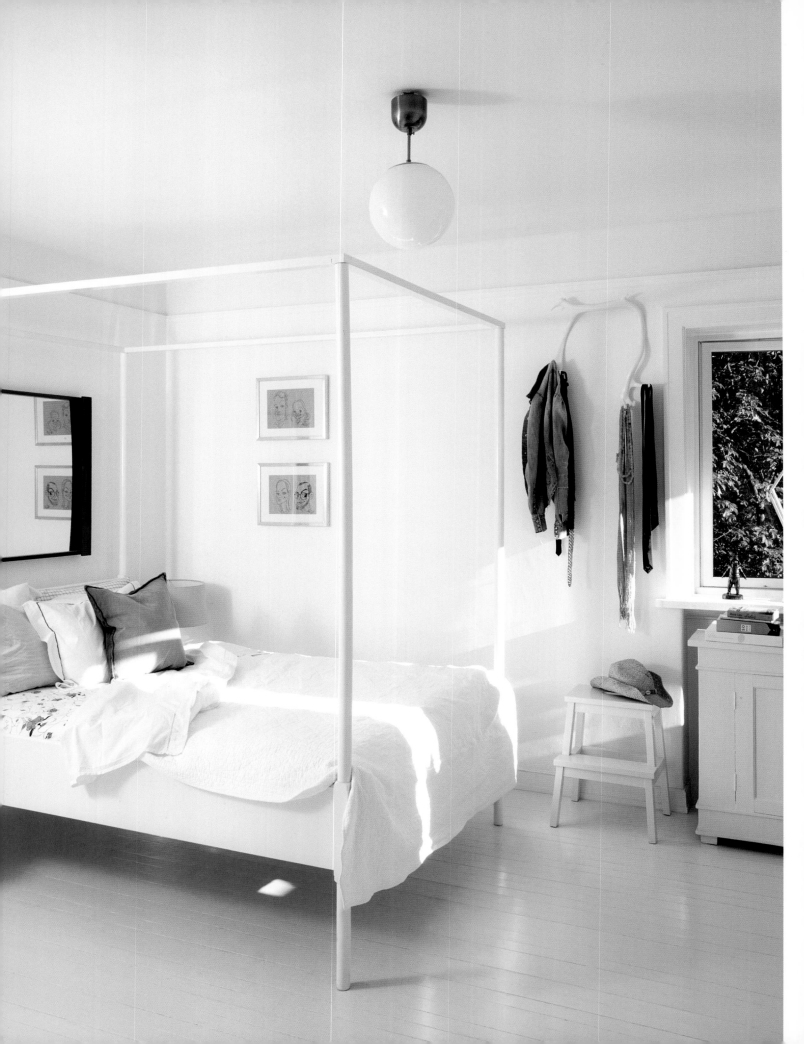

5

BED ROOM

Simple, contemporary, calm—when you think of Scandinavian design you think of natural beauty and effortless style, and nowhere more so than in the bedroom. A serene sanctuary, the idea is to surround ourselves by the natural, the uncomplicated, the relaxed—and our minds will hopefully follow suit as well. Here's how to get the pared-back, chilled-out style at home.

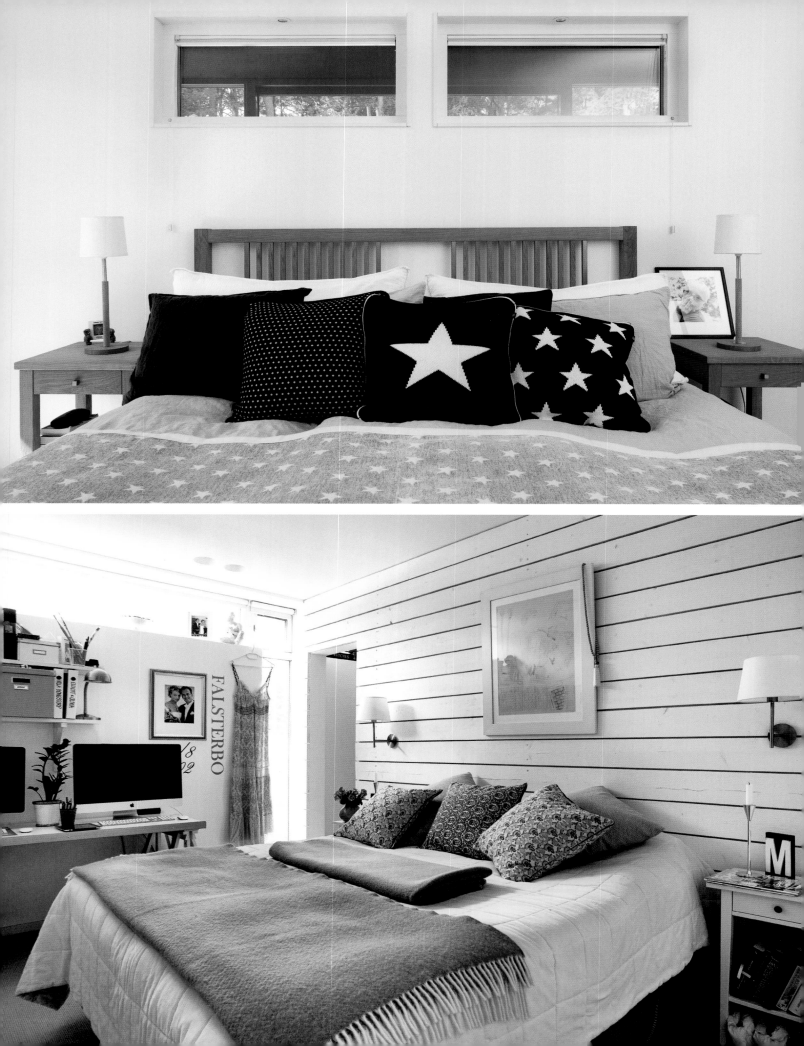

THE PALETTE

Paying homage to Scandinavian simplicity, paint the interior in a calming white or in soft tones to create a light, breezy atmosphere. A dark gray-blue tone is also nice as it helps to achieve a contemporary, yet restful feel. This trick of sticking to a restrained palette is the fastest way to pull together a room and make it feel sophisticated. It also gives free rein to introduce pattern and texture elsewhere.

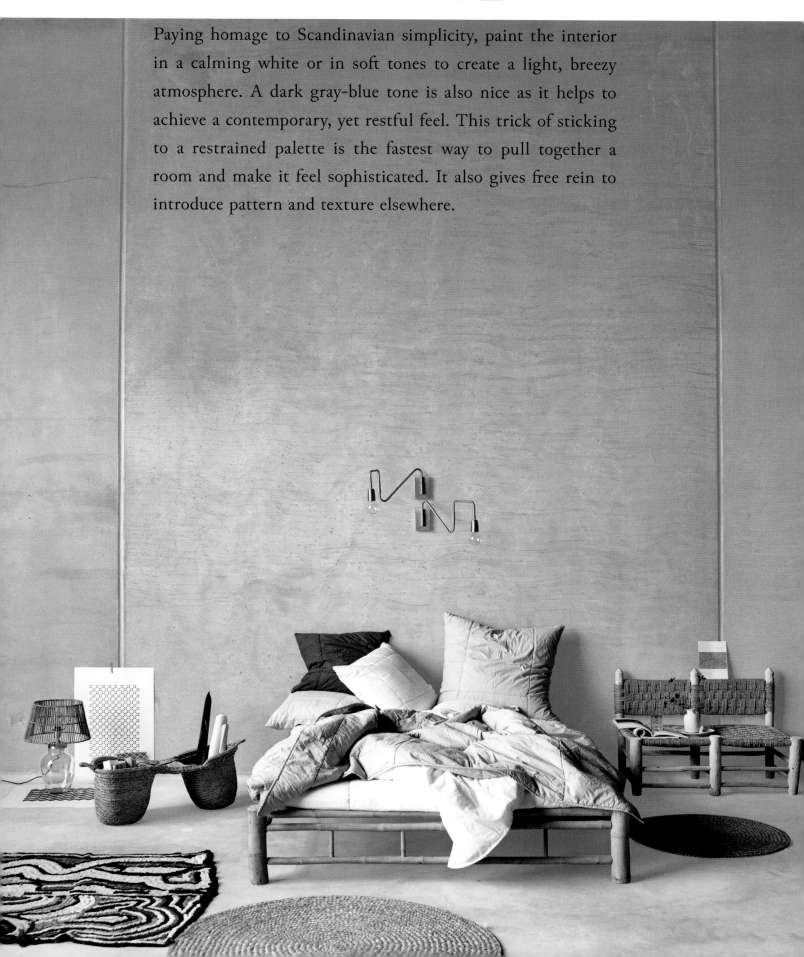

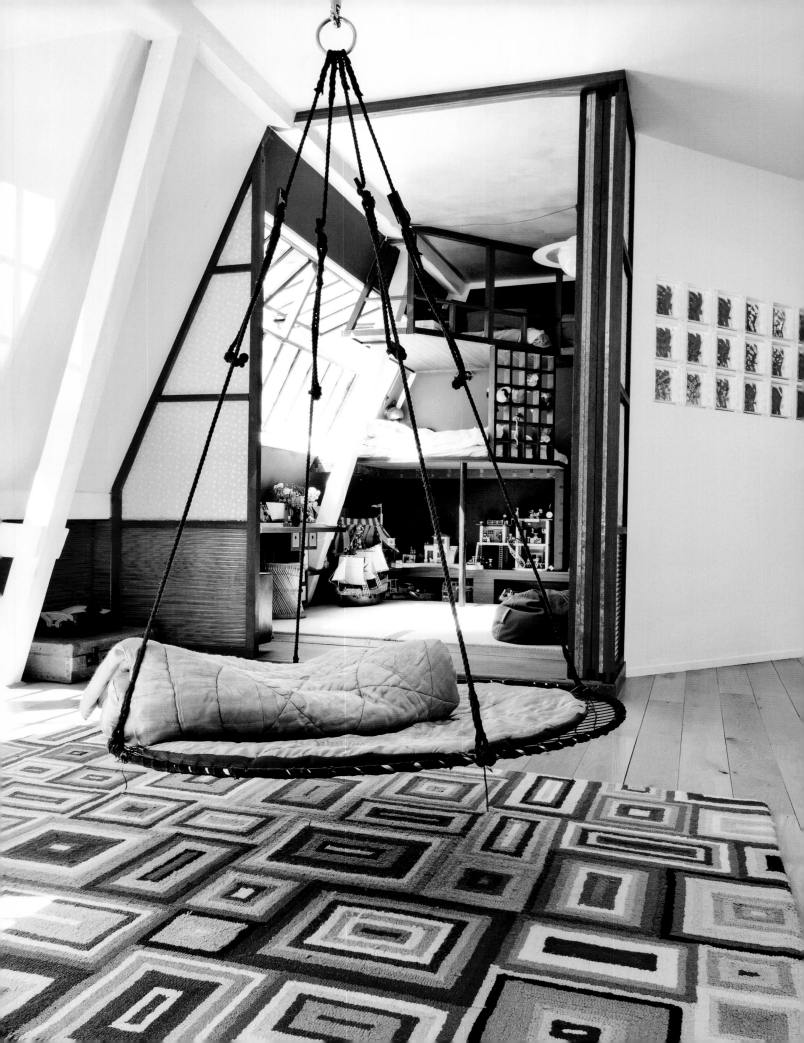

LEFT: Is there anything more fun than a hanging chair? Anchored to a ceiling joist, this hammock-style swing is perfect for a morning meditation or the kid's story time.

WALL ART: You don't have to be into flowers for wallpaper. This pink stripe is still romantic and reflects the Scandi love for vintage style. Places always feel more home-ly with a bit of character, so put up those family photographs and have fun decorating your walls.

THE INTERIOR

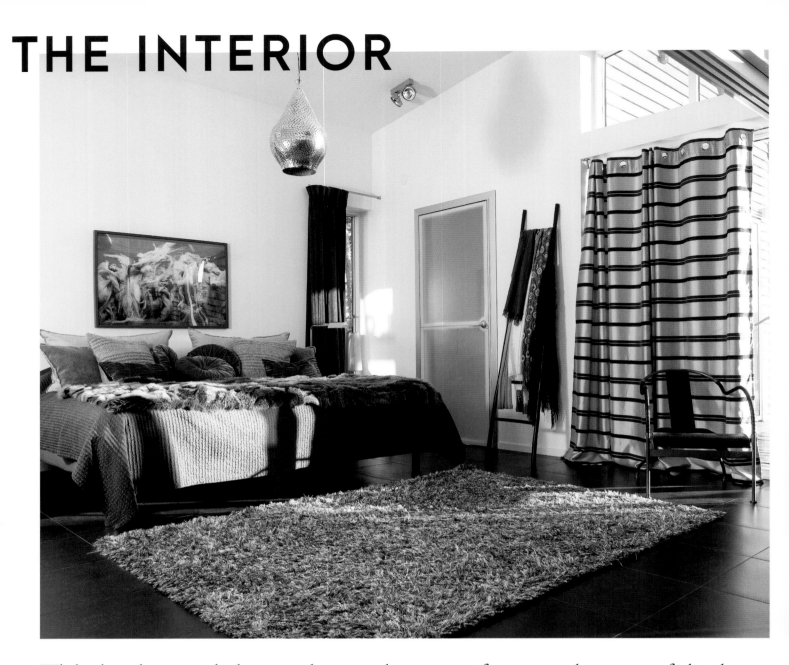

While the scheme might be one color, vary the textures if you want the room to feel right. Bedspreads are naturally soft and cozy, whereas white linens are cool and crisp to the touch. Panels of lace at the windows filter in beautiful light and rugs in the bedroom look best when they are super shaggy and toe-sinkingly soft. Layer them up on glossy painted floorboards for added contrast.

Starting with the bed, the natural focal point in the room, take different textures and make them feel as though they are sumptuous. The whole basis of bedding from the pillowcases to the sheets, duvet cover, and throw is to show how they all work together. Fringed alpaca wool throws, textured knit blankets, quilted patterned bedspreads, velvets, and raw linen—these all combine to create a beautifully comfortable and layered effect.

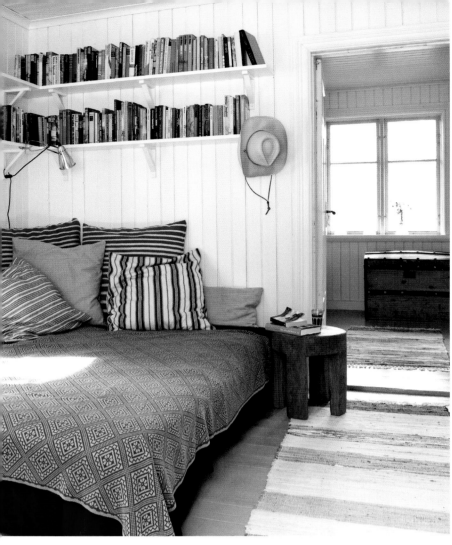

THIS PAGE, TOP: Indulge your stripe obsession by picking fabrics with bold tones. Alternative colors will make an interesting point of difference.

Lighting can be used to bring life to the simple scheme. The understated beauty of a bare bulb works just as well as a classic Anglepoise lamp, or step up your minimalist credentials with a pair of slim LEDs at either side of the bed. Blocks of oak or a pair of vintage chairs serve really well as bedside tables, and a bench at the end of the bed is a useful perch, as well as providing an additional surface for stashing magazines, ditching clothes, and so on. For me, it's important to have a mix where the less aesthetic things are hidden and personal objects and mementos are on display.

The simple silhouettes of natural wood furniture and layers of snug textiles turn this most practical space into an ultra-desirable place to be. It is a look that proves that you don't have to go over the top to be sexy.

BOTTOM: Add coziness with a stack of cushions and throws.

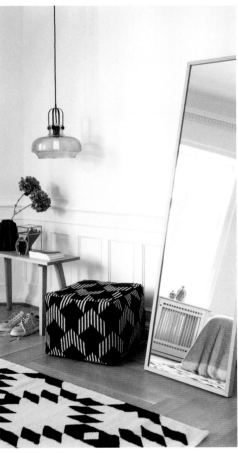

THE STORAGE

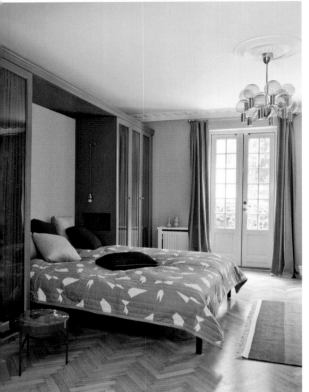

Bedrooms call for clever storage—everyone needs a place for clothes—but it doesn't have to be made into a feature. Built-ins work really well in the bedroom as they blend into the space and are key to achieving a calm mood. Look for unusual places where you can make the most of storage. Capacity can be built into an oak headboard, or a false wall creates a really useful recess behind the bed. It's a neat way to fix wall lights, and as it makes a shelf, there's a ledge to store books, water, etc.

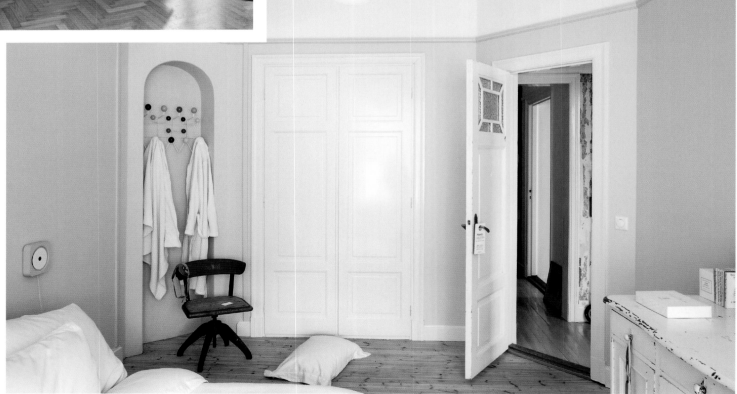

TRUNK SHOW: Treat an old military trunk as a bedside table and blanket box combined.

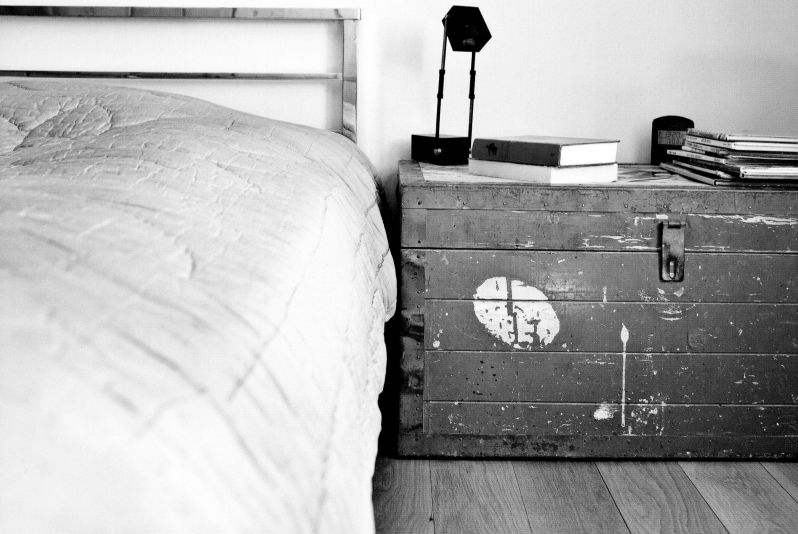

HOW TO DECLUTTER

Gorgeous and clean, the trick for creating a calm, soothing space is to take things away, rather than adding. Tidy house, tidy mind, as the saying goes, so take your first step to decluttering with a good Scandi-style sorting of your wardrobe. Every so often review what you have and assess if you really need and use it. If not, be ruthless and give it a new home. By keeping the space clutter-free, you can see what you do have much more clearly. Organize clothes into colors and when you buy something new, aim to take something old away.

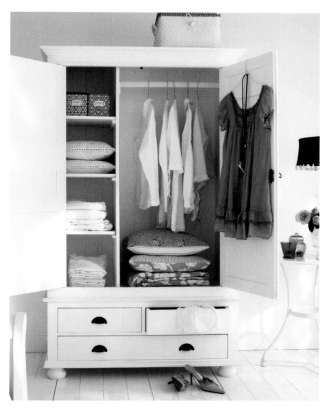

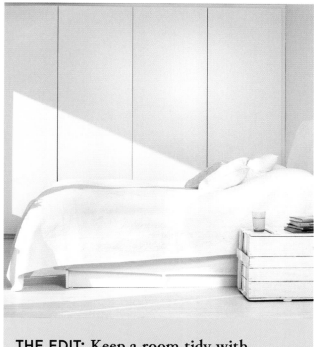

THE EDIT: Keep a room tidy with good-looking storage.

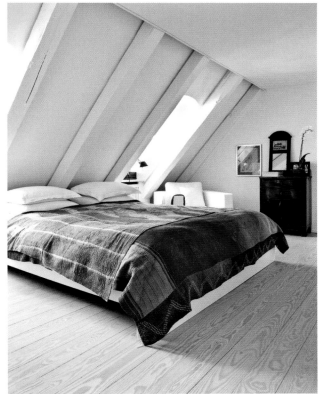

NINA TOLSTRUP

Designer

Despite living and working in London, Studiomama (*studiomama.com*) founder Nina stays true to her Scandinavian roots with a love for pared-back perfection. Here, she shares her golden rules to putting together a scheme.

———

1 | Form follows function is the most common cliché about Scandinavian design.

2 | Fresh, bold, and colorful is how I would describe Scandinavian style today.

3 | I don't do decorating. In my work, I try to solve problems that include social awareness and aesthetic importance.

4 | There is a lot of great design around, so anything new has to be innovative, adding value, and be well-considered in all sustainable aspects.

5 | My favorite colors change all the time, but I always like to combine colors with natural materials.

6 | I love the mix of old and new. Sometimes I can put objects together that have been made decades apart, and it feels as though they are one family. Other times, it is their very difference that appeals.

7 | My best design advice is to get rid of everything that is not special to you, does not tell a story, or has no practical use.

8 | A great mattress is my biggest must-have in a home.

9 | My bedroom is simple, functional, and colorful with good access to natural light and a feeling of space. We have a lovely old Hans Wegner bed with built-in side tables. I designed a pink wardrobe, which can open up and act as a room divider, and we have a free standing mirror that can rotate to become an ironing board. We have lots of personal objects and art (many from friends) on display, so there's always lots to look at. They act as triggers to our collective memories of the past.

10 | Good lighting is my most valued thing.

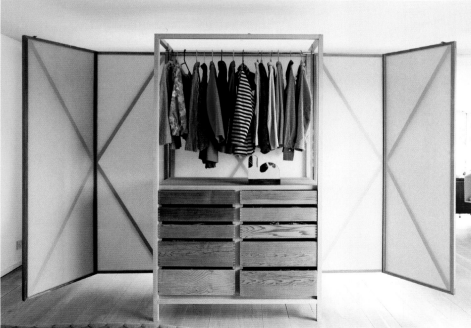

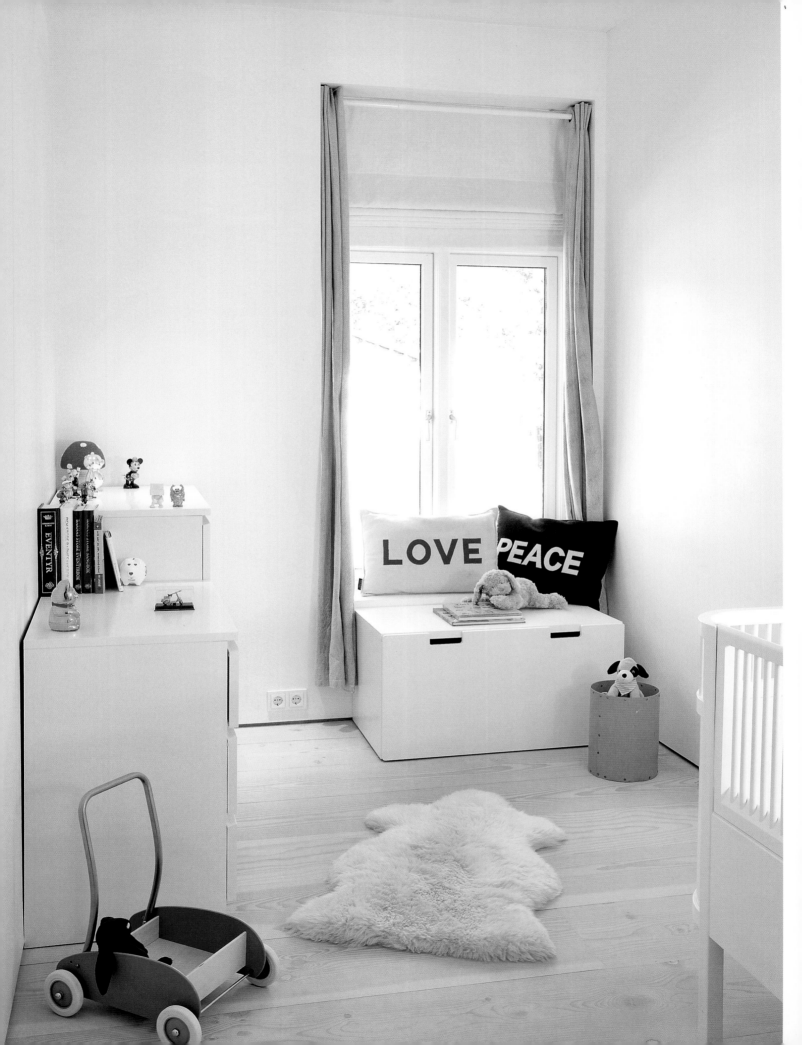

6

KIDS ROOM

With a little imagination, family living doesn't need to come at the cost of style—well, not in the Scandinavian home. Mixing smart practicality with effortless cool, get into the Scandi character with sensible storage and a Bohemian touch. Let's not forget a Kay Bojesen wooden monkey—every home should have one.

THE PALETTE

As children's toys are almost always colorful, painting a room in a soft gray or white will make a space seem larger than it is. The plain walls also provide an anything-goes backdrop for all those primary colored plastic toys. The beauty of a neutral palette is that it crosses the girl-boy divide, leaving you free to add traditionally girly or boyish flourishes on top. One thing that many Pinterest posts tagged "Scandinavia" have in common is a white-painted floor. It's so dark in the north during winter, that many paint their floors white to get as much light as possible. This is also the reason behind the lack of curtains, but I couldn't live without my lined blackout curtains in my daughter's room.

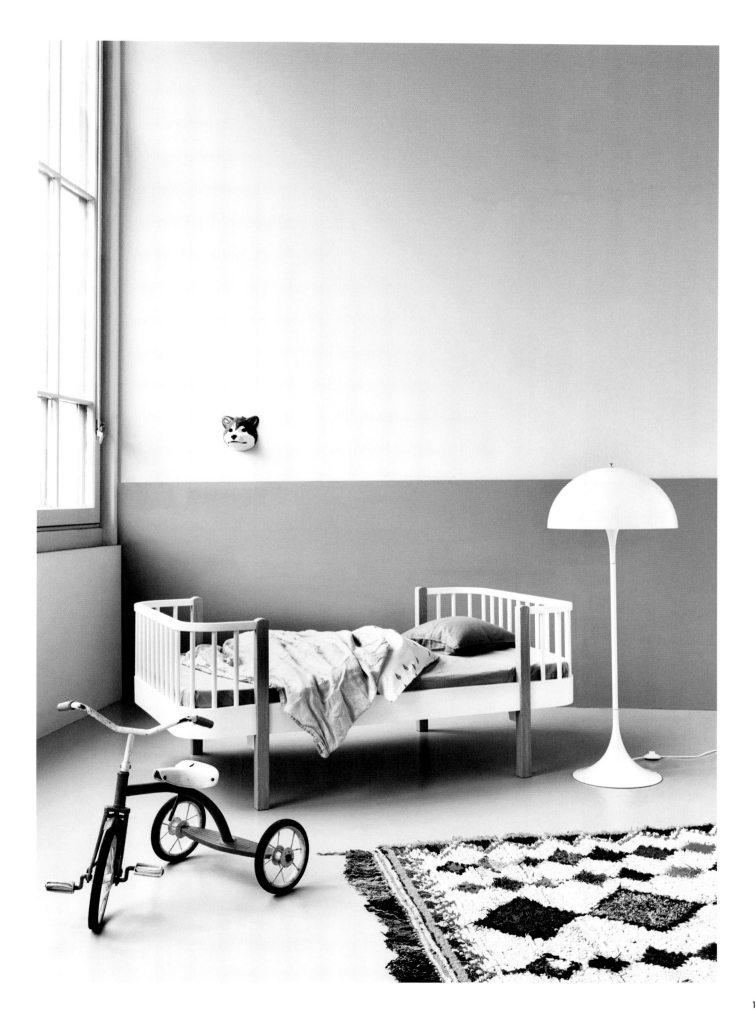

THE INTERIOR

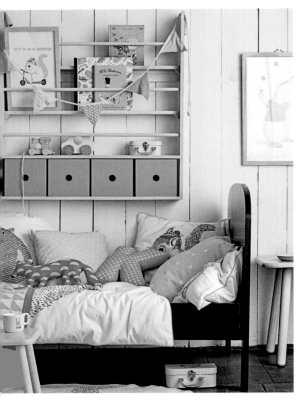

Keep it simple. Keep it easy. A modern white scheme and pretty print mash-ups and your child's bedroom dilemma is solved. Happy-go-lucky, this is where you get to have fun with bright, feel-good designs. For instance, an Eero Aarnio-designed Magis Puppy stool and fabulous Marimekko curtains are a good place to start. No Scandinavian child's room is complete without a Flensted Moomin mobile, too. Think beyond kiddie wallpaper designs and paste up massive maps on the wall to capture their imagination. Likewise, a full-size poster on the door looks striking against an otherwise white space.

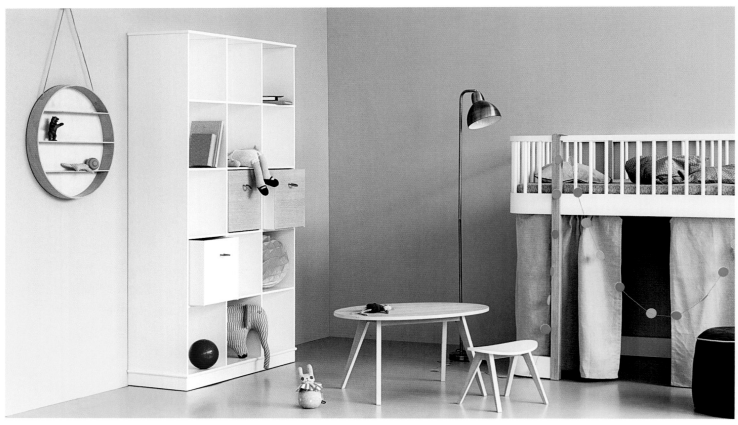

In terms of how things are used, for younger children, I like a circular table with stools for playing, as it can be moved anywhere in the room. For older children, a clean-lined hanging desk, such as the wall-mounted desk from Danish design brand Sebra creates a flexible space for work and play. I love it because it doesn't take up any room on the floor. Books should be easy-to-reach, and the Ribba picture rails from IKEA are perfect for keeping them neatly arranged. Alongside this, layer soft textiles, beanbags, and leather floor cushions to create a cozy burrow to curl up in at story time. Playful nightlights around a window create a warm, soothing space to sleep.

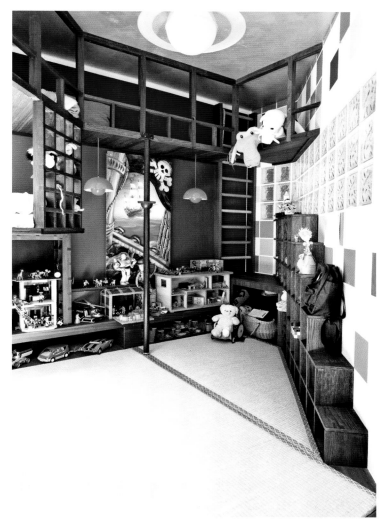

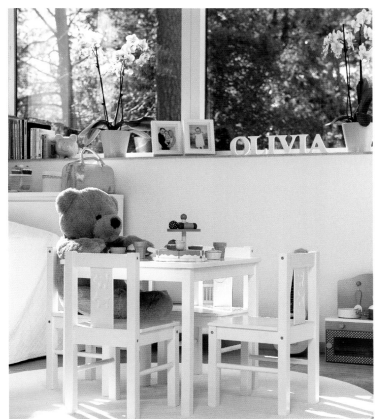

THE STORAGE

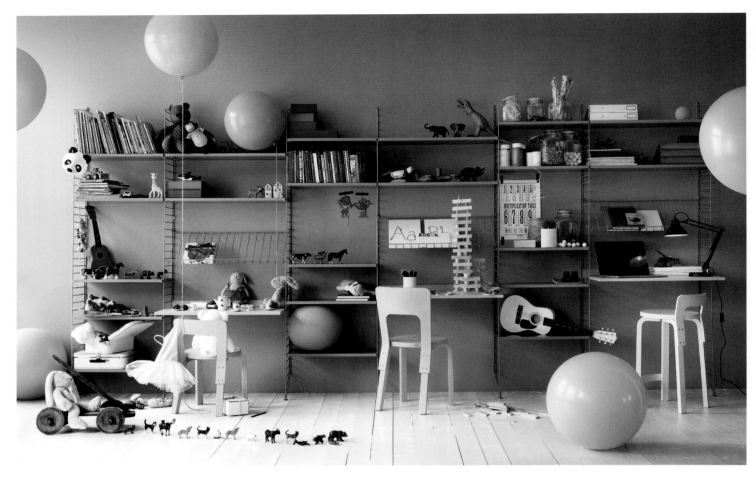

It's tricky to create a playroom that's devoid of clutter. Those clever Scandinavians, however, know a thing or two about good storage and have many solutions to keep stuff in check. The most versatile option for a child's room is to go modular with units that can be added over time. The minimalistic String shelving, designed by Swedish architect Nils Strinning in 1949, sets the bar when it comes to flexible storage. In rustic contrast, vintage crates on castors are great for storing toys, while doubling up as a ride-on toy. Keeping with the vintage vibe, a mid-century Danish tallboy is a good investment for clothes. That said, folding, is apparently overrated. In the name of keeping things tidy, put up as many hooks and hanging rails for kids to sling items over instead.

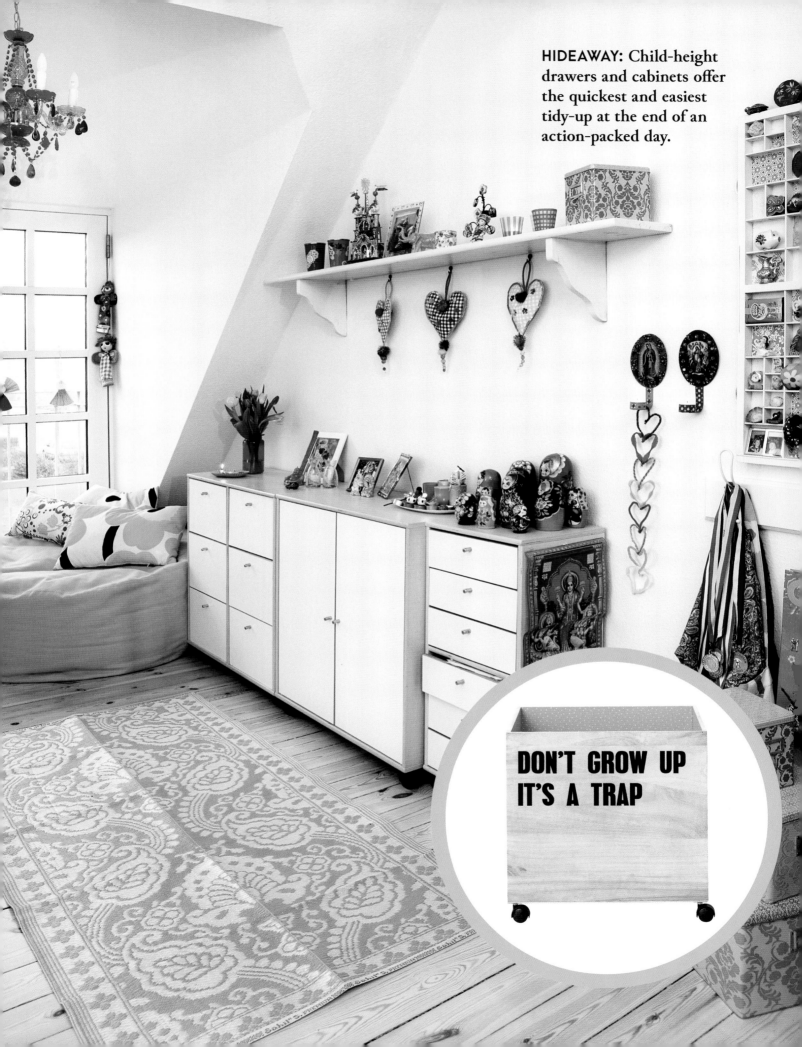

HIDEAWAY: Child-height drawers and cabinets offer the quickest and easiest tidy-up at the end of an action-packed day.

DON'T GROW UP IT'S A TRAP

HOW TO MAKE
MOON & CLOUD
CUSHIONS

———

Cute as a button in a child's room, moon and cloud cushions look beautiful on the bed or hanging from the ceiling. To start, sketch the shape onto paper and cut out. Fold the fabric in half with wrong sides together. Felt is a good choice of fabric as it doesn't move around or fray. Place the paper template on top and trace around with a pencil or chalk. Pin these together and cut through both layers of fabric. Stitch around the outside about ⅜ inch (1 cm) from the edge, leaving a 4-inch (10 cm) gap at the end. Turn the fabric the right side out and fill with stuffing. Finish by stitching across the gap to close.

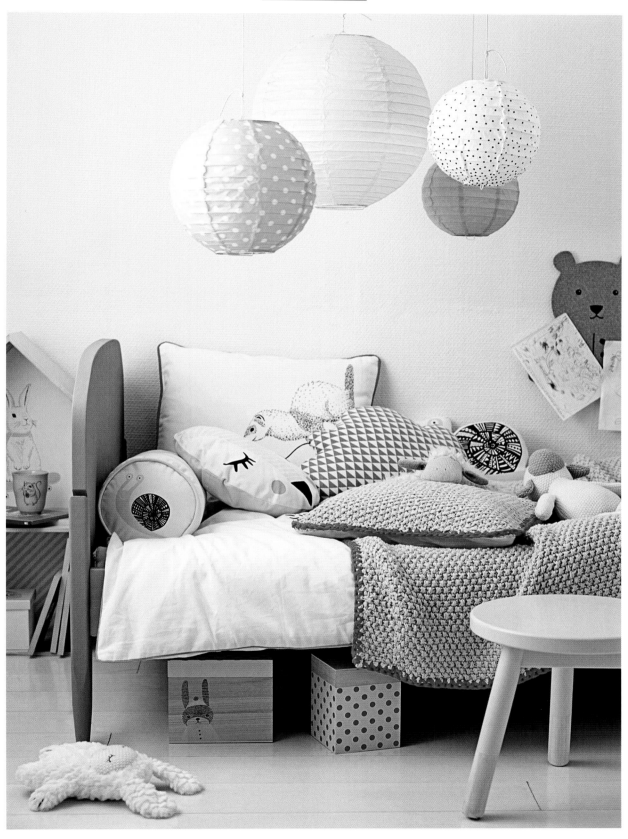

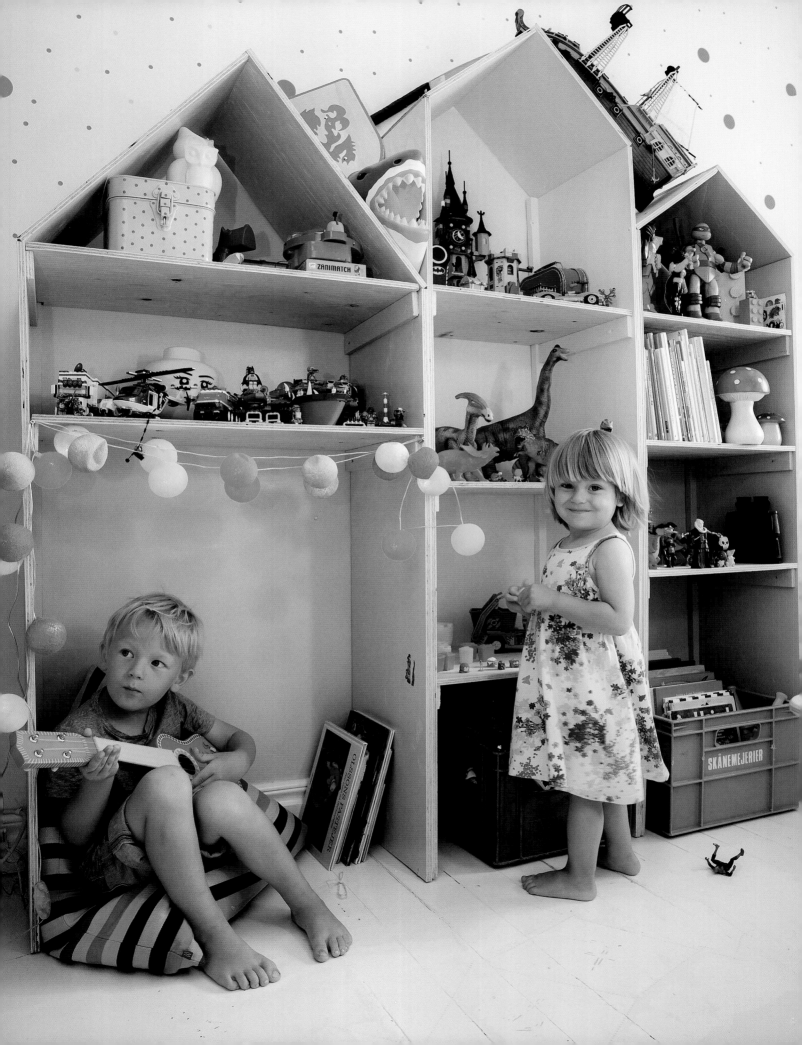

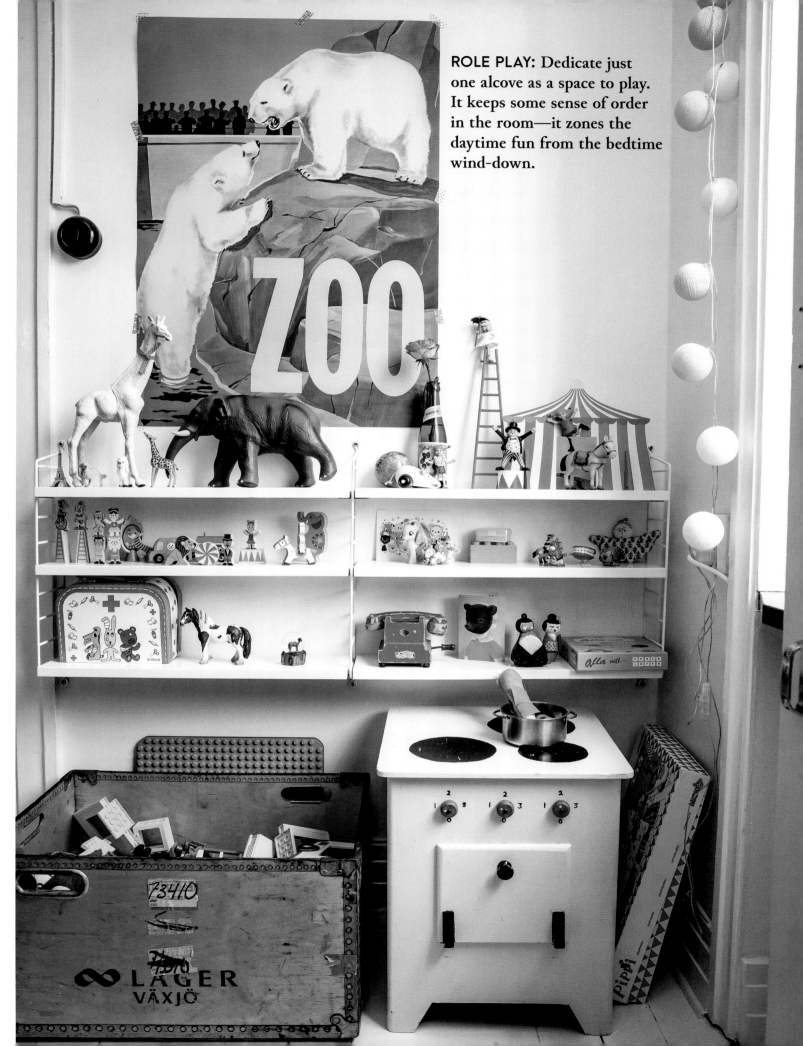

ROLE PLAY: Dedicate just one alcove as a space to play. It keeps some sense of order in the room—it zones the daytime fun from the bedtime wind-down.

JENNY BRANDT

Style Blogger

Swede Jenny Brandt runs the lifestyle and design blog
DOS FAMILY (*dosfamily.com*). With a focus on modern family homes,
she knows what makes a good kid's room click.

1 | The biggest misconception about Scandinavian design is that we all have beautiful bright interiors that match our blond hair. Of course, our homes come in just as many shades as our hair color, (thank God).

2 | It's exciting that Scandinavian style is getting a bit bolder.

3 | For me, decoration just happens. It might start with a shade of paint or a piece of furniture I find at the flea market, and then I just free style from there. I shoot from the hip, so to speak.

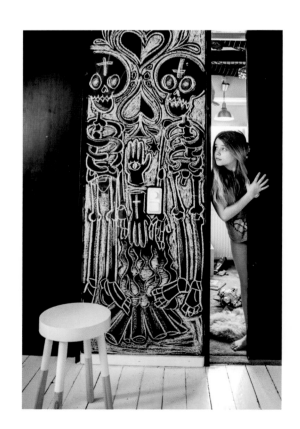

Top Tips from Scandi Creatives

4 | My favorite color combination is black-and-pink.

5 | My best decorating advice is to get to know a person with an auto paint shop. You can never get that perfect slick finish painting stuff yourself.

6 | Tables are my biggest must-have in a home. The dining room just isn't enough for my family. We have a Lego table, a crafting table, a dining table, and an all-purpose kind of table for everything else.

7 | The best thing about my daughter's room is the climbing net on the ceiling.

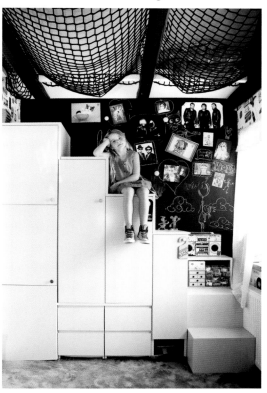

8 | Many people take their decorating way too seriously! It's just décor, so have a little fun and let your kids in on the action, too. Also, a child's room doesn't have to match the rest of the house. That is just bonkers. Our house is full of color, but our 11-year-old daughter is currently rebelling by having an all-white décor.

9 | Since the bed takes up so much room in a child's room, it's a clever idea to add some storage underneath.

10 | I would spend my last decorating dollar on a disco ball.

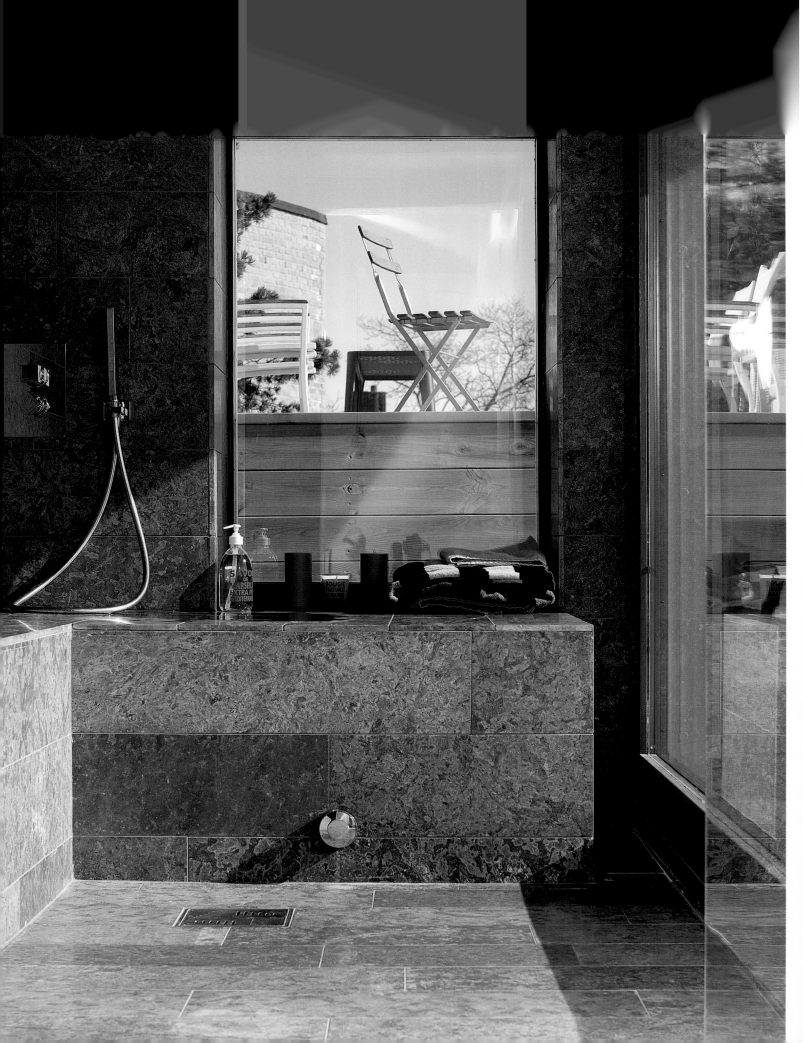

7

BATH
ROOM

Passions for simple graphic shapes, natural materials, and smart engineering merge in the Scandinavian bathroom. It is a place to wash, a place to relax, a tranquil, calm space—in 50 shades of gray.

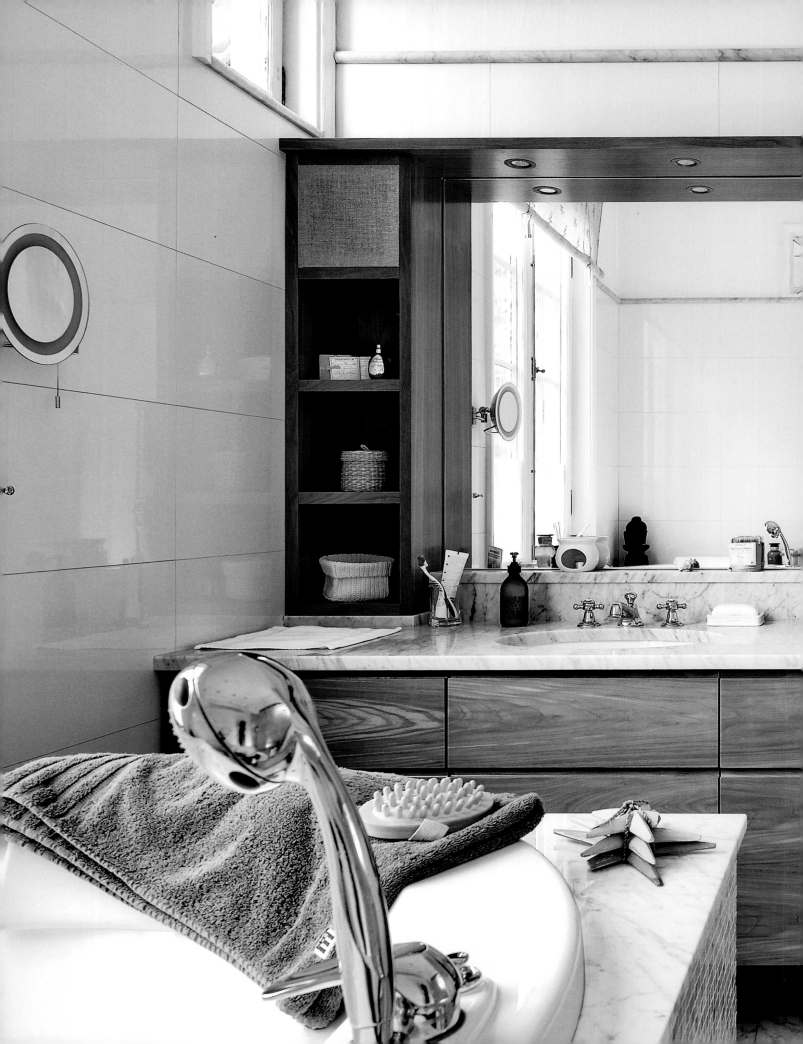

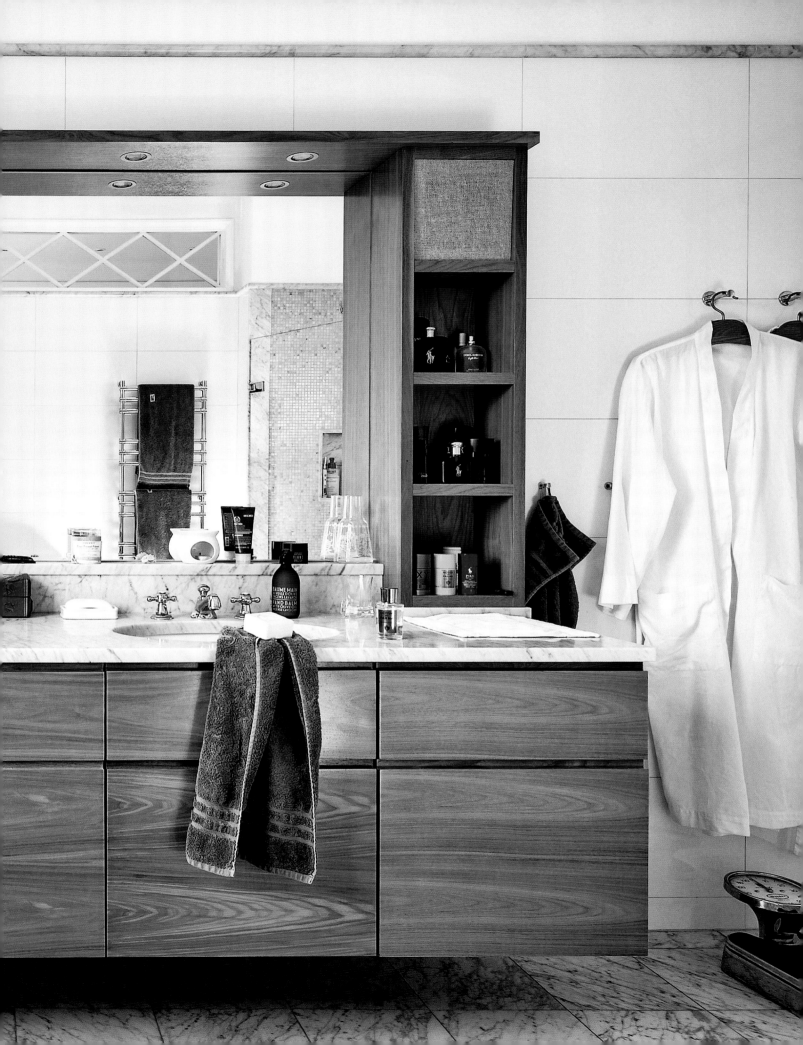

THE PALETTE

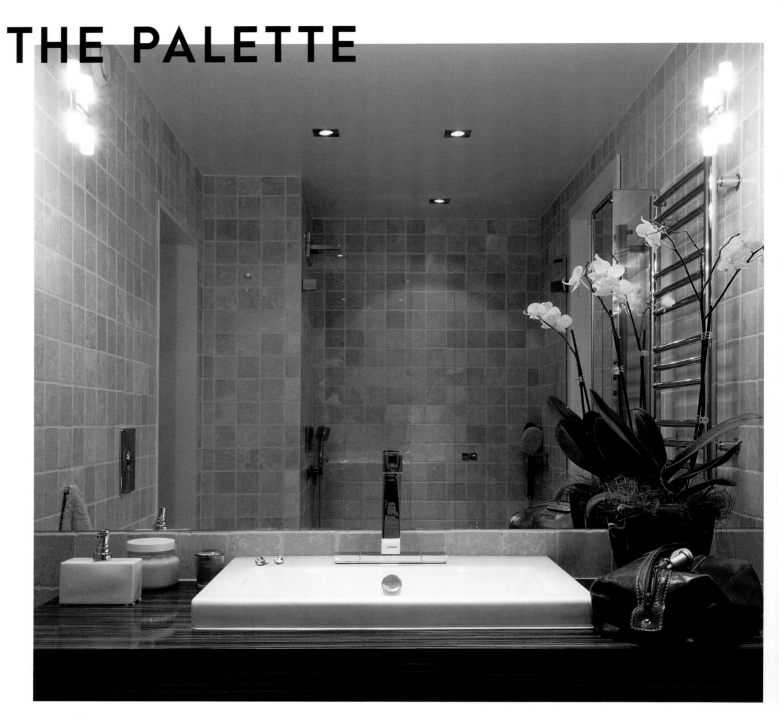

A light color scheme and sense of space is central to the Scandi look. To start, I would lose any random accessories and blinds at the windows, as this will breathe air into a space. Go for etched glass instead. The trick is to mix textures and finishes—rough with smooth, matte with shiny, hard with soft—to give a room some depth. In contrast to luxe marble tiles or smooth ceramics, timber adds a spot of rusticity and helps to bring the outside in. Tactile materials such as linens and seagrass also add textural interest, and lively spring greens and flowers will look more vibrant than ever against all those harmonious, cool tones. In place of ceramic tiles, cork is lovely to walk on, and if you can do away without a bathroom cabinet, a mirrored wall above the sink looks beautiful and bounces light all around.

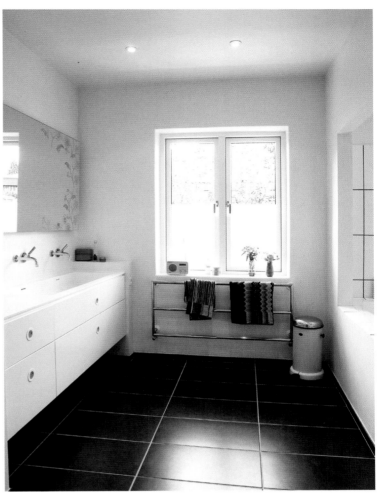
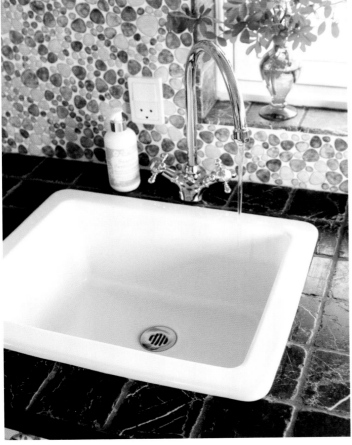
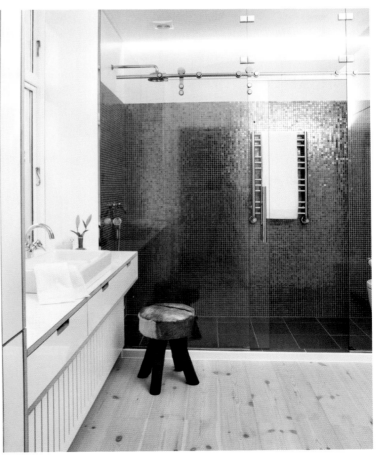

THE INTERIOR

Once, it was all about the bathroom suite. These days, it's time to break free from the vacuum-formed mold. But should you go for a freestanding roll top bathtub or a contemporary, boxy bathtub that is built in to the wall? Whether your inspiration is vintage or modern, both suit the Scandi vibe. The aim is to make the space to feel uncomplicated and open. Keep it pure and simple, and you can't go too far wrong. I love it when grandness and simplicity is combined. A roll top bathtub with the base painted in a shade to tie in to a pale gray-and-beige scheme looks great separated from the shower by a glass partition. To make the shower as streamlined as possible, recess the tray into the joists so it is flush with the floor.

It's possible to do a bathroom on a budget. While you can't cut down on the cost of the bathtub, shower fittings, faucets, etc., you can do without tiles and opt for painted walls and linoleum. I'm a big advocate of linoleum. Unless you are lucky enough to have underfloor heating, I love the soft, foot-padding, warm feel it has, along with the seamless look. Sure, it's not poured resin or gorgeous Tadelakt polished plaster, but I would take it over a cold porcelain tile with grout lines any day.

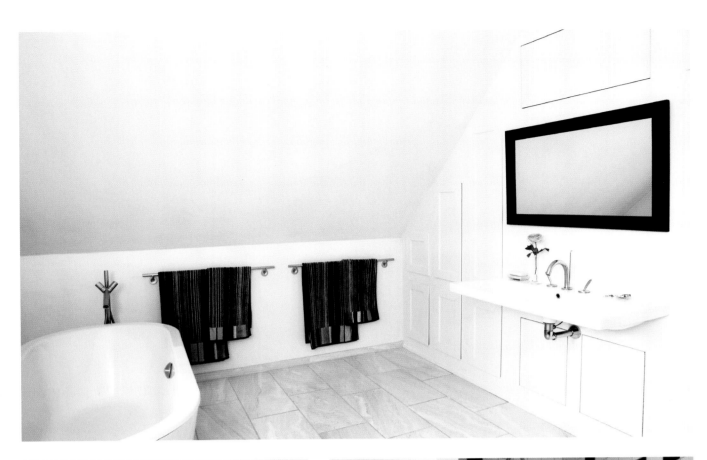

MONOCHROME: Use touches of black to add drama to a space. Against the dark-paneled wall, this roll top bath really stands out.

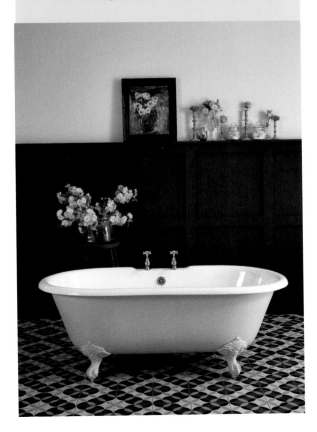

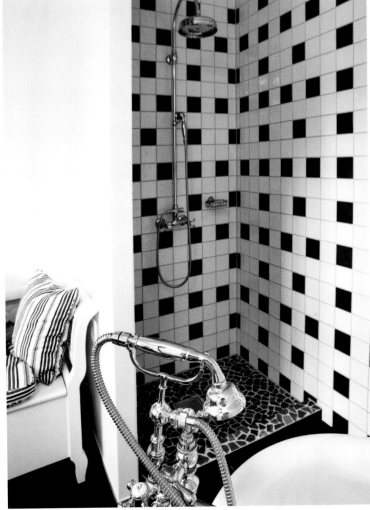

THE STORAGE

It's a simple design trick: empty space. We don't need so much stuff out all at once. The less things there are, the better as it allows the more individual pieces to shine. The first step to this is to be brutal and edit your accessories. Shampoo, conditioner, and shower gel: that will do for the day-to-day. The remaining cosmetics, cleaners, toilette paper rolls, and so on, can be neatly stowed under the sink in boxes or hidden behind a cabinet door. Focus on simple, well-made design. Weathered benches that can be tucked under a vanity unit are useful or for towels, a ladder looks good propped up against the wall. I store my towels in a large, white-painted canvas bag, while the ones that are in use are hooked on the back of the door.

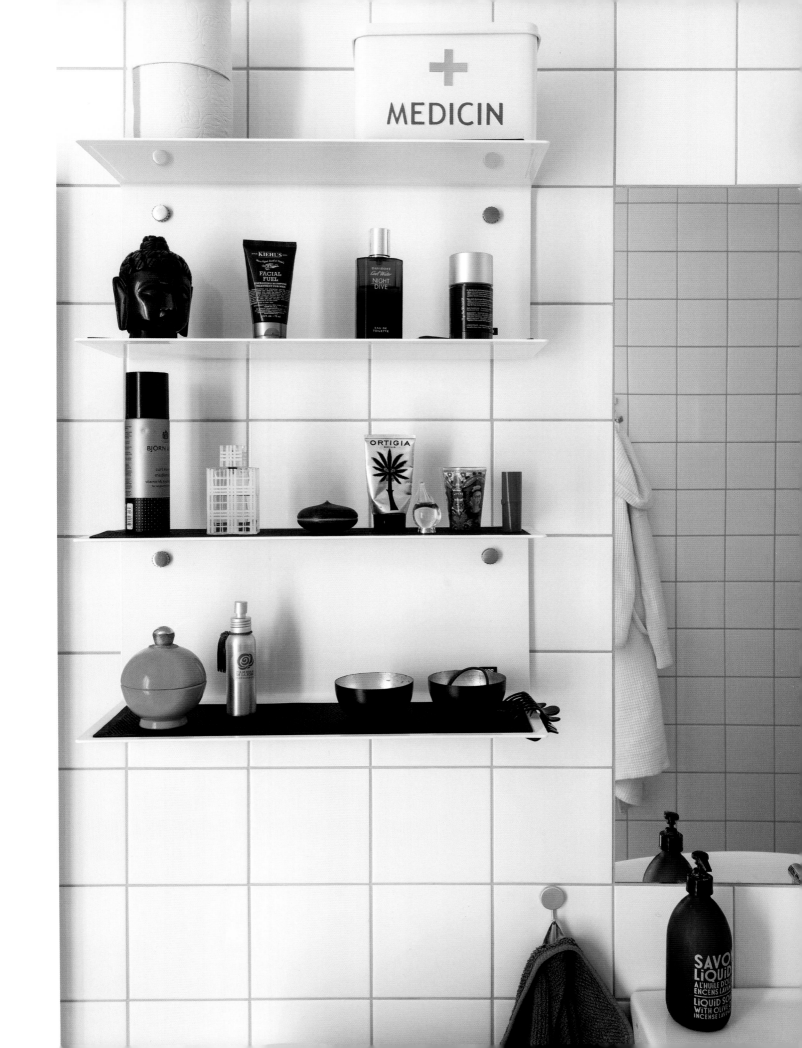

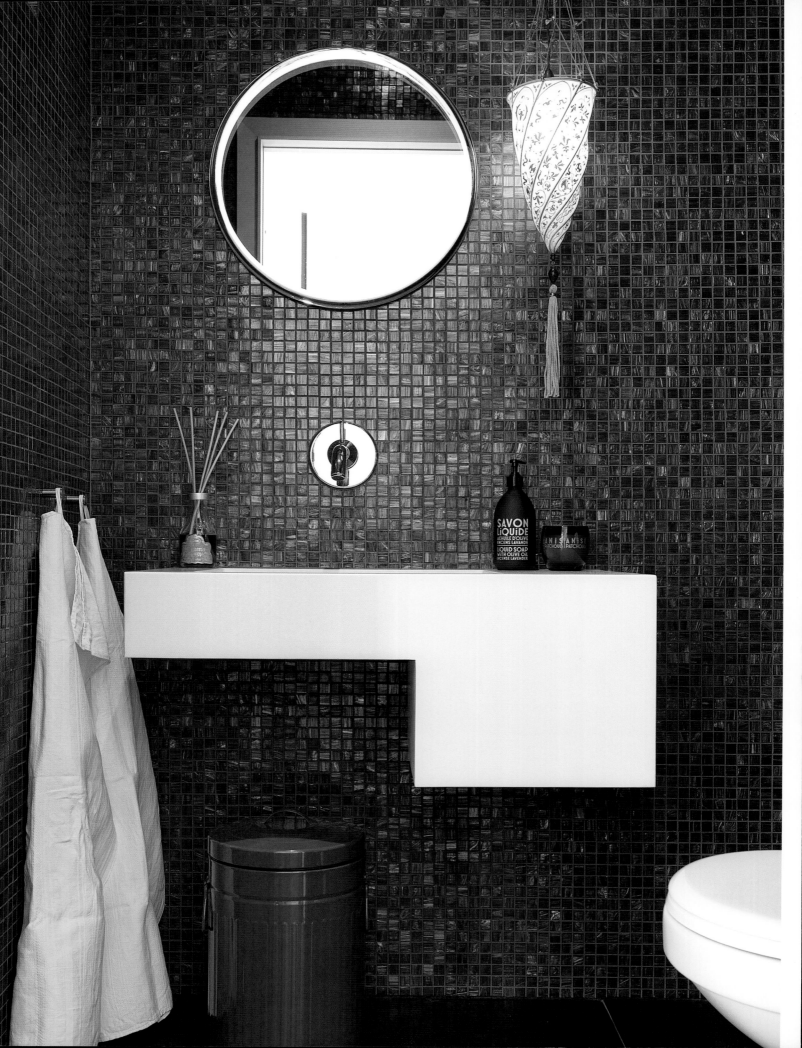

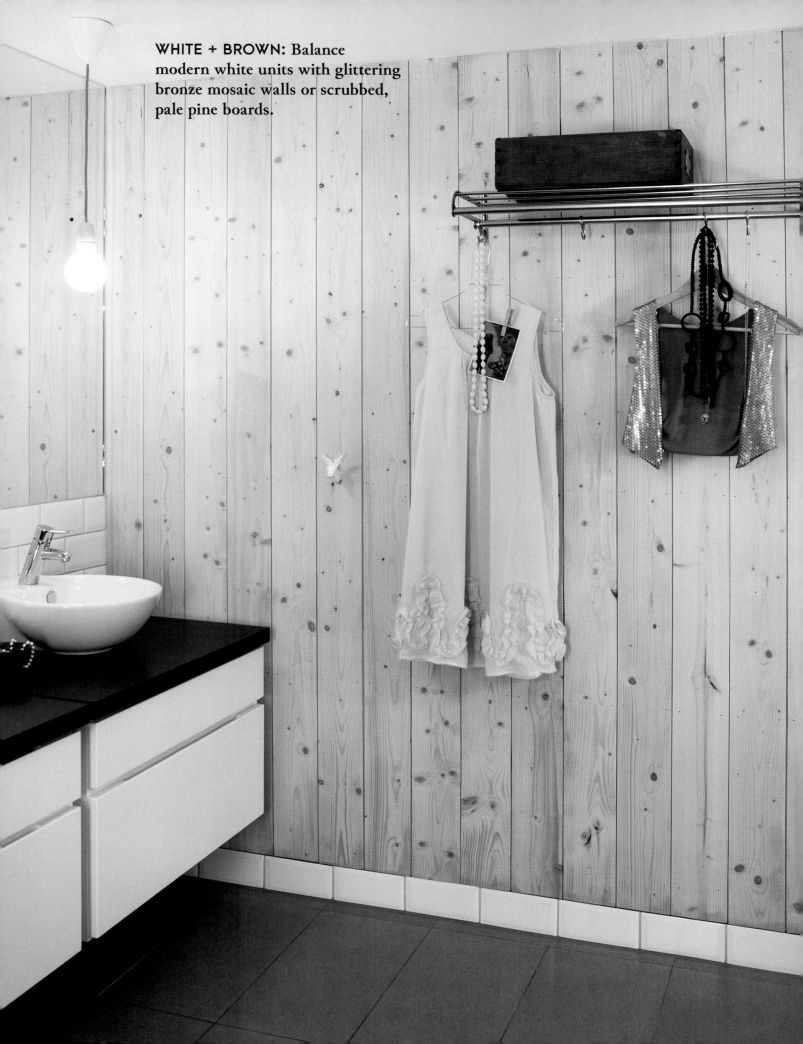

WHITE + BROWN: Balance modern white units with glittering bronze mosaic walls or scrubbed, pale pine boards.

HOW TO DO
HANGING PLANTS

Lush greenery works wonders in a white bathroom. Succulents, ferns, and orchids are perfect in this setting as they don't need much water and thrive on the humidity. You can either buy plant hangers from Bloomingville or ferm LIVING, or you can make your own hanging garden, by creating a rope sling for your pots and hang it in a trio. Using a braided cotton clothesline, cut 3 lengths of rope about 10 feet (3 m) each. Fold these in half and tie a loop knot to create a knot at the top. This leaves six strands of rope hanging down. Next, split each set of ropes into pairs and knot the left strand from one set to the right strand next to it. You can do this wherever you like to create a pattern. Repeat that again, but splitting the strands again. Finally, knot all of the ropes together at the bottom and trim the ends. If you have more rope to work with, you can let the ends hang long.

TONI KAY

Retailer

Always on the lookout for unique and functional design, Toni is the owner of online design store Skandivis (*skandivis.co.uk*), which literally translates to "living the Scandinavian way."

———

1 | Minimalism, as in whitewashed wooden floorboards combined with all white walls, has got to be the ultimate design cliché.

2 | Lightness in a room and the sense of freshness and airiness that comes from using natural materials makes Scandinavian style special. Provenance and craftsmanship is central to the Scandinavian style, too.

3 | I'm loving the steady introduction of a darker and richer color palette. It's a departure from the white and natural wood we are used to.

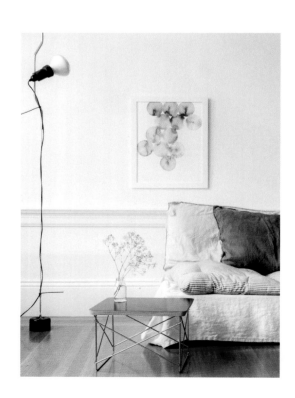

4 | My approach to decoration is relaxed and free spirited. I usually start with a single focus, whether that's a color, texture, or an object. From that initial idea, I build up a coherent look.

5 | I look for functionality and design in that order. Even everyday objects such as a broom or paper towel holder will have to meet this criterion before coming to "live" with me.

6 | My favorite color combination is black-and-white.

7 | I blend different styles by keeping a coherent color scheme throughout the home.

8 | My decorating advice is to think very carefully before you make an expensive purchase, as it's likely to stay with you for a long time. It will set the tone for the rest of your home.

9 | My bathroom is a restful room with a black-and-white roll top bathtub as the main feature. The look is softened by lots of lush green hanging ferns and Japanese Kokedamas.

10 | My must-have in a home is a huge dining table that feels welcoming as there will always be room for one more person.

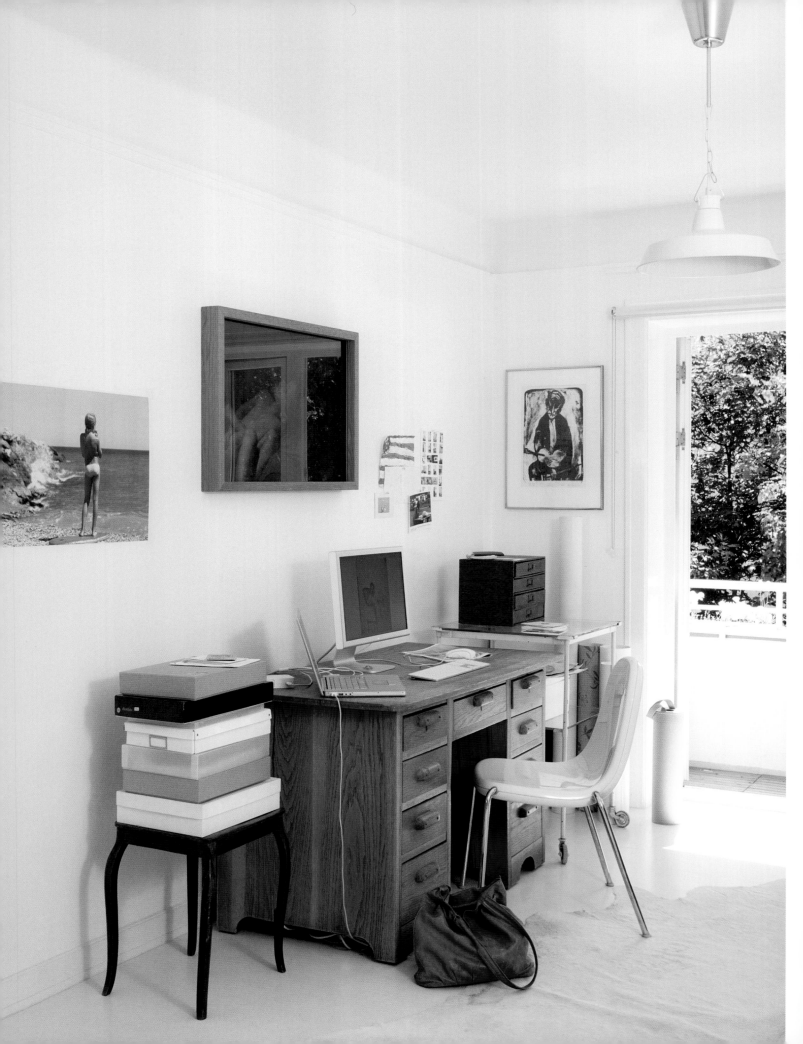

8

WORK SPACE

The decorating code for a home office needn't be dull—a desk and a chair, for sure. However, it's okay to make it cool and inviting, too. Who wants to spend any time in a corporate, sterile space? If like me, you work from home, this tends to be the room you spend the most time in. So aim to create a nook where you feel happy, comfortable, and ideally inspired. At their best, a good workspace can help you zone out and concentrate on the task at hand. Befitting the Scandinavian lifestyle, it's also a perfect spot for Fika (the art of the Swedish coffee break), when your first deadline is done.

THE PALETTE

To create a cohesive working environment, natural materials, such as woven textiles and wood, add warmth. Textures are important, so work in lots of inviting textures—we're talking rugs under your chair, sheepskins, and tactile materials that will make you want to settle in for the day. As always, the Scandinavian color palette is neutral, so personalize your desk with an amazing piece of art. If an interior is muted, it works really well with bold photography. A color print will stand out in a slim white frame. Just make it as big as the desk.

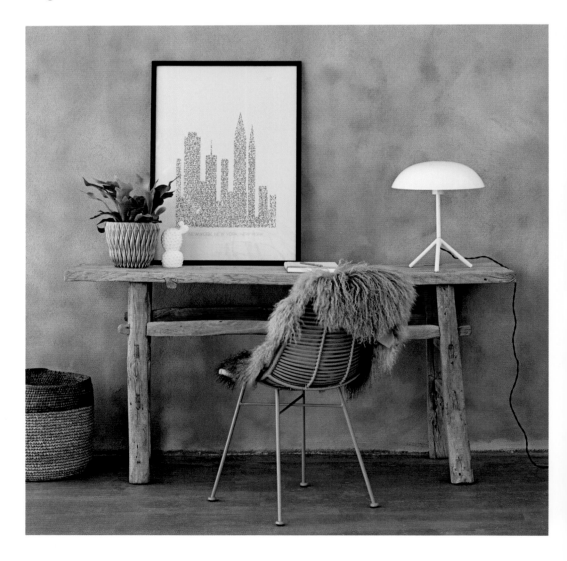

ORIGINAL THINKING: Rather than formal shelving, white-painted apple crates are used as storage for books, while providing space for still-life arrangements on top.

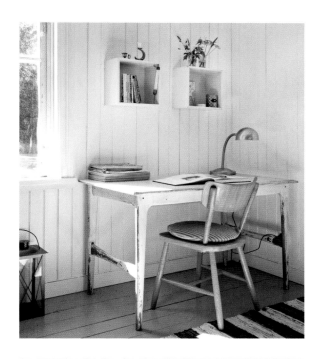

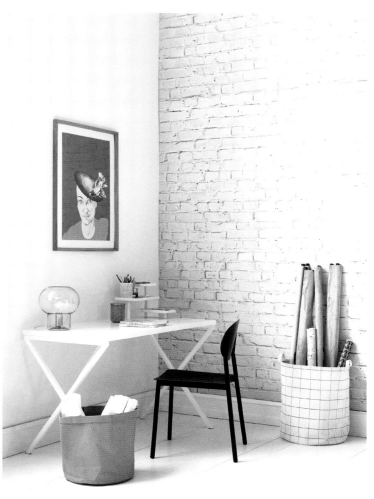

WHITE WALLS: From brick to wood panels, faux-effect wallpaper looks striking as a feature wall and will add depth and charm to a simple scheme. Painting the floor-boards white will bring extra light into the room.

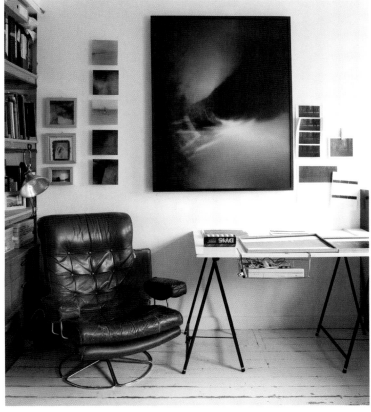

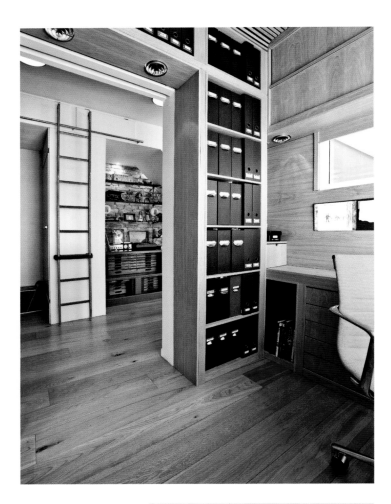

OFFICE TIDY:
Bespoke bookshelves are the ultimate in achieving an organized space. Measure out what storage you need—heights and lengths—and plan out your shelves to match.
For a more casual look, a sizable chalkboard or pinboard is always useful. Simply prop it against the wall from the floor.

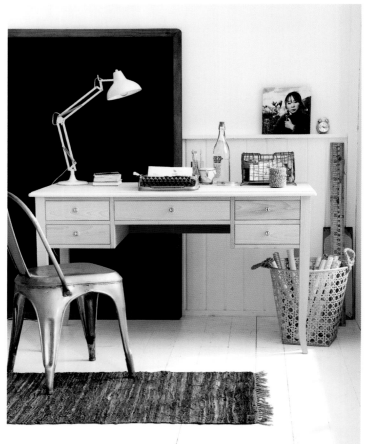

THE INTERIOR

What does a Scandinavian-inspired home office look like in the age of technology? Think simple forms combined with tech-savvy touches. Following the Nordic mantra of doing things simply but properly, an efficient workspace requires a calm, clutter-free area with a well-designed desk, an ergonomic (but good-looking) chair and an adjustable wall or desk lamp providing crisp, white LED light. It's always important to have good lighting, especially so in the office if you want to avoid eyestrain.

If space allows, a home office benefits from good space-saving storage—freestanding shelving or a bookcase suits the home environment, or a cart is handy allowing you to wheel stuff around. My printer is neatly hidden away under a canvas coffee bean sack on an IKEA stainless steel cart. I say, shut away the ugly stuff and keep wires out of sight. A cork wall is useful for pinning notes and images. Paint it white or cover with a gray felt if you want to avoid additional color in the space.

With a roll call of design classics to choose from, think of this as your opportunity to treat yourself to a beautiful sculpted desk chair. My ultimate would be a PP502 swivel chair by Hans J. Wegner for PP Møbler. I'm sure it would improve my day-to-day efficiency, especially if partnered with a Wegner CH110 desk.

THE SPACE

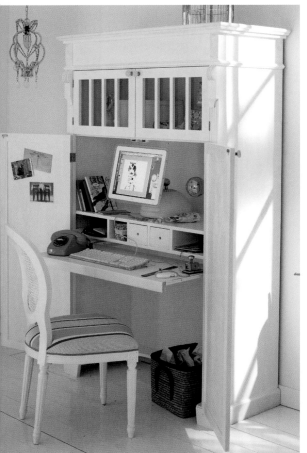

The good thing that goes with Scandinavian simplicity is that you don't need a lot of space. Literally, a desk, a chair, and a couple of shelves above, and you can set up shop anywhere. A floating shelf or skinny console can double up as a desk, which makes them ideal for long, narrow spaces. Clear acrylic chairs tucked under a built-in shelf visually take up no space at all, making these a good option if you want to save space. Or think like a hotel room and introduce a desk as a large bedside table. For the ultimate streamlined space, create an office in the manner of a wardrobe. One that you can open up when you need it and close the door or pull a curtain across when you don't. Now, that's tidy.

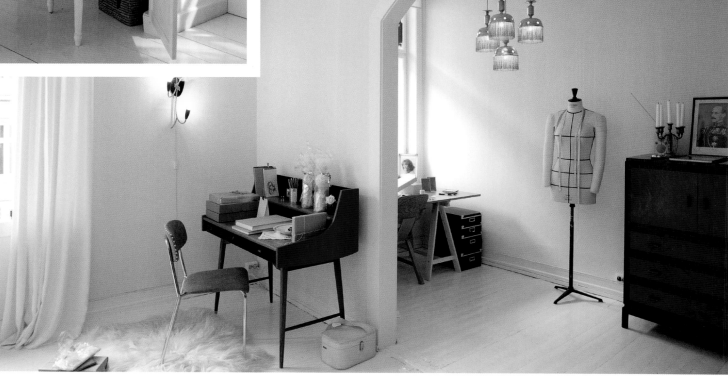

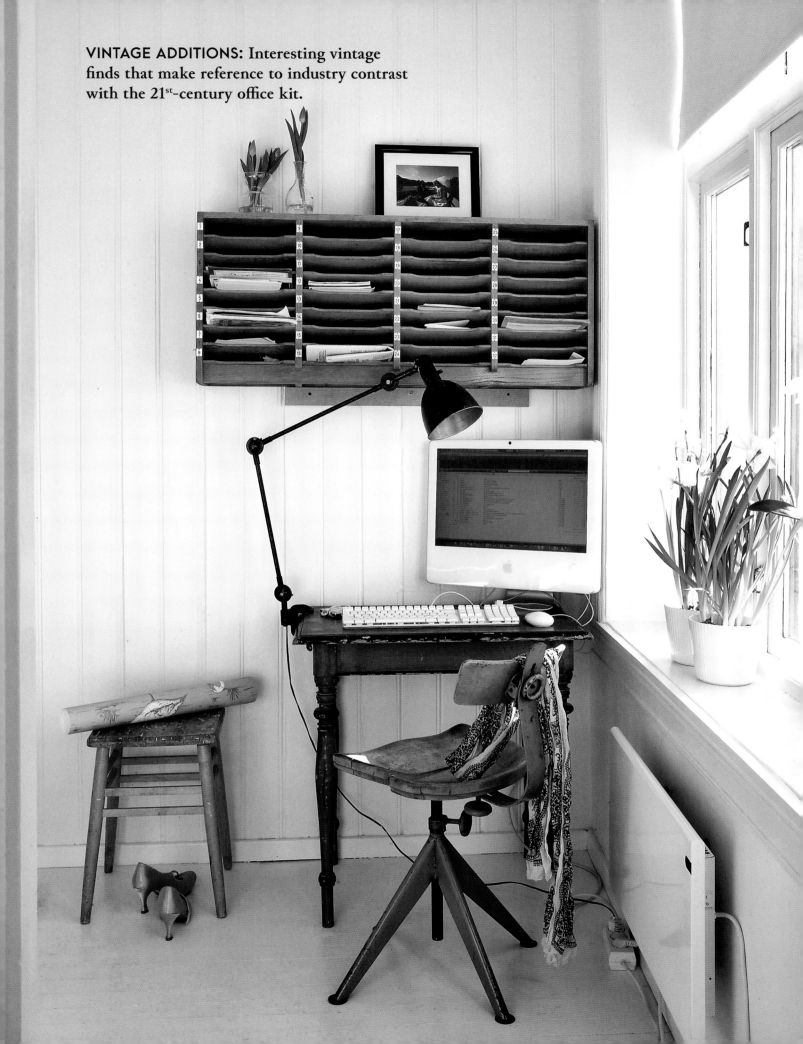

VINTAGE ADDITIONS: Interesting vintage finds that make reference to industry contrast with the 21st-century office kit.

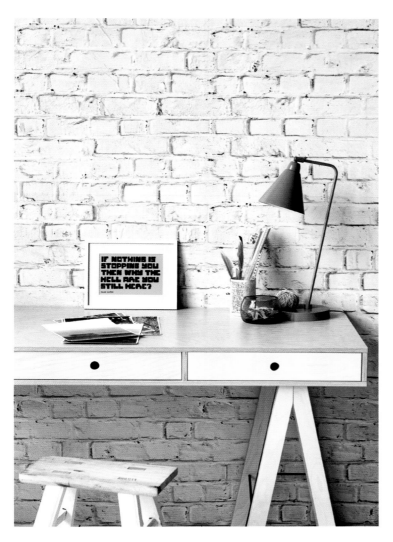

OPPOSITE PAGE:
Living room shelves can double up as office storage. Displays of books complete the library scene.

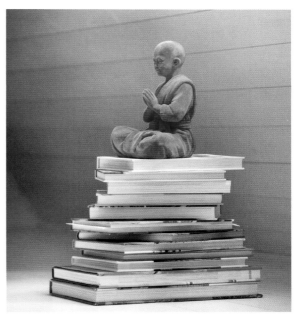

GET IT RIGHT: When setting up your office, make sure the desk is a good height to work from and that the screen isn't facing a window, so you're not dazzled by sunlight. Practical features, such as power and data sockets also need to be considered for a well-equipped workspace.

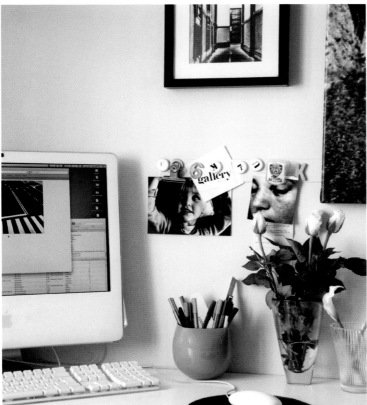

139

HOW TO USE
METALLICS

A touch of shimmering metal can make a work-space a more inspiring place to be. In true Scandi style, there is an art to getting the balance right. To avoid metallic overload, soften the look with natural textures (wool, wood, linen, and leather) and a neutral palette. You want to keep the color scheme nice and subdued. Small doses of brass or silver is all you want, so accessories such as a desk lamp or stationery organizers are perfect. If you want to go glam, brightly polished is your go-to. For something a tad more low-key, try brushed metals instead.

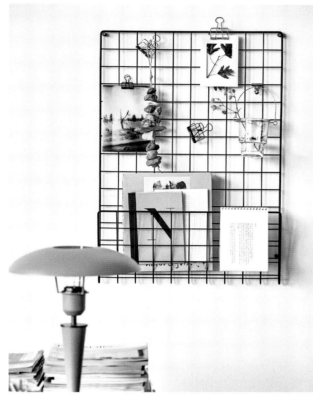

LESS IS MORE: A touch of metallic is all you need to enliven a natural scheme. A chair leg, a pendant light, and/or wastepaper basket is enough.

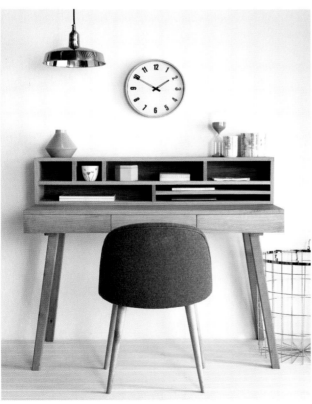

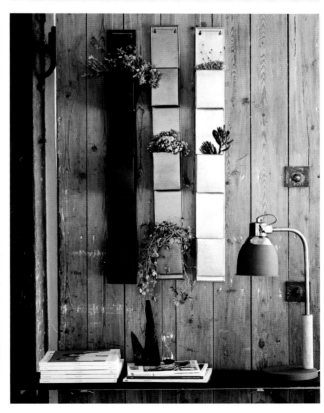

ANNA TEURNELL

Textile Artist

Creative director of Finnish design house Marimekko (*marimekko.com*),
Anna knows a thing or two about how to add pattern into the home. Pretty, playful,
simple but inventive, their designs are the essence of Scandinavian chic.

———————

1 | At its best, Scandinavian design is a combination of quality, function, and beauty. It is timeless, often with a warm touch and works for every-day life.

2 | Our four very different seasons offer endless inspiration for Scandinavian designers.

3 | Prints by Finnish designer icons, such as Oiva Toikka, Maija Isola, and Vuokko Eskolin-Nurmesniemi never cease to inspire.

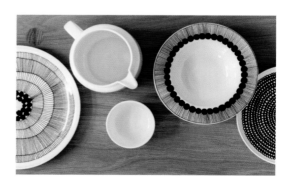

Top Tips from Scandi Creatives

4 | I think decorating should add a touch of inspiration to everyday. Small things, such as using beautiful napkins on Tuesday dinners, can make mundane moments a bit more special.

5 | I would describe my workspace as jungle, Finnish design classics, and prints.

6 | Colors and prints are a great way to express your personality. They have the power to make you feel stronger.

7 | My trick for blending objects is to put things close to each other. It's more dynamic to have objects arranged in groups, rather than spreading them out.

8 | My best style advice is to trust your intuition. Marimekko has always been about empowering people in their daily lives and encouraging them to turn their homes into a means of self-expression.

9 | Quality tableware that lasts forever is my must-have in a home. There's nothing nicer than serving food from a lovely plate.

10 | I would spend my last decorating dollar on something that would bring joy to my everyday life for years to come. A great example of this is Marimekko's Oiva tableware series by Sami Ruotsalainen.

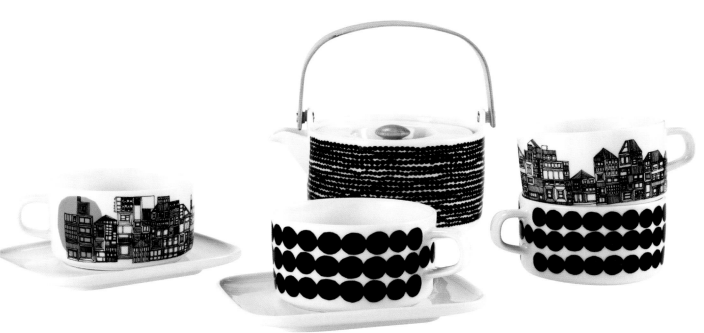

9
OUTDOOR

Picture the scene: on the terrace, Alvar Aalto chairs and an Anders Hager dining table. There's a grill in the corner and weathered decking down below. The relaxed Scandinavian lifestyle is all about living both inside and out. To create a haven of peace and comfort in the Nordic fashion, think just as you would do indoors: plain, simple, useful—and get out there, rain or shine.

THE MATERIALS

It's a style that is rustic without being too shabby chic. For me, this means keeping the scheme neutral by using colors and materials that spring from the building and the atmosphere of the environment. Decking is the most obvious choice for flooring. To get a natural finish, let timber weather and age over time. Untreated hardwoods will fade to a silvery grey, which sits beautifully in the landscape. You can also treat the timber with an iron sulfate wood preserver called Jernvitriol, which gives wood cladding a brownish-gray tone. For a more streamlined, industrial aesthetic, poured concrete flooring is the shape of things to come for patios. Extend from the kitchen and out into the garden to ramp up the indoor-outdoor charisma.

DECKED OUT: The beauty of a decked terrace is that you don't need an even floor as it is built over the top. It's warm underfoot and works in any environment. Choose a hardwood such as ipe, iroko, or balau. They contain natural oils that make them suitable for exterior use.

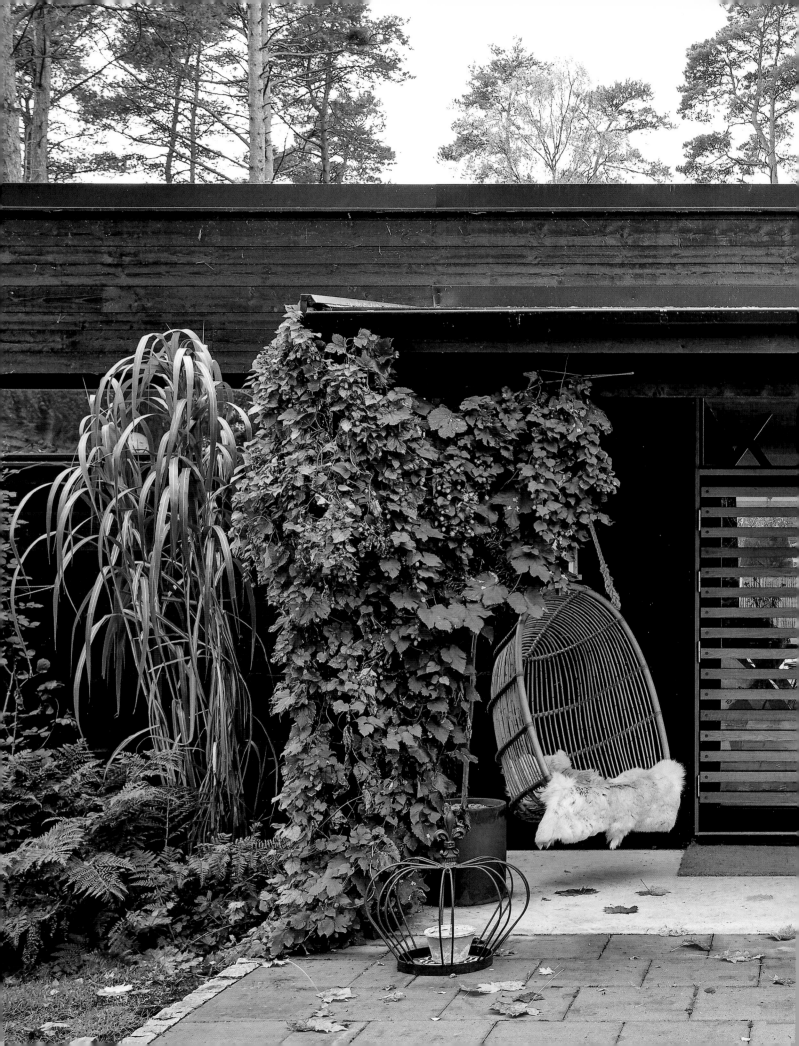

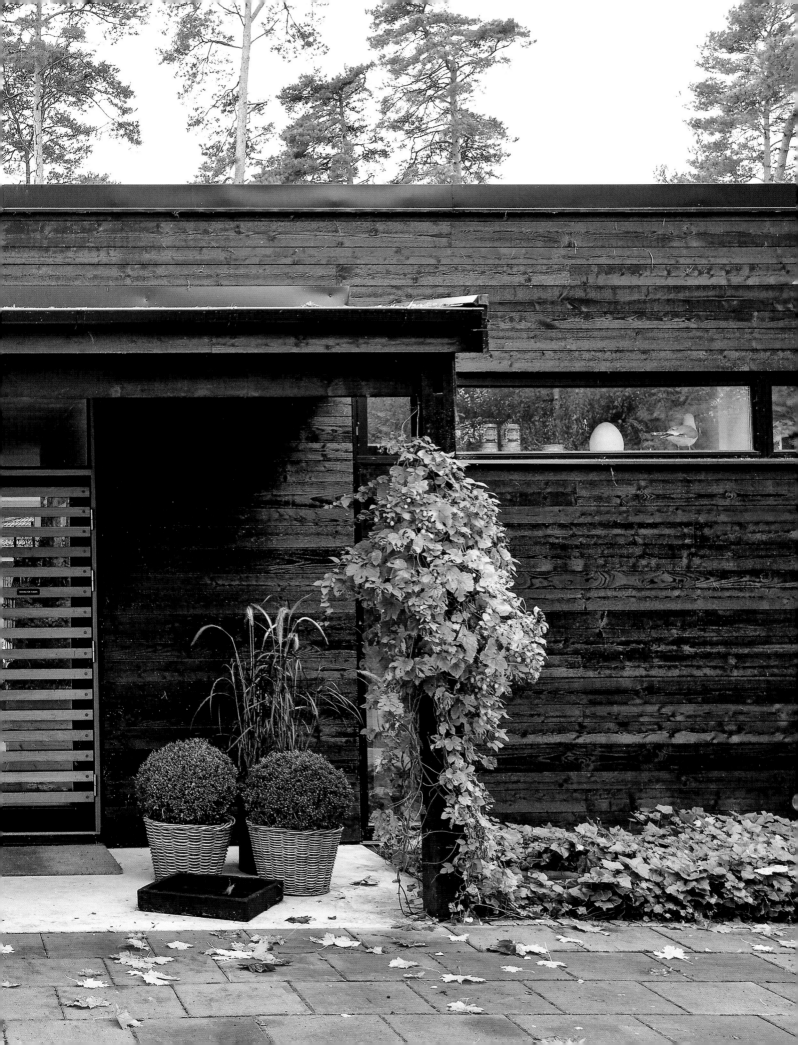

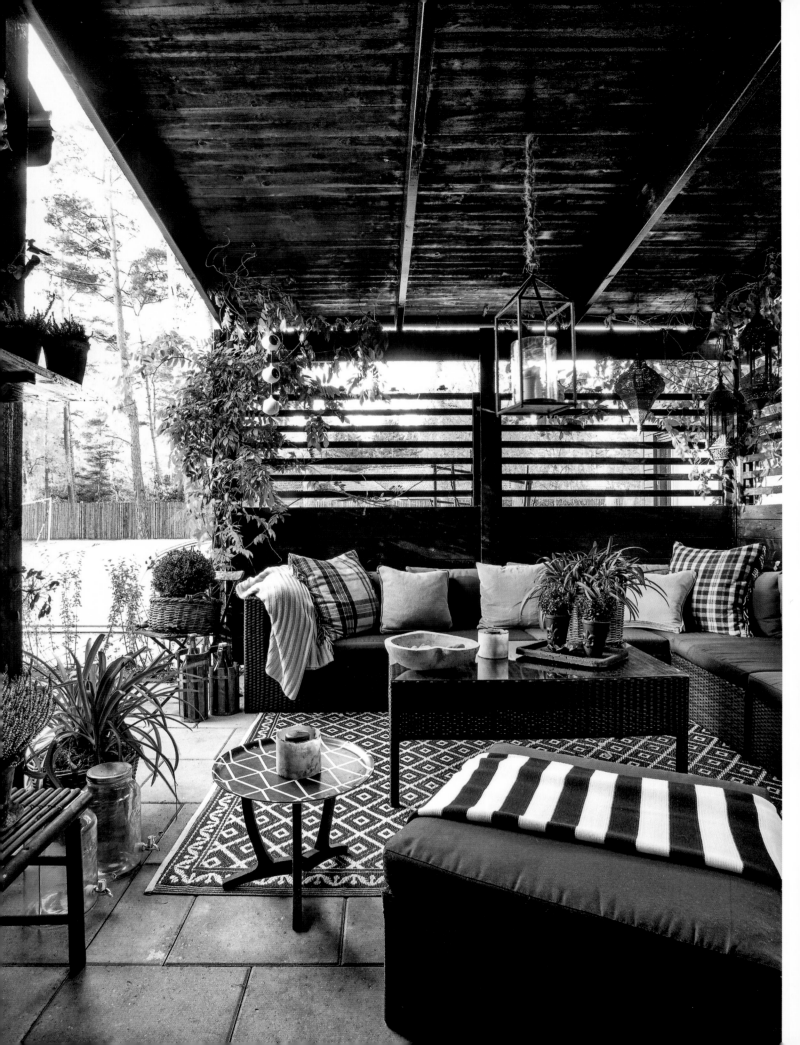

THE FURNITURE

To create a serene and inviting mood in an outdoor space, keep things simple. For tables and chairs, think modernity and straight lines. A pairing of vintage pieces and industrial-style accessories is a combination that works really well. Cane armchairs, beautiful glassware, candles, and cozy textiles will add to the chilled-out scene. This minimal furniture also suits lush greenery in the garden. The aim is to give a feel of living in the countryside. Typically laid-back, Scandinavians love low maintenance and child-friendly; think boxy raised planters, clusters of sculptural pots, and a meadow-flower lawn. A predominantly white palette goes well with the quiet, understated aesthetic. The result? A casual looking garden or terrace that is an extension of your home and makes your kitchen feel double the size. Go for built-in benches mixed with soft furnishings and all-weather textiles. Cushions, tablecloths, throws, and rugs: there is no such thing as bad weather. Just make sure the firepit is blazing, and you're nice and bundled up.

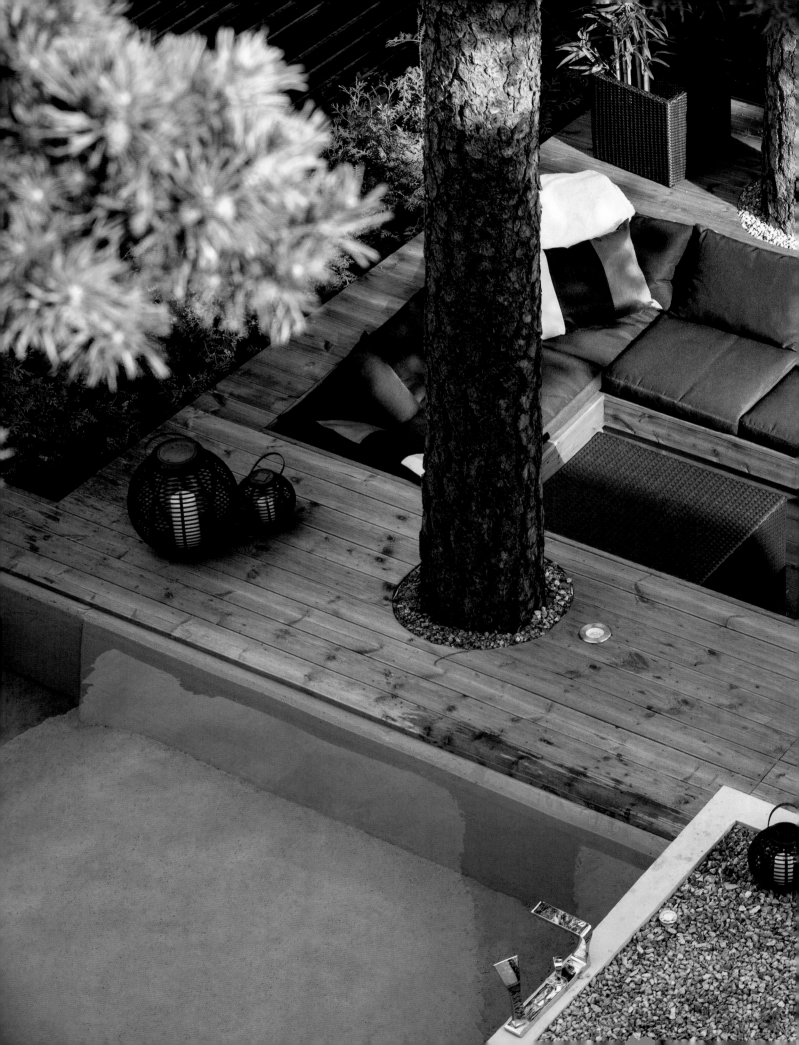

THE LIGHTING

Bring your garden to life after dark with hurricane lanterns, string lights hanging from your trees, or parasol and discreet uplighters for glittering gardens. It is the easiest and quickest way to create atmosphere and make a great talking point around the grill. If you opt for solar-powered lighting, then you have easy-peasy, year-round use. When you're choosing where to position your outdoor lights, it's useful to make your decisions from the house. This makes sure they look pretty from indoors, too.

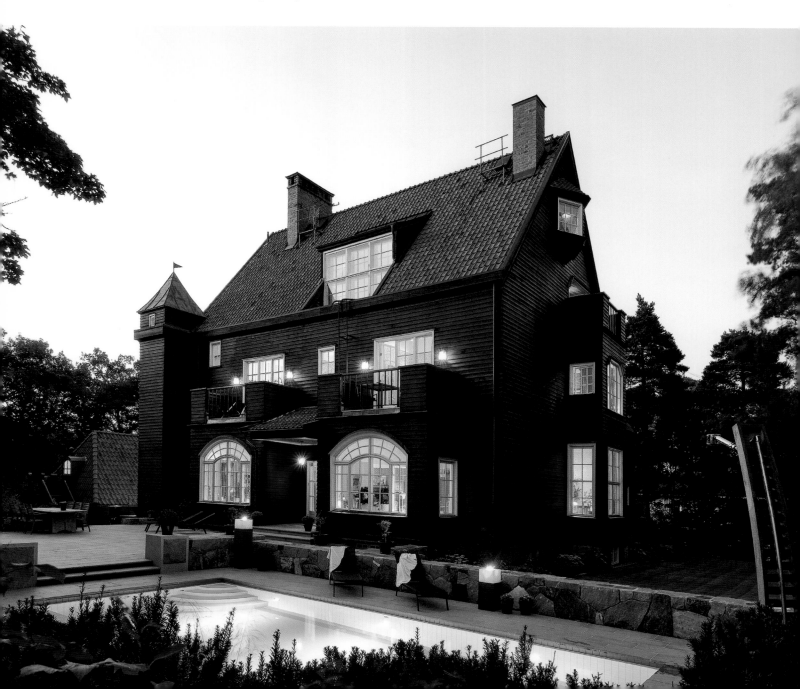

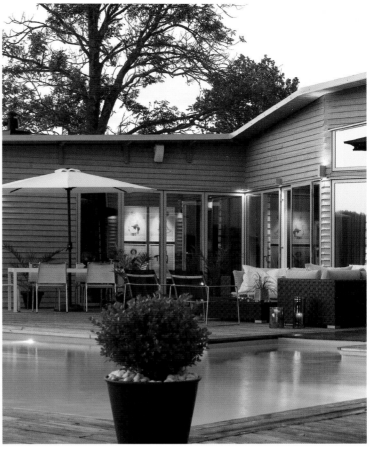

NIGHT LIGHT: Give your garden a magical glow with lighting. Oversized lanterns on the terrace are a quick and easy fix while smart downlighters will give your outdoor space a lift.

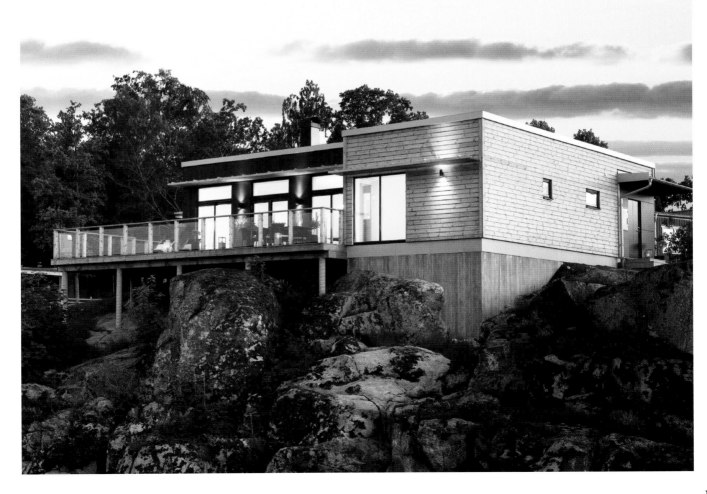

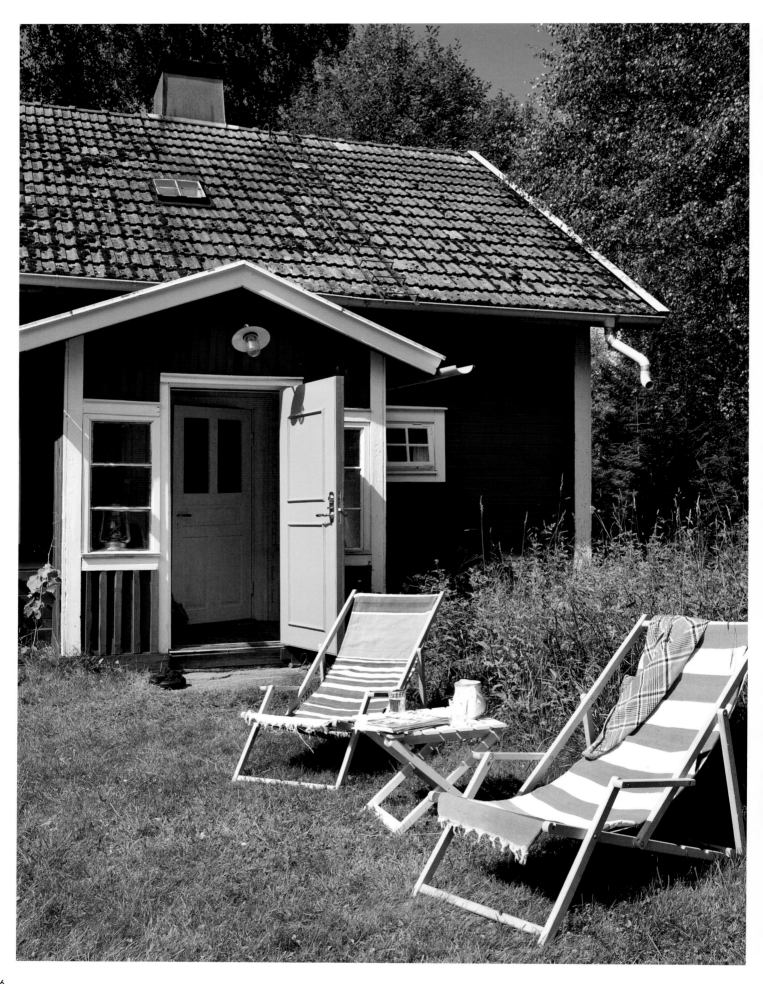

ALFRESCO ATTITUDE: Make the most of a front porch with laid-back hammocks, benches, and tables. Chill out on canvas sun loungers, softened with simple throws.

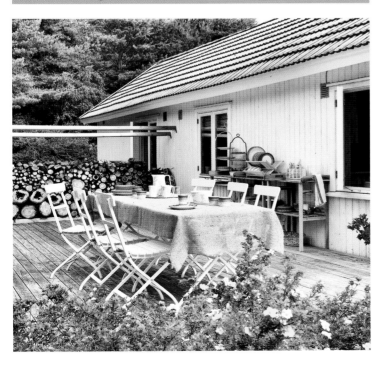

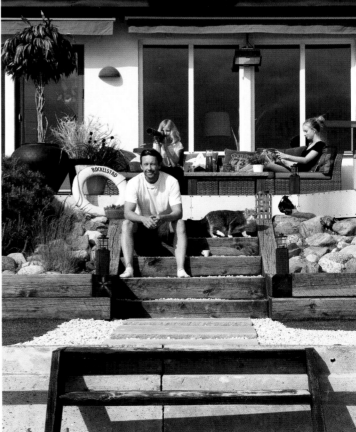

To bee or not to bee!

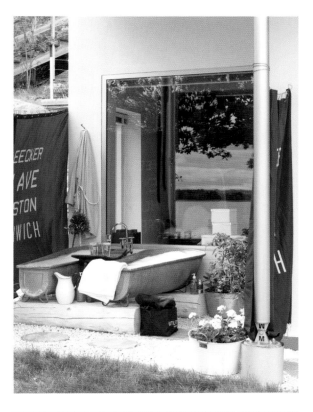

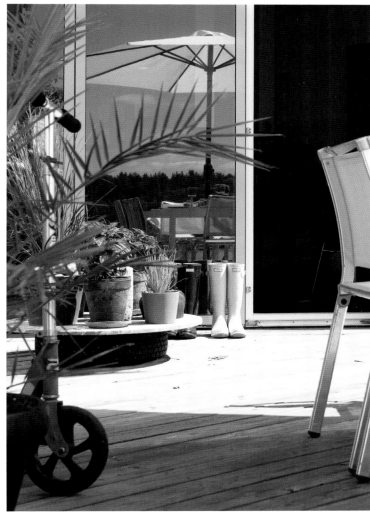

LEFT: Treat your outdoor space to a dedicated dining area. This could be a continuation of the kitchen area or a more secluded area set away from the house. Define the area with a roof structure, hang a light, and go for a textured wall.

HOW TO CREATE A
LIVING
WALL

———

The trend for vertical planting is perfect for adding greenery to small spaces. They are also a good solution for covering ugly walls. The easiest way to create a green wall is to use purpose-designed pocket planters, which are available in different sizes, for example from Woolly Pocket. Fix to the wall and fill the pockets with soil, just like ordinary gardening, and plant with a mixture of herbs, lettuces, ferns and grasses, varying the size and color of the leaf.

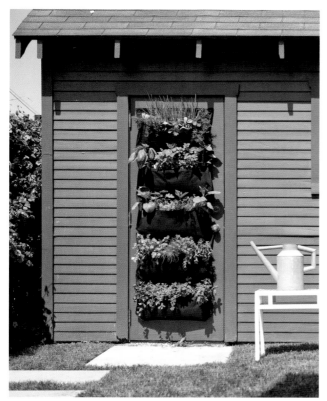

FRESH LOOK: A living wall will add cool to the smallest of spaces from a balcony to an urban backyard.

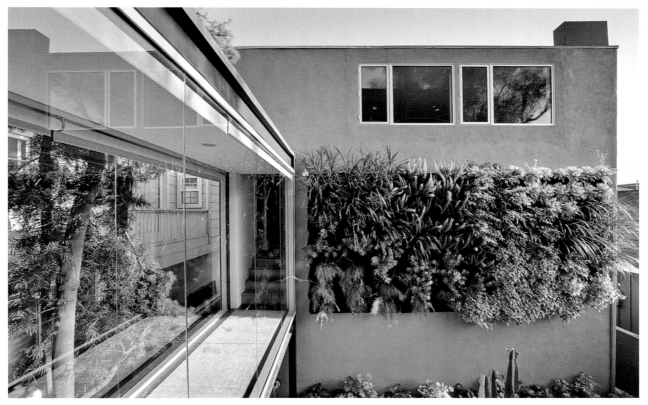

STEINAR BERG-OLSEN

Visionaire

Norwegian-born Steinar is the creative mind and owner of Wren Home (*wrenhome.com*) in London. Living in France, he turns his Scandinavian flair for design and passion for floristry to the great outdoors.

———

1 | The most common cliché about Scandinavian design is pine and IKEA.

2 | As we don't have light for much of the year, we tend to make the most of everything. In winter we use lots of candles and open fires, inside and out. Most Scandinavians use house-plants, even when it is unfashionable.

3 | My approach to decorating is that if you collect things you love, they will somehow naturally go together.

4 | Red, teal and moss is my all-time favorite color combination in the home. For the garden, white with lime and green.

5 | My best design advice is to take your time. Things that you may think are right at first often change as you live there and as the seasons go by.

6 | My biggest must-have in the home are comfortable chairs—everywhere.

7 | My garden is like a room: easy to maintain and relaxing.

8 | Unconventional furniture, rugs, and lots of pots (the bigger the better), even in a small space, are the key ingredients for a fabulous garden.

9 | Camellias are my favorite flower.

10 | My latest decorating purchase is on eight big pink blossom trees, which will take the place of patio umbrellas that blow away.

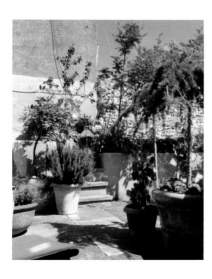
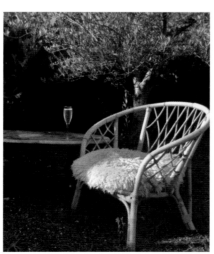

LIVING IN
&
WITH NATURE

Good design lasts. The idea that things are around for a long time is at the heart
of Scandinavian thinking. They buy for longevity, favoring well-made,
quality homewares that are handcrafted from renewable materials such as wood,
clay, or stone—integrated with heirloom pieces that have been handed down through
the family and passed on. This focus on classic, timeless design is very much
influenced by the countryside. From the grain of wood, the cut of stone,
the contours of the landscape—if something exists in nature, then it's a fast-track
way to ensure that it works in the home.

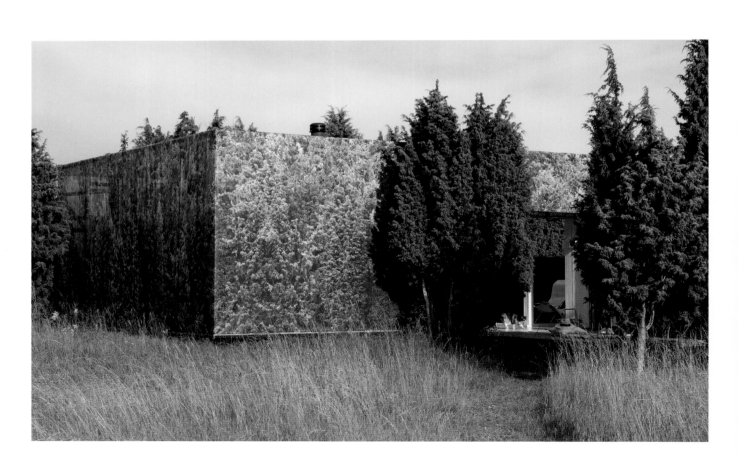

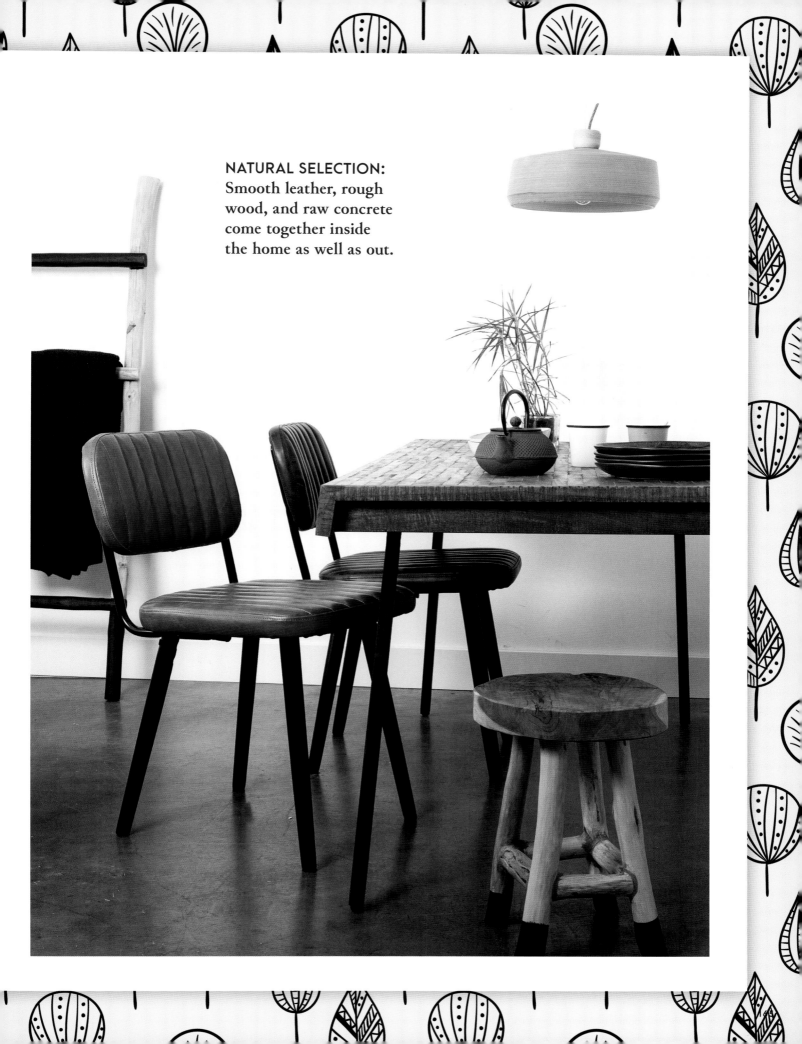

NATURAL SELECTION:
Smooth leather, rough
wood, and raw concrete
come together inside
the home as well as out.

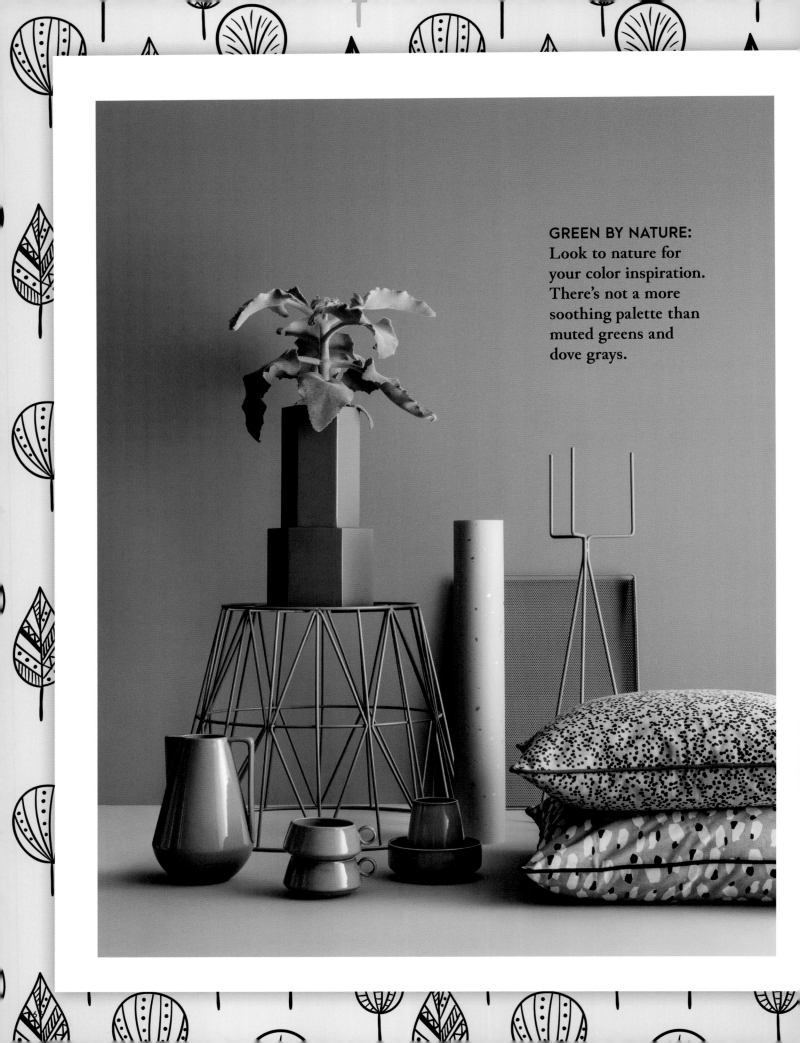

GREEN BY NATURE: Look to nature for your color inspiration. There's not a more soothing palette than muted greens and dove grays.

LIVING IN & WITH NATURE

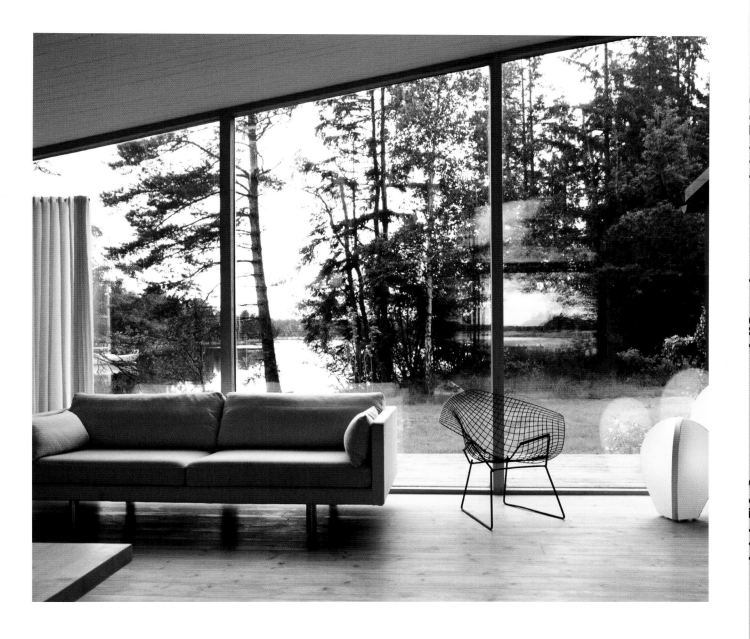

A connection with the outdoors is emphasized by an expansive use of floor-to-ceiling
windows and oodles of natural light. Endless views of the trees and sky become
a backdrop to an interior scheme where simple furnishings don't detract from
the beauty of the scenery outside.

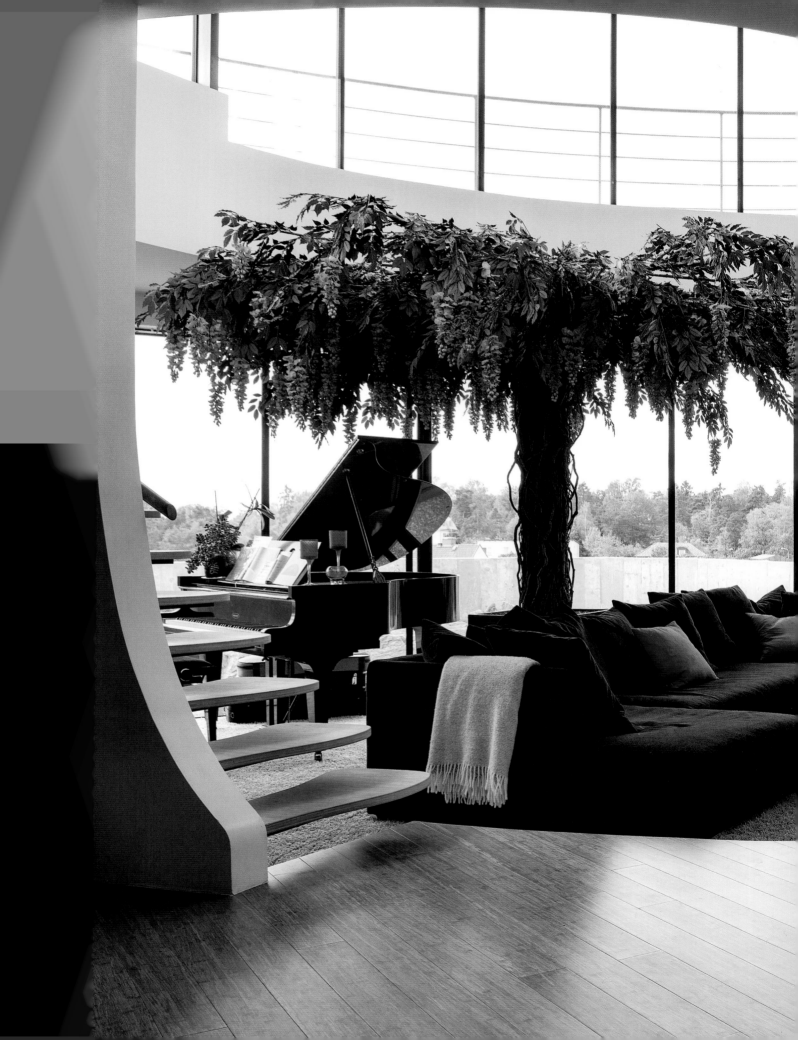

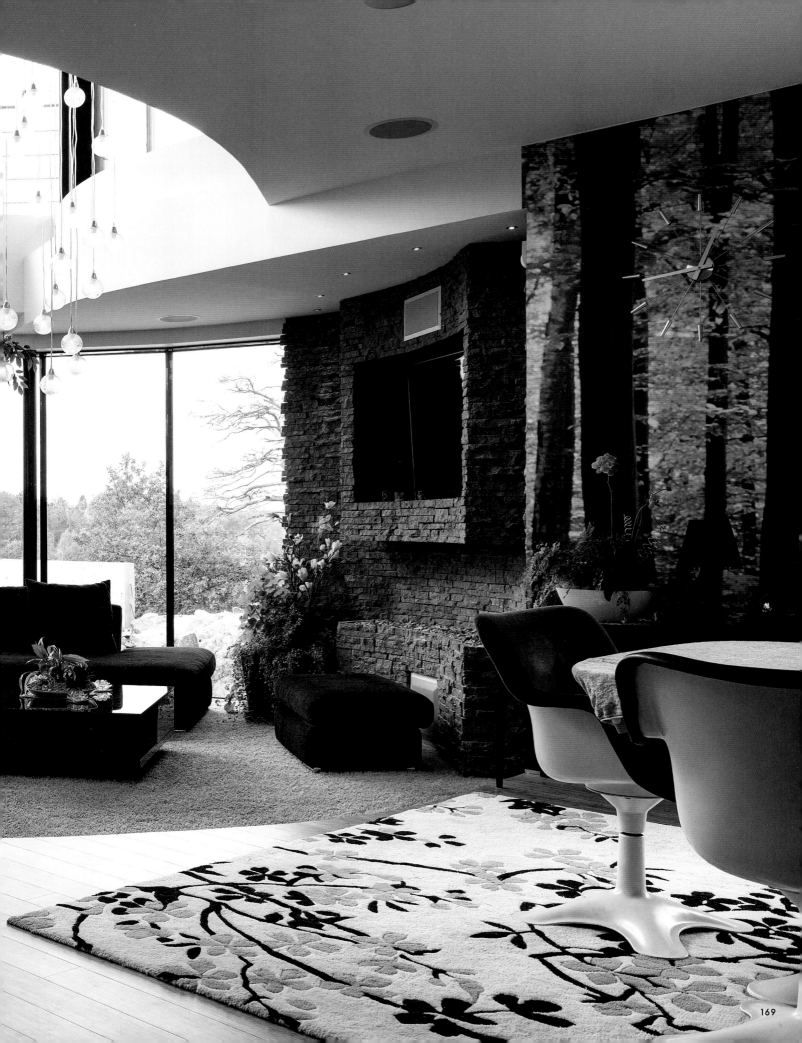

MANUFACTURERS & SUPPLIERS

BLOOMINGVILLE
(pp. 77, 104, 107, 109, 126, 132)
Bloomingville is deeply rooted in the famed Danish aesthetic tradition and has always been working to bring new life and small surprises into modern homes.

Bloomingville HQ, Lene Haus Vej 3–5, 7430 Ikast, Denmark
Phone: +45 96 26 46 45
www.bloomingville.com

CAR-MÖBEL
(pp. 5, 56, 72–73, 77, 82–83, 97, 104, 134, 136, 141, 165)
For 50 years, car-Selbstbaumöbel has been working with various magazine editors to design timeless, unique furniture that you can put together yourself in the comfort of your own home!

Car-Möbel, Gutenbergstraße 9a, 24558 Henstedt-Ulzburg, Germany
www.car-moebel.de

CARL HANSEN & SØN
(p. 134)
Every piece of furniture produced by Carl Hansen & Søn reflects over 100 years of furniture history with respect and passion for craftsmanship.

Carl Hansen & Søn A/S, Hylkedamvej 77-79, 5591 Gelsted, Denmark
Phone: +45 66 12 14 04
www.carlhansen.com

DESIGN HOUSE STOCKHOLM
(pp. 66–67)
The publishing house for Scandinavian design.

Design House Stockholm, Stadsgården 6, 10 tr. 116 45 Stockholm, Sweden
Phone: +46 8 509 08 100
www.designhousestockholm.com

DOS FAMILY
(pp. 5, 110–113)
Dos Family is Jenny Brandts personal blog on country living, everyday life, food, home tours, and so much more.

www.dosfamily.com

FARROW & BALL
(pp. 12, 70)
Farrow & Ball makes incomparable paints and wallpapers. Products are available in their showrooms, at specialty stores worldwide, and online.

Farrow & Ball, 21/22 Chepstow Corner, Notting Hill, London W2 4XE, UK
showroom@farrow-ball.com

www.farrow-ball.com

FERM LIVING
(pp. 19, 94, 127, 166)
The Danish company designs and manufactures interior products with a graphic touch, including furniture, textiles, and wallpaper.

ferm LIVING ApS, Laplandsgade 11, 2300 Copenhagen S, Denmark
Phone: +45 (0)7022 7523
www.fermliving.com

FLENSTED MOBILES
(p. 104)
Made in Denmark—A Flensted Mobile is made from a perfect combination of love, dedication, and quality, bringing a unique design into your home!

www.flensted-mobiles.com

HAY
(p. 11)
At the heart of everything that HAY does is the notion that contemporary design should spring from a good idea, innovative technology and quality materials in combination with joyful, straightforward, and uncomplicated aesthetics.

Nine United Denmark A/S, Havnen 1, 8700 Horsens, Denmark
Phone: +45 42 820 282
www.hay.dk

HÖGANAS KERAMIK
(p. 77)
The Swedish manufacturer is specialized in pottery and stoneware products that combine tradition and modernity.

www.rorstrand.com

HOUSE DOCTOR
(pp. 133, 139, 141)
House Doctor gives you a daily vitamin boost for a more stylish, more inspiring, and more personal home.

House Doctor ApS, Industrivej 29, 7430 Ikast, Denmark
Phone: +45 97 25 27 14
www.housedoctor.dk

MANUFACTURERS & SUPPLIERS

IITTALA
(p. 77)
As a company based in Finland, where quality, aesthetics, and functionality are important values, Iittala believes in interior design that lasts a lifetime.

www.iittala.com

IKEA
(p. 19)
The IKEA Concept starts with the idea of providing a range of home furnishing products that are affordable to many people, not just a few. It is achieved by combining function, quality, design, and value—always with sustainability in mind.

www.ikea.com

KORBO
(p. 141)
KORBO handmade wire baskets are functional baskets with a history that dates back to the early 1920s Sweden.

www.korbo.se

LOUIS POULSEN
(pp. 31, 61, 81)
Louis Poulsen's approach to lighting lies in a very strict and uncompromising product philosophy grounded in simplicity. The designs are admired for their unique quality and lasting appeal.

Louis Poulsen A/S, Gammel Strand 28,
1202 Copenhagen, Denmark
Phone: +45 7033 1414
www.louispoulsen.com

MAGIS DESIGN
(p. 105)
Design, for Magis, is above all a way of thinking and producing new concepts. It's filling one's head with ideas, and then screening them, knowing which ones to choose and develop.

www.magisdesign.com

MAGNET
(p. 53)
A Magnet kitchen will synchronize with your life and be exactly the space you want it to be. Because it's made that way. A multi-function kitchen to suit your multi-dimensional lifestyle.

www.magnet.co.uk

MARIMEKKO
(pp. 28, 142–143)
Marimekko is a Finnish design company renowned for its original prints and colors. The company's product portfolio includes high-quality clothing, bags, accessories, as well as home décor items ranging from textiles to tableware.

www.marimekko.com

MATER DESIGN
(p. 19)
Mater is a Danish design brand with a strong vision to create timeless and beautiful design, based on an ethical business strategy.

www.materdesign.com

MUUTO
(pp. 16, 19, 84–85)
MUUTO is rooted in the Scandinavian design tradition characterized by enduring aesthetics, functionality, craftsmanship, and an honest expression. By expanding this heritage with forward-looking materials, techniques, and bold creative thinking, Muuto's ambition is to deliver a new perspective on Scandinavian design.

www.muuto.com

MYLANDS
(p. 121)
Traditional craftsmanship and finest quality from London's oldest paintmakers. Mylands has been manufacturing quality interior and exterior paints and polishes since 1884.

Mylands, 26 Rothschild Street,
London, SE27 0HQ, UK
Phone: +44 (0)20 8670 9161
www.mylands.co.uk

OLIVER FURNITURE
(pp. 5, 103, 104)
Oliver Furniture creates wooden furniture for the modern family. Born from a proud Scandinavian tradition of wood making, the products are time-tested and thoroughly contemporary—designed to last for generations.

Oliver Furniture A/S, Ndr. Strandvej 119 A,
3150 Hellebæk, Denmark
Phone: +45 (0)4970 7317
www.oliverfurniture.com

MANUFACTURERS & SUPPLIERS

ÖRSJÖ BELYSNING

(p. 60)

Örsjö Belysning AB is a company with roots deep in the southeast corner of Småland in southern Sweden, an area known for its entrepreneurial spirit and strong tradition of design and handicraft, qualities that they've honored for over 65 years.
Today, Örsjö stands for timeless lighting fixtures and collaborations with Scandinavia's leading designers.

Örsjö Belysning AB, Emmabodavägen 14, 382 45 Nybro, Sweden
Phone: +46 (0)481 509 60
www.orsjo.com

REPUBLIC OF FRITZ HANSEN

(pp. 58–59)

Fritz Hansen's design philosophy reflects their history and inspires the creation of new, simple, sculptural, and original furniture that is timeless and relevant in time.

www.fritzhansen.com

RÖRSTRAND

(p. 77)

For almost 300 years Rörstrand has been synonymous with quality and fine craftsmanship.

www.rorstrand.com

ROYAL COPENHAGEN

(p. 77)

For more than 240 years Royal Copenhagen porcelain has been a symbol of an up-to-date, quality conscious lifestyle.

www.royalcopenhagen.com

SAGAFORM

(p. 77)

Sagaform stands for joyful, innovative products for the kitchen and the set table. Indoors and outdoors. Joyful gifts for friends or family, or to spoil yourself with.

www.sagaform.com

SEBRA INTERIOR

(p. 105)

Sebra Interior combines modern design and an innovative choice of colors with old kinds of handicraft such as crocheting and knitting. A large part of the collection is handmade and made of natural materials such as wood, wool, and cotton.

www.sebra.dk

SKAGERAK

(p. 16)

The Danish design brand creates indoor and outdoor furniture and accessories that are ensured a long lifespan by virtue of their aesthetic and functional qualities.

www.skagerak.dk

SKANDIUM

(pp. 42–43)

Retailer and contract dealer of modern Scandinavian furniture, lighting, kitchenware, and glassware for the home and office.

www.skandium.com

SKANDIVIS

(pp. 128–129)

Scandinavian contemporary design shop.

www.skandivis.co.uk

STRING FURNITURE

(p. 106)

Manufacturer of one of the 20th-century's foremost design icons—the modular shelving system by Nils Strinning.

String Furniture AB, Grimsbygatan 24, 211 20 Malmö, Sweden
Phone: +46 40 18 70 01
www.string.se

STUDIOMAMA

(pp. 98–99)

Simplicity and integrity are the trademarks of Studiomama's designs; a pared-down, contemporary but characterful aesthetic combined with a democratic belief in good design for all.

www.studiomama.com

SVENSKT TENN

(pp. 22–23)

Svenskt Tenn is an interior design company located in Stockholm, Sweden.

www.svenskttenn.se

MANUFACTURERS & SUPPLIERS

THE CAST IRON BATH COMPANY

(p. 121)

The Cast Iron Bath Company has the largest selection of freestanding cast iron baths in Europe.

www.castironbath.co.uk

TINE K HOME

(pp. 76–78, 89, 93)

With respect for history, culture, and traditional handcraft, Tine K Home creates a series of clean and elegant styles which together result in timeless collections where colors and materials are in focus.

www.tinekhome.com

WE DO WOOD

(pp. 4, 17)

We Do Wood was founded in Copenhagen in 2011 and is based on the vision that eminent design and strict sustainability principles should go hand in hand.

www.wedowood.dk

WOOLLY POCKET

(p. 161)

Woolly Pocket's modular, green, breathable vertical garden planters are made from up to 100% recycled plastics.

www.woollypocket.com

WREN HOME

(pp. 162–163)

Wren Home is a unique vintage interiors store located in the heart of Bloomsbury. With a focus on timeless design Wren Home aims to offer individual and inspiring pieces for the home.

www.wrenhome.com

CLAIRE BINGHAM

Claire Bingham is an interiors journalist who writes about architecture,
design, and style for several publications worldwide.
Before becoming an author with her first book *Modern Living*,
she was the Homes Editor for UK *Elle Decoration* and her work has been featured
in international glossies, including *Vogue Living* and *Architectural Digest*.
Scouring the globe for inspiring interiors and discovering the talents behind the scenes,
she is interested in well-considered design that fits with our individual needs.
Ultimately, she writes about the design and decoration of people's homes
and how they like to live.

www.clairebingham.com

PHOTO CREDITS

We extend our thanks to all of the manufacturers, suppliers, and dealers who allowed us to use their photographs in *Modern Living – Scandinavian Style.*

Cover: © Mainstream Images / Elisabeth Aarhus; Back Cover: top © Hübsch Interior, available from car-moebel; bottom © Göran Uhlin
Front and end papers: © freepik.com

p. 2 © Göran Uhlin; p. 4 top: © Mainstream Images / Pernille Enoch; bottom left: © We Do Wood; bottom right: © Göran Uhlin; p. 5 1st row left: © Mainstream Images / Elisabeth Aarhus; right: © car-moebel; 2nd row left: © Göran Uhlin; right: © Jenny Brandt / DosFamily; 3rd row left: © Göran Uhlin; right: © Mainstream Images / Elisabeth Aarhus; 4th row left: © Mainstream Images / Darren Chung; right: © Oliver Furniture; p. 6 © Anne Nyblaeus, styling by Anette Mörner; p. 8 © Mainstream Images / Anitta Behrendt; p. 9 © Göran Uhlin; p. 10 Mainstream Images / Elisabeth Aarhus; p. 11 left: © Mainstream Images / Pernille Enoch; right: © HAY; p. 12 © Farrow & Ball; p. 13 top: © Mainstream Images / Pernille Enoch; bottom left: © Mainstream Images / Elisabeth Aarhus; bottom right: © Göran Uhlin; p. 14 © Mainstream Images / Elisabeth Aarhus; p. 15 © Göran Uhlin; p. 16 top: © Skagerak; bottom: © Muuto / photo by Petra Bindel; p. 17 © We Do Wood; p. 19 top left: © ferm LIVING; top right: © Mater; bottom left: © Inter IKEA Systems B.V.; bottom right: © Muuto / photo by Petra Bindel; p. 20 © Mainstream Images / Pernille Enoch; p. 21 © Mainstream Images / Elisabeth Aarhus; pp. 22–23 Svenskt Tenn; p. 24 © Mark Roskams, styling and design by Inson Wood; p. 26 © Mainstream Images / Elisabeth Aarhus; p. 27 top: Mainstream Images / Elisabeth Aarhus; bottom left: © Mainstream Images / Pernille Enoch; bottom right: Mainstream Images / Anitta Behrendt; p. 28 © Marimekko, print design by Maija Isola 1964; p. 29 © Mainstream Images / Elisabeth Aarhus; p. 30 © Göran Uhlin; p. 31 top: © Louis Poulsen; bottom: © Mainstream Images / Elisabeth Aarhus; p. 33 top: © Göran Uhlin; bottom: © Mainstream Images / Elisabeth Aarhus; pp. 34–35 © Göran Uhlin; p. 37 Göran Uhlin; p. 38 top left: © Mark Roskams, styling and design by Inson Wood; top right: © Mainstream Images / Elisabeth Aarhus; bottom: © Mainstream Images / Pernille Enoch; pp. 39–41 © Göran Uhlin; p. 42 & 43 bottom: Christina Schmidt; p. 43 top: Phil Ashley; p. 44 © Göran Uhlin; p. 46 © Göran Uhlin; p. 47 © Mainstream Images / Elisabeth Aarhus; p. 48 © Mark Roskams, styling and design by Inson Wood; p. 49 top left: © Mainstream Images / Elisabeth Aarhus; top right & bottom right: © Göran Uhlin; p. 50 © Göran Uhlin; p. 51 right: © Mainstream Images / Darren Chung; p. 53 © Magnet; pp. 54–55 © Mainstream Images / Pernille Enoch; p. 56 © car-moebel; p. 57 © Mainstream Images / Elisabeth Aarhus; pp. 58–59 © Republic of Fritz Hansen / photo by Ditte Isager; p. 60 top: © Örsjö Belysning; bottom: © Mark Roskams, styling and design by Inson Wood; p. 61 © Louis Poulsen; pp. 62–63 © Göran Uhlin; p. 64 © Mainstream Images / Elisabeth Aarhus; p. 65 © Mainstream Images / Pernille Enoch; pp. 66–67 © Jonas Lindström except chair on p. 66 © Design House Stockholm; p. 68 © Mainstream Images / Elisabeth Aarhus; p. 70 top: Mainstream Images / Elisabeth Aarhus; bottom: Farrow & Ball; p. 71 © Mainstream Images / Pernille Enoch; p. 72 Hübsch Interior, available from car-moebel; p. 73 top left: © Anne Nyblaeus, styling by Anette Mörner; top right: © car-moebel; bottom: © Mark Roskams, styling and design by Inson Wood; p. 74 © Mainstream Images / Pernille Enoch; p. 75 top left: © Mark Roskams, styling and design by Inson Wood; top right & bottom: © Mainstream Images / Pernille Enoch; p. 76 © tinekhome.com; p. 77 1st row: © Bloomingville, "Mollie" & "Carla" series, available from car-moebel; 2nd row left: © Ib Laursen, "Mynte" series, available from car-moebel; 2nd row mid: © Sagaform / Mimbild ab, "Retro" series; 2nd row right & 3rd row left: © Rörstrand, "Mon Amie" & "Filippa K" series; 3rd row right: © Iittala, "Taika" series;

4th row left & 5th row left: © Iittala / photos by Timo Junttila, "Kastehelmi" & "Sarjaton" series; 4th row mid: © tinekhome.com; 5th row mid: © Royal Copenhagen, "Contrast" series; 5th row right: Höganas Keramik; pp. 78–79 © tinekhome.com; p. 81 top left & bottom right: © Louis Poulsen; top right: Hübsch Interior, available from car-moebel; bottom left: © Mainstream Images / Anitta Behrendt; pp. 82–83 © car-moebel; pp. 84–85 Muuto; p. 86 © Mainstream Images / Elisabeth Aarhus; p. 88 top: © Göran Uhlin; bottom: © Mark Roskams, styling and design by Inson Wood; p. 89 © tinekhome.com; p. 90 © Mainstream Images / Pernille Enoch; p. 91 top left & bottom: © Göran Uhlin; top right: © Mainstream Images / Darren Chung; p. 92 © Göran Uhlin; p. 93 top: © Mainstream Images / Pernille Enoch; bottom left: © tinekhome.com; bottom right: © Hübsch Interior, available from car-moebel; p. 94 top: © ferm LIVING; bottom: © Mainstream Images / Elisabeth Aarhus; p. 95 © Mainstream Images / Pernille Enoch; p. 97 top left: © car-moebel; top right: © Göran Uhlin; bottom left: © Mainstream Images / Pernille Enoch; bottom right: © Mainstream Images / Elisabeth Aarhus; pp. 98–99 © Studiomama; p. 100 © Mainstream Images / Elisabeth Aarhus; p. 102 © Mainstream Images / Anitta Behrendt; p. 103 © Oliver Furniture; p. 104 top right: © Moomin Characters ™ & Flensted Mobiler aps; top left: © Bloomingville, available from car-moebel; bottom: © Oliver Furniture; p. 105 top: © Mainstream Images / Pernille Enoch; mid: © Magis Spa; bottom left: © Sebra / photo by Palle Peter Skov; bottom right: © Göran Uhlin; p. 106 Marcus Lawett / String Furniture AB; p. 107 large image: © Mainstream Images / Anitta Behrendt; small image: © Bloomingville, available from car-moebel; p. 109 © Bloomingville; pp. 110–113 Jenny Brandt / DosFamily; p. 114 © Göran Uhlin; pp. 116–117 © Göran Uhlin; p. 118 © Mainstream Images / Elisabeth Aarhus; p. 119 © Mainstream Images / Anitta Behrendt; p. 121 top & bottom right: Mainstream Images / Anitta Behrendt; bottom left: © The Cast Iron Bath Company, paints by Mylands; pp. 122–124 © Göran Uhlin; p. 125 © Mainstream Images / Elisabeth Aarhus; p. 126 © Bloomingville; p. 127 © ferm LIVING; pp. 128–129 © prints by Silke Bonde, photos from left to right by FrenchByDesignBlog.com, studiooink.de, silkebonde.dk; Toni Kay portrait by Sandi Friend; p. 130 © Mainstream Images / Elisabeth Aarhus; p. 132 © Bloomingville; p. 133 top left: © Mainstream Images / Pernille Enoch; top right: © House Doctor; bottom: © Mainstream Images / Ray Main / Chrystel Lebas; p. 134 top left: © Mainstream Images / Pernille Enoch; top right: © Carl Hansen & Søn; bottom: © car-moebel; p. 136 top: © car-moebel; bottom & p. 137: © Mainstream Images / Elisabeth Aarhus; p. 138 © Göran Uhlin; p. 139 top left: © House Doctor; top right: © Göran Uhlin; bottom: © Mainstream Images / Pernille Enoch; p. 141 top left: © House Doctor; top right: © Korbo; bottom left: © Hübsch Interior, available from car-moebel; bottom right: © Madam Stoltz, available from car-moebel; pp. 142–143 © Marimekko, "Oiva" series designed by Sami Ruotsalainen, print design by Aino-Maija Metsola 2012 (Sääpäiväkirja plate p. 142 top), print design by Maija Louekari 2009 (Räsymatto teapot and mugs p. 143 & Siirtolapuutarha plates and mugs p. 142 bottom); p. 144 © Göran Uhlin; p. 146 Anne Nyblaeus, styling by Anette Mörner; p. 147 top: © Mainstream Images / Elisabeth Aarhus; bottom: © Göran Uhlin; pp. 148–150 © Mark Roskams, styling and design by Inson Wood; pp. 152–155 © Göran Uhlin; p. 156 © Mainstream Images / Pernille Enoch; p. 157 top & bottom right: © Göran Uhlin; bottom left: © Mainstream Images / Darren Chung; p. 158 Mark Roskams, styling and design by Inson Wood; p. 159 © Göran Uhlin; p. 161 © Woolly Pocket; pp. 162–163 © Steinar Berg-Olsen; p. 164 © Göran Uhlin; p. 165 © car-moebel; p. 166 © ferm LIVING; p. 167 © Mainstream Images / Ray Main, designer Ann von Schewen; pp. 168–169 © Göran Uhlin; p. 174 © Dandelion Photography

© VG Bild-Kunst, Bonn 2016:
p. 38 bottom by Inge Blomqvist (paintings)

IMPRINT

Words by **Claire Bingham**
Copy editing by **Maria Regina Madarang**
Editorial management by **Nadine Weinhold**
Design, Layout & Prepress by **Christin Steirat**
Production by **Alwine Krebber**
Imaging & proofing by **Jens Grundei**

Published by teNeues Publishing Group

teNeues Media GmbH & Co. KG
Am Selder 37, 47906 Kempen, Germany
Phone: +49 (0)2152 916 0
Fax: +49 (0)2152 916 111
e-mail: books@teneues.com

Press department: Andrea Rehn
Phone: +49 (0)2152 916 202
e-mail: arehn@teneues.com

teNeues Publishing Company
7 West 18ᵗʰ Street, New York, NY 10011, USA
Phone: +1 212 627 9090
Fax: +1 212 627 9511

teNeues Publishing UK Ltd.
12 Ferndene Road, London SE24 0AQ, UK
Phone: +44 (0)20 3542 8997

teNeues France S.A.R.L.
39, rue des Billets, 18250 Henrichemont, France
Phone: +33 (0)2 48 26 93 48
Fax: +33 (0)1 70 72 34 82

www.teneues.com

ISBN: 978-3-8327-3418-3
Library of Congress Control Number: 2016942227
Printed in the Czech Republic